Inventories and Transformations

The Photographs of Thomas Barrow

Jacket illustration: *Notations on Modernism*, detail

Library of Congress Cataloging in Publication Data

Gauss, Kathleen McCarthy.
 Inventories and transformations.

 1. Barrow, Thomas F. 2. Photography, Artistic—Exhibitions.
 I. Barrow, Thomas F. II. Los Angeles County Museum of Art.
 III. Title.
TR647.B364 1987 779′.092′4 86-5529
ISBN 0-8263-0901-1
ISBN 0-8263-0902-X (pbk.)

Published for the Los Angeles County Museum of Art by the
University of New Mexico Press, University of New Mexico,
Albuquerque, New Mexico 87131.

Inventories and Transformations

The Photographs of Thomas Barrow

Kathleen McCarthy Gauss

Published for the
Los Angeles County Museum of Art
by the
University of New Mexico Press

"I'm fascinated by the extraordinary

materialism of our age and all

the things that are produced in series,

as countless multiples. These things

are the essence of our culture."

Contents

Foreword

Earl A Powell III
*Director, Los Angeles County
Museum of Art*

The Los Angeles County Museum of Art is extremely pleased to present the work of Thomas Barrow, one of the major contributors to experimentation in American photography during the past two decades. This is the first retrospective exhibition of this mid-career artist, and it examines the development of challenging and provocative work over a twenty-year span. In Barrow's photographs the expansive potential of photography as a contemporary art form is clearly demonstrated.

This is the first major exhibition organized by the Museum's Department of Photography for the new Ralph M. Parsons Photography Gallery opening in 1987. We would like to express our gratitude to the Ralph M. Parsons Foundation for their vision and generous support of the photography program at the museum.

It is perhaps fitting that such a retrospective originate with the Los Angeles County Museum of Art, for it follows in the tradition of innovative contemporary exhibitions that have been a hallmark of the museum's photography program during recent years. Moreover, Los Angeles itself has a tradition of artists who have broadened the perimeters of the medium with their experimental use of photography.

We would like to thank Kathleen McCarthy Gauss, curator of Photography at the Los Angeles County Museum of Art, who organized this exhibition and wrote the catalogue. We are also grateful to the institutional and individual lenders without whose support this exhibition would not be possible.

This exhibition has been made possible in part by a grant from the National Endowment for the Arts and through support of the Ralph M. Parsons Foundation Endowment Fund.

Introduction

Kathleen McCarthy Gauss
*Curator, Department of
Photography*

Thomas Barrow is an important mid-career artist whose work has made a substantial contribution to the advance of contemporary photography and to the expansion of its scope. His is an innovative and cerebrally rigorous body of work. Scarcely known outside the photography field, even within it Barrow is not among the most popular practitioners. Having resided in New Mexico since 1973, he stands geographically outside the principal art centers. More to the point though is Barrow's aesthetic distance from the mainstream of the medium, his lack of interest in the traditional appearance of photographs. The iconoclastic approach, which characterizes all his work, and the recondite, obdurate nature of his photographs have contributed to the scant attention his work has received.

While the work of the senior masters has been presented in large retrospective exhibitions, the oeuvre of photographers who came through art schools in the 1960s has only in the past few years been closely examined. Barrow is among this relatively small group of mid-career artists working with photography who have been active for several decades, individuals who have not succumbed to rote production but who have continued to experiment with the medium, searching for new avenues, new vocabulary.

One of the primary tasks of this volume is to elucidate Barrow's photographs, which are still not understood by many. These are cerebral prints that challenge us to look beyond the visual. Barrow abandoned the traditional approach toward photography early on. He looked to the work of printmakers and painters and to the experimental traditions of early twentieth-century artists. He shows a strong affinity in certain of his series to the Bauhaus approach, which in turn was transplanted to the Institute of Design where Barrow studied. His work also displays

ongoing orientation to contemporary culture. These works document the nature of our times, and, much like Kurt Schwitters collages, they not only scrutinize, but are often taken directly from the material artifacts of our age. The mass-produced multiple, detritus and flotsam, icons of automobiles and fashion, architecture and gizmos, the sublime and absurd are all depicted. The mass media has also been a principal source for Barrow's accumulations since the mid-1960s. He recycles material and images, returning it to us in a dense, multilayered manner that approximates both the complexity of modern life and the proliferation and multiplicity of objects. He has increasingly challenged the limited physicality of photography as he compromises the sanctity of the works, constantly pushing the medium into new forms. Serialization, the negative image, the photogram, and language are important and recurrent elements in Barrow's work.

Barrow's oeuvre is divided into diverse series, each visually distinct, although constant themes, motifs, and interests interconnect all the groups. Accordingly the catalogue is arranged in eleven sections, addressing each group in chronological order. The Prologue focuses on the milieu of Barrow's early years and his first series on the automobile as he finished at the Institute of Design. The following section examines "fashion," his early series utilizing found images, montage, and the negative image, in turn setting the stage for future experimentation. Next are chapters on the works from the late 1960s. The TV montages are a group of complex multiple images that were shot from the television. The section on two series, Pink Stuff and Pink Dualities, examines his radically pink-toned diptychs. The following section examines Barrow's experiments with a copy machine, his Verifax prints, from

the late 1960s through the mid-1970s. The chapter on the series Libraries looks at Barrow's most classic group, one focusing on language and image. The brown series, Cancellations, examines what are perhaps Barrow's best-known work; vandalized negatives printed with great care offer views of the Southwest. A section on the several lithographic prints follows. The last three chapters examine Barrow's work since 1978: the important spray-painted photograms, a major ongoing group of unique, complex works that summarize elements from previous series and demonstrate the expansive potential of the photograms; the caulked reconstructions, which carry visual transformation to another step; and finally the diverse collages of recent years that are yet another departure from the normative appearance of photographs.

Barrow's work must be read carefully. He offers clues, but demands that the viewer look beyond the obvious to discern what the work is about. The iconography in these prints carries rich allusions and reference. Formal exploration, while a part of Barrow's work, has been secondary to the content and its implications. Throughout his varied series Barrow has looked not to what photography has been, but to what new possiblities the medium can achieve. In this series Barrow offers a transformation of his subject and the medium, while providing a catalogue or inventory of aspects of contemporary American culture.

I wish to express my thanks for the support of Dr. Earl A. Powell III, director, and Myrna Smoot, assistant director for Museum Programs, in the undertaking of the exhibition. Thanks also go to many colleagues at the museum who have contributed to this project: Renee Montgomery, registrar, and Anita Feldman, assistant registrar, who have handled many arrangements and

provided superb documentation; John Passi, exhibition coordinator, whose attention was most helpful in circulating the exhibition; Lissa Burger, former departmental secretary, and Lisa Kahn, secretary, who provided much assistance with the manuscript and loans; the staff of the Photographic Services Department, Lawrence S. Reynolds, head photographer, and photographers Peter Brenner and Steve Oliver; press officer Pamela Leavitt and her staff who coordinated the publicity; Dr. James Peoples and his staff who have attended to the details of preparation of the exhibition and handling of the work; and Victoria Blythe Hill, paper conservator. Special thanks must be extended to Mitch Tuchman, managing editor at the museum, for his advice and careful assistance with the publication, and graphic designer Kiran RajBhandary.

I have had the assistance of many outside the museum, including my editor Dana Asbury and her colleagues at the University of New Mexico Press, who have helped produce this catalogue. Documentation of the photographs was also provided by John Eden of Art Documentation in Los Angeles and Robert Reck in Albuquerque. In the course of developing the exhibition numerous people have been helpful, among them Van Deren Coke, Robert Fichter, Roger Mertin, Betty Hahn, Robert Sobieszek, Keith Davis, Susan Spiritus, Rod Slemmons, Sarah Greenough, Peter Bunnell, James Borcoman, Victor Schrager, Laurence Miller, Andrew Smith, and Henri Barendse.

Prologue
Education and Early Works

Opposite—
From the series The Automobile—
Untitled (#76), detail, 1964–65

For a clear understanding of the source and motivation behind Barrow's choice of imagery, issues, and interests, one must begin with his early art training. Repeatedly, whether considering works from the late 1960s, the 1970s, or even the early 1980s, issues that are of concern to him are not merely passing ideas, but rather have their origin much further back. Together the disparate series, when seen comparatively, reveal certain dominant and recurring themes that extend back for twenty years.

Unquestionably sixties Pop art influenced Barrow as it did many artists. There was at the time a general expansion of the traditional definitions and forms of painting; the conventional, flat, rectangular canvas was no longer paramount as a new attention came to the common object and other expressive forms—dimensional paintings, kinetic art, performance, light works, and so on. Artists were caught up in the experimental spirit that accompanied the much wider cultural changes taking place during that period. Art photography, by the late 1960s, was experiencing radical innovation and an incursion from the print media that began challenging the institutionalized hegemony of the documentary approach. Numerous young artists were pushing to expand traditional boundaries of the medium and rejecting the traditional photographic aesthetic.

The influence on Barrow of established painters and printmakers using photographic imagery in the 1960s is apparent. He has always acknowledged this source, occasionally even in titles of his works. But in actuality, his visual *interests* came less from such prominent artists as Rauschenberg or Warhol or even the image explosion of Pop art than from a more fundamentally ingrained and personal viewpoint.

The profound influence of Barrow's initial art interest and training is still apparent today, evident in virtually every facet of his life. Perhaps more than any single concern it is design in the widest sense, from architecture to product design, from revered buildings to insignificant contraptions and gizmos, that subordinates all but his encyclopedic interest in literature. And the confluence of these two, design and literature, can readily be seen in all his work. The concept of design, however, transcends the mere stylish appearance of objects and looks back to the utopian planning of the early twentieth century by such groups as the Bauhaus or De Stijl. But again, this pervasive design interest is more than attention to a historical model, or an intellectualized fascination with modern design. Barrow was trained in the late 1950s and early 1960s in graphic design and product design when the Bauhaus was still highly influential, and he has never relinquished study of these areas. Further reinforcing this background was his study at the New Bauhaus, the Institute of Design.

Barrow started out at the Kansas City Art Institute in product design but ended up taking his degree in graphic design, minoring in painting and photography. The curriculum required courses in many other areas, in ceramics and sculpture for example, along with those more directly related to design. But by his third year, he realized he was more interested in the photographic medium and made plans to pursue a master's degree in that field. In the early 1960s the most noted school for graduate work was the Institute of Design in Chicago, and with his allegiance to the Bauhaus tradition it was a most likely choice. To understand Barrow's work, it is also instructive to recall the period he grew up in and responded to.

Following the war, there were staggering material changes as industrial production shifted from defense to domestic output. New products and technology were now available to the American public, giving rise to a new era of unabashed consumerism. The standard of living and the production of goods were unprecedented, standing in dramatic contrast to the spartan homefront of the previous decades of the depression and wartime America. This period saw the burgeoning of suburban life, with its baby boom, and new houses, cars, appliances, clothing, and technology such as the TV that invaded all American life. Middle-class families, with the luxury of money and available, enticing new products, suddenly became avid consumers.[1] Long after the closing of the American frontier, society turned its acquisitive nature to another frontier, the domestic realm. The acquisition of material goods became the yardstick of the good life and personal success. All of these machines, gadgets, appliances, and vehicles give definition to our culture. They fill the landscape, urban and suburban—many frankly planned to become obsolete—just as they fill the frames of Barrow's prints.

The media has fueled the acquisitiveness of the American public, from simple magazine articles and photographs, to increasingly sophisticated subliminal TV commercials that pander to and form the ideals and aspirations of the consumer.[2] References to the media have shown up frequently in Barrow's works for over twenty years, adding a background noise to the compositions. And so it is not only the appearance of objects and their function, or a trendy interest in pop culture that has occupied Barrow, but rather an enduring concern with the diverse manifestations of the overwhelming materialism of our time.[3] The essence of Barrow's imagery is cataloguing this

material abundance and compiling dense, multilayered inventories.

A more expansive interest in culture, art, and media led him to graduate school. Founded by László Moholy-Nagy in 1937, the Institute of Design quickly became the most prominent art and design school.[4] Its original goal to produce "universal designers" and its eclectic combination of science, art, and social studies were ideal for a design-oriented artist.[5] Among the aims of the New Bauhaus was the training of designers for hand- and machine-made products along with training of typographers, photographers, architects, painters, and sculptors.[6] The fertile cross-media curriculum and emphasis on technology and products influenced Barrow profoundly.

Moholy-Nagy always had a special appreciation for the potential of photography. But he also saw it as providing the source material for other art disciplines.[7] The experimental, multidisciplined approach and theoretical writings of Moholy-Nagy have helped shape the attitudes toward photography both at the Institute and more widely in the field. He "established a rationale for placing photography on a high intellectual plane" for it was the ideal means to integrate the disparate aims of art and technology.[8]

The photography program at the Institute of Design had a small number of graduates each year. The undergraduate program focused on a comprehensive Foundation Course which was also studied, in essence, by graduate students as well. As Aaron Siskind observed, the experimental atmosphere of the institute and its Bauhaus system was fundamental and that in turn set a tone of encouraging research, innovation, and problem solving. The cross-disciplinary approach with a stress on experimentation formed the basis for Barrow's work. A cominitment to

innovation and design are evident in all his photographs.

The dominant photographic aesthetic in the 1960s, however, looked in other directions, to the reportorial street photography of Robert Frank and his successors and back to the Modernism of Stieglitz and Weston. This heritage can be seen in the abstractions of Aaron Siskind, Harry Callahan, and successive generations of artists who were concerned with the formal issues of pictorial strategy. The evocative imagery of Minor White with its spiritual attitude and the personal, metaphorical orientation was also adduced by Modernism. But this tradition was not at all of interest to Barrow.

The pervasive photographic aesthetic for most of this century has placed its emphasis chiefly on how things looked through the camera lens, whether formal or reportorial. The success of a photograph ultimately was defined by what it looked like. Perhaps more is accomplished in considering not Modernism, or even the newly popularized appellation of Postmodernism but rather Barrow's insistence on modernity, that is, contemporaneity in his work. Assuredly modern, Barrow has been more concerned with the avant-garde than with Modernism per se and ways that the medium could be used experimentally. And there is an alignment in his work with those aspects of the avant-garde that Renato Poggioli described, such as a strong experimentalism, expansion of form, attention to factors extraneous to art, and pursuit of breadth of an art medium.[9] For many, Thomas Barrow's photographs present difficulties because there is, for the most part, an irreverent disruption of the visual elements and an emphasis on information. His work is abstruse, recondite, and not always visually satisfying. And it has little in common with the dominant aesthetics of "straight" photography and the formalist traditions of photographic

modernism. Barrow's photographs have always been about something beyond the mere pictorial image. Thus, he has frequently subordinated the visual to the intellectual, and the appearance to the content, although "the look of the thing," as he says, is very important to him. The rigor of these works makes them too challenging for those who are merely seeking attractive or interesting pictures.

There are peculiar *retardataire* tendencies in photography, a medium continuously willing to embrace newly made photographs that adopt nineteenth-century pictorial formulas and utilize nineteenth-century materials, such as platinum prints. The ground already covered by photography has never been of personal concern to Barrow. Instead, he has been more profoundly influenced by the vocabulary of contemporary artists Richard Hamilton and Eduardo Paolozzi than by photographers. Early twentieth-century art stands as a major factor, and much of his work reflects the theories and experiments of Moholy-Nagy and other artists who worked with photography, language, design, typography, montage, and found imagery. Barrow's attention to contemporary culture, its products, and insignificant by-products explains too why his work has an obsession with design and the mechanistic. Additionally, his cultural and design interests suggest why there is such an affinity to the German and Russian avant-garde with their focus on the artist as social designer.

The first photographs to attain visibility were a group published as a small portfolio, *Student Independent 6*, by the Institute of Design in 1966. The ten photographs were drawn from a larger, three-part series of 115 prints on the automobile, made during 1964 and 1965. Although Barrow had been encouraged by Aaron Siskind to pursue a documentary project for his graduate thesis, his

"Product design

seemed so practical,

so much

at the heart of

our system.

Someone had to

design

all the stuff for

consumers."

photographs nonetheless reveal allegiances to other interests. The project, cast as an allegorical reference to the biblical garden, focuses on the quintessential American consumer item, the car—its high technology, its product design and its evolution, and the broad cultural implications. Seriality is seen both in the content of the photographs and in the very idea of an extended body of work. These are all topics that would continue to occupy Barrow in the future. The book-like format of the portfolio, though a conventional design, still illustrates Barrow's attention to the book as a manner of presentation. The extended series, now quite common, was an Institute of Design methodology championed by Harry Callahan but stemming from Moholy.

Although not influenced by Leo Marx, Barrow's series grapples with some of the same ideas as Leo Marx's important study, The *Machine in the Garden*. The intrusion of technology, the corruption of the land, the increasing mechanization of life, as Marx pointed out, were not unique to our times, having been addressed in the mid-nineteenth century as well.

The car, as the recurrent motif, is significant not only as as pervasive cultural object but also as an icon for the young man. Having worked on cars during his adolescent years, Barrow had a special interest in their performance and design. Barrow's series constitutes a biography of the car, the representative consumer object, bought new and replete with possibility, then discarded shabby and thoroughly consumed.

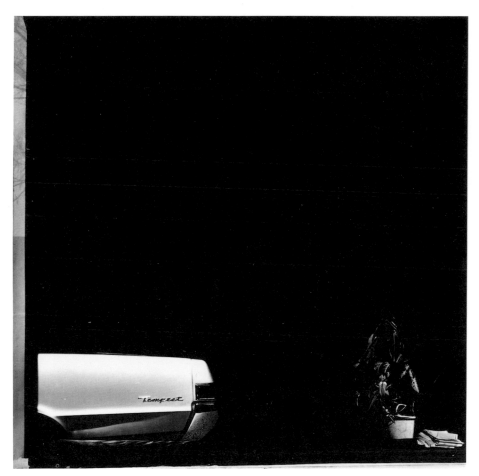

From the series The Automobile—
Untitled (#1), 1964–65

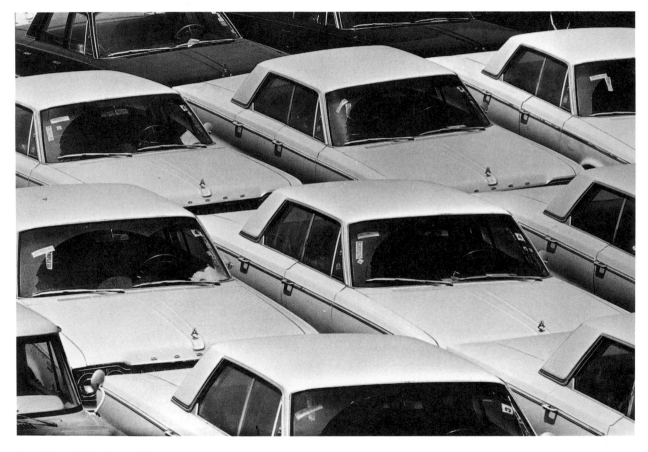

From the series The Automobile—
Untitled (#15), 1964–65

Automobiles are chronicled from their origin in showrooms and lots full of identical new models to the garages and streets. The beginning of the series portrays the vehicles in an idealized state: clean, polished, and perfect in their newness. The car is shown as the paragon of personal consumer technology, sleek and powerful, the quintessential icon of American ingenuity and economic supremacy. Barrow used a high-contrast printing with exceptionally deep black tones and bright whites to portray his high-gloss subject.

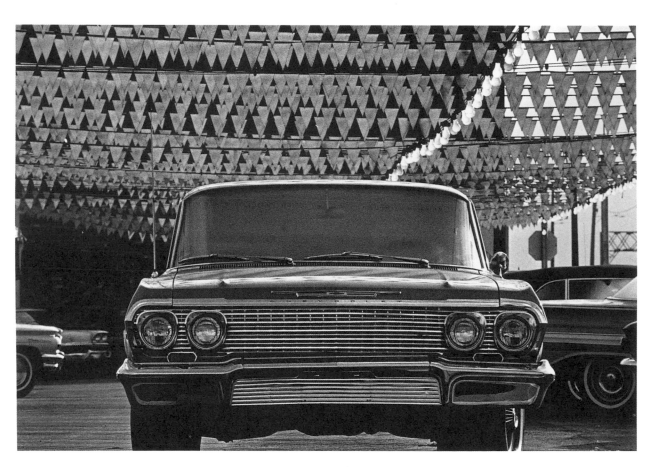

From the series The Automobile—
Untitled (#17), 1964–65

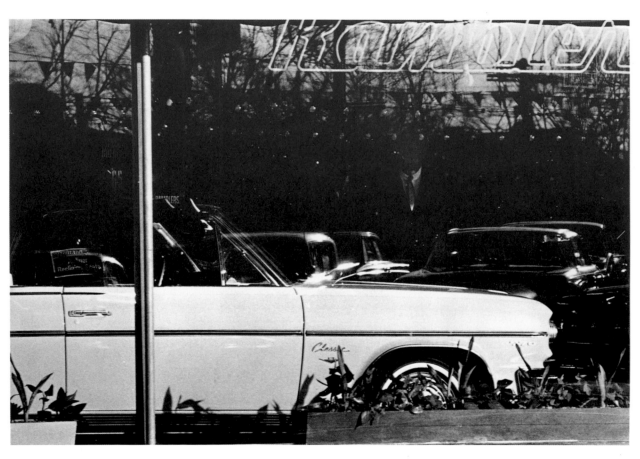

From the series The Automobile—
Untitled (#18), 1964–65

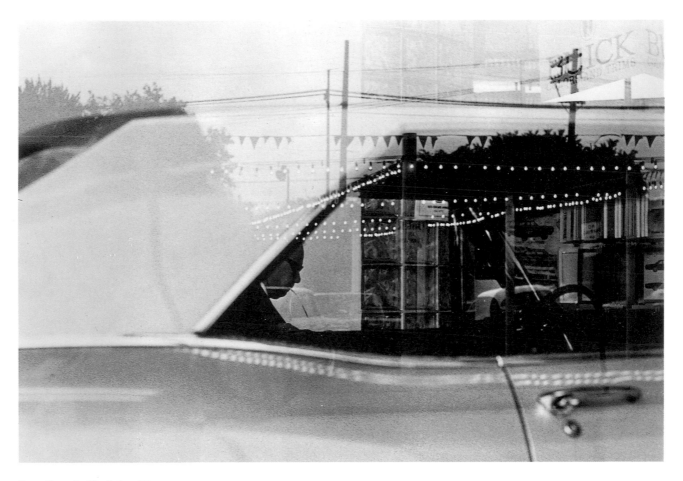

From the series The Automobile—
Untitled (unnumbered), 1964–65

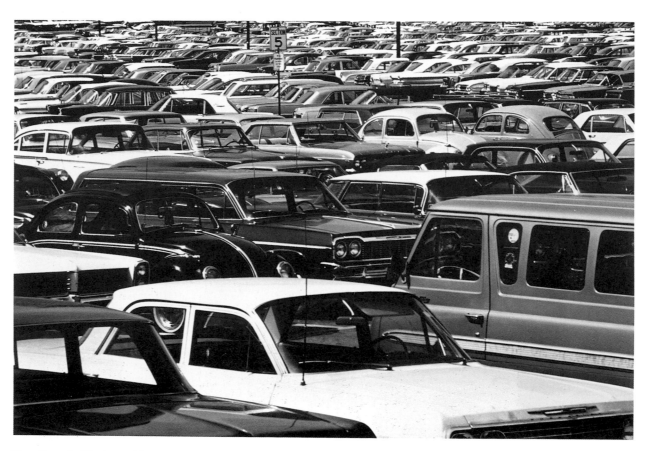

From the series The Automobile—
Untitled (#27), 1964–65

From the series The Automobile—
Untitled (#76), 1964–65

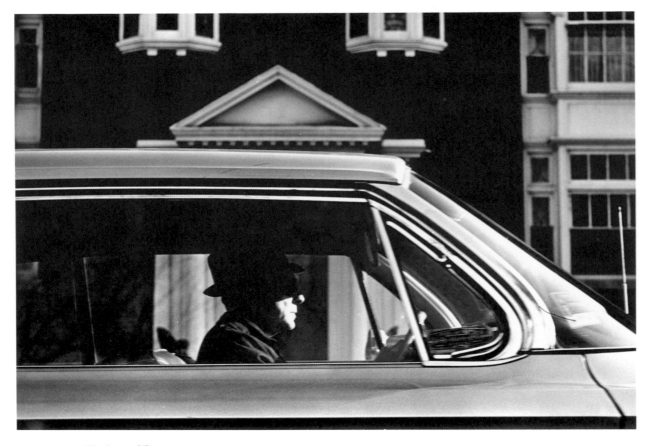

From the series The Automobile—
Untitled (#29), 1964–65

Barrow traces the car in daily use from the state of original perfection. *The Student Independent* includes a selection of images depicting people in their cars taken from the second of the three sections. These images are less representative of the overall series in that they focus on passengers. Many of these images were made in bumper-to-bumper traffic, where vehicles and people were immobilized in a kind of suspended animation.

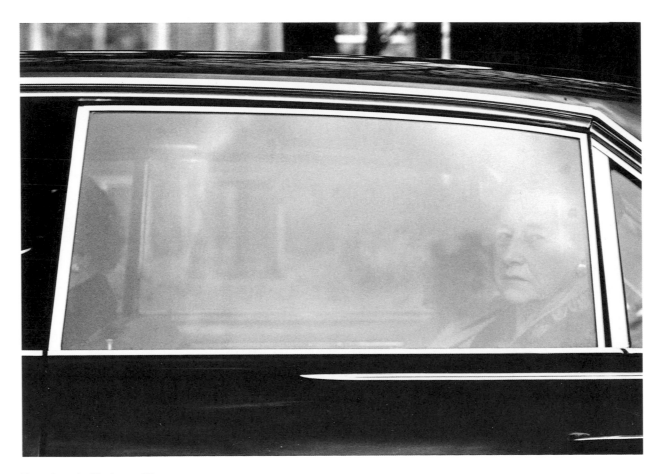

From the series The Automobile—
Untitled (unnumbered), 1964–65

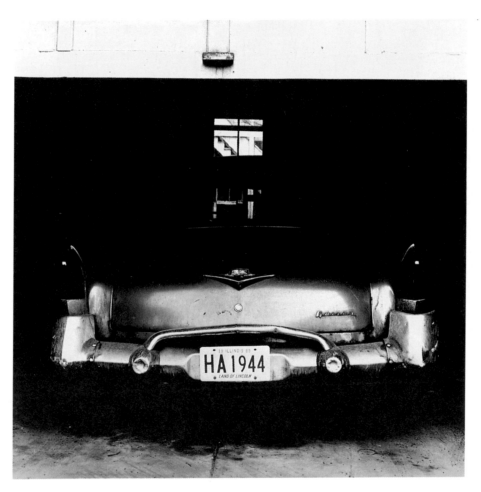

From the series The Automobile—
Untitled (#45), 1964–65

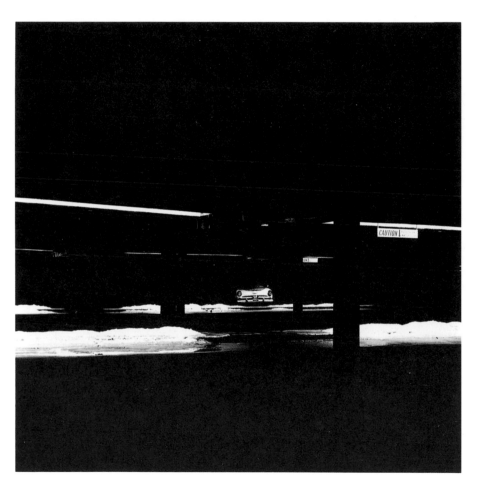

From the series The Automobile—
Untitled (#77), 1964–65

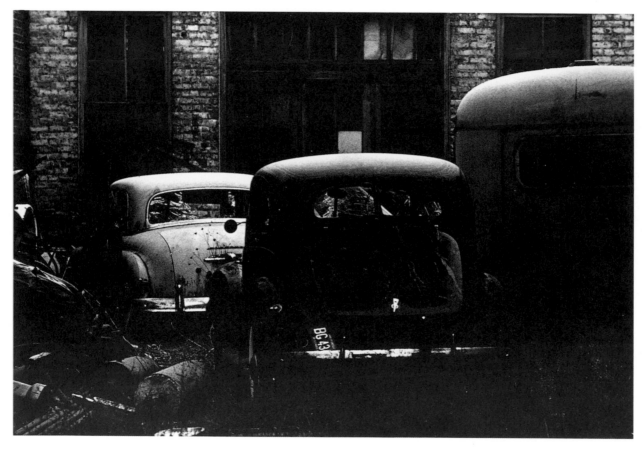

From the series The Automobile—
Untitled (#88), 1964–65

In the final part, Barrow depicts the inevitable decline of the machine. Abandoned cars, cannibalized for parts, are littered about the urban and rural landscape. The end brings us full circle, to vehicles once again seen in dense patterns of modular units. Here though, the car is reduced to utter junk, cultural rubbish. This richly printed series follows the cycle of birth to death of the machine, its use and obsolescence.

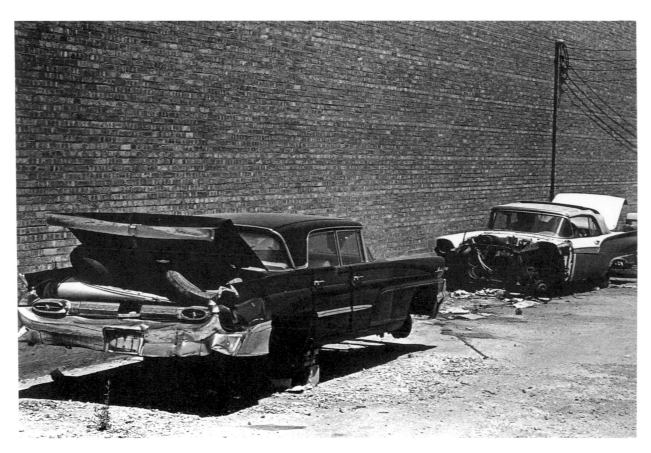

From the series The Automobile—
Untitled (#87), 1964–65

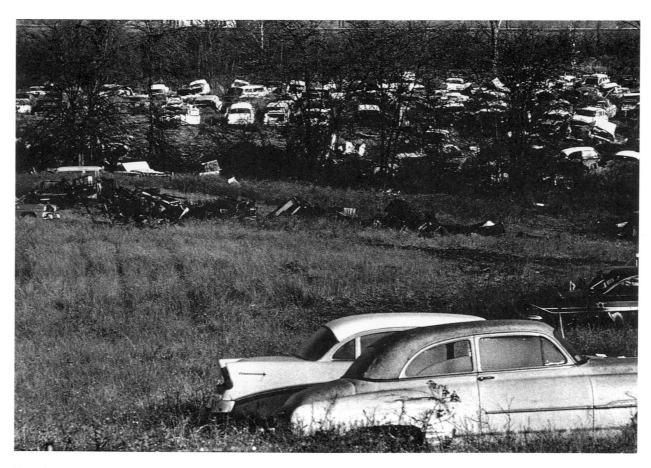

From the series The Automobile—
Untitled (#93), 1964–65

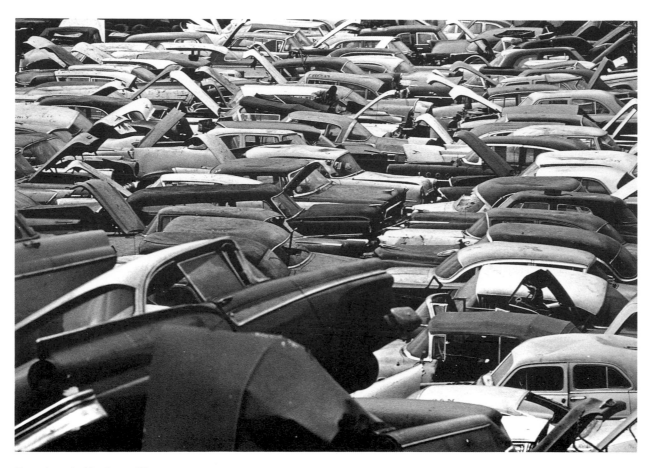

From the series The Automobile—
Untitled (#76), 1964–65

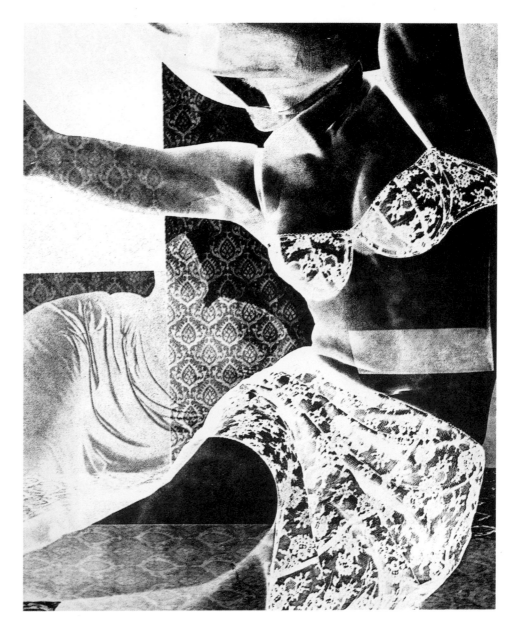

Untitled [Lingerie], *1963*

"Aaron Siskind, very early on, suggested

that we make accidental juxtapositions by

tearing out magazine pages and

printing them. The magazine page was

a very fertile source. Although the

emphasis was on formal aspects, I was

curious about the content too."

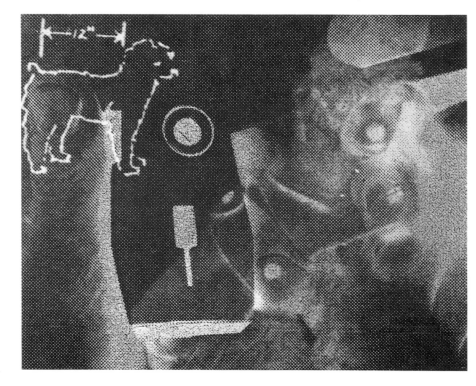

Untitled [Dog], *1963*

After completing the coursework for his M.F.A degree, Barrow moved to Rochester, New York, in the summer of 1965 and joined the curatorial staff of the George Eastman House, working for Nathan Lyons. He was still working on his thesis project, which was shot partially in Chicago and partially in Rochester.

The brash experimental approach that has characterized Barrow's later work is prefigured in some very early pieces of juvenalia that warrant recognition here. The fascination with media presentation of photographs is illustrated in several photographs dating from 1963. *Untitled* [Lingerie] is particularly noteworthy for it provides a clear and early indication of Barrow's use of the photogram, the print-through process, and contemporary cultural iconography. The print bears an uncanny resemblance to the later "fashion" series, which began in 1967. The print is based entirely on the found image and the pop rendition and uses the techniques of montage and abstracting the subject in its negative image. The grainy repetition, the vernacular subject, and the overlay of patterns were all derived directly from experimental problems given at the Institute of Design. The print-through process using magazine pages had been explored by Arthur Siegel and was taught by Siskind as part of the course.[10]

Untitled [Dog], 1963, makes freer use of the abstract composition along with the prominent crude outline of a dog. The complex montage and negative image includes textual

31

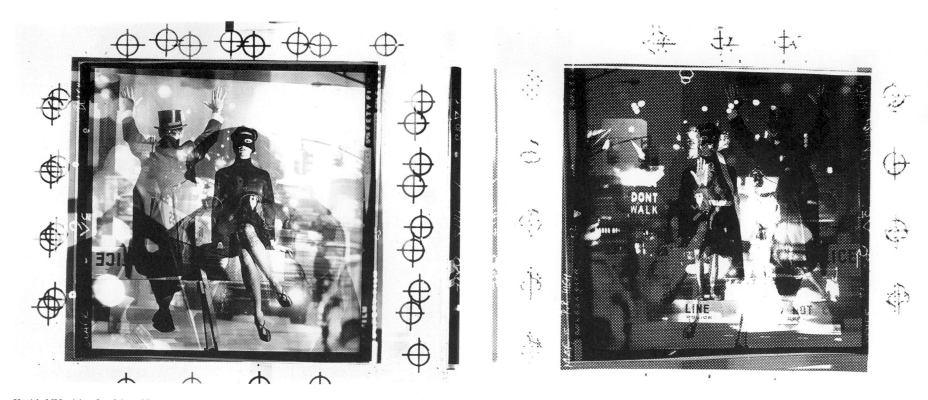

Untitled [Magician Quadriptych] *1966*

elements, shifting perceptual problems, and the obvious dot pattern of a newspaper or magazine reproduction.

The found vernacular image and the montage format are again utilized in *Untitled* [Magician Quadriptych], a complex four-part work produced in 1966. A bizarre assemblage of multiple images, the composition shifts from positive to negative (print 1 and print 4). In the left image, a workman from a famous Eugene

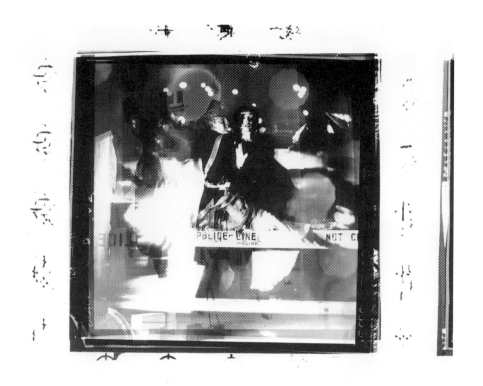

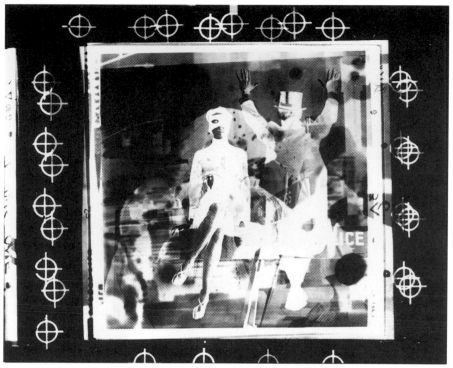

Smith photograph can be discerned along the street scenes as well as the figure of a top-hatted magician and a fashion model. Surrounding the square-format negative are a constellation of printers' registration marks. The chance patterns and illegibility of the image and its topical fashion orientation establish a complexity that requires scrutiny. The layers are subtly interwoven, and information shifts from one plane to another, changing in each of the four versions to a new transformation. The blackness of the second frame contains slightly more text: "Don't Walk" and "Police Line Do Not Cross." The mysterious sparkling quality of the second frame prefigures the TV images that Barrow used later. Here the figures are hidden in the overall screen patterns and the density of the montage. The third frame resembles both the first and the second but shows an increasing abstraction of the compositional elements and disruption of the image. The recurrent magician figure and model are the link that ties the images together. The final frame is a precise inversion of the first, flopped from left to right, and from positive to negative.

The negative image, the found image, and montage form the experimental thrust of Barrow's work through the mid-1960s.

The Series "fashion"

Started 1967

The first work that Barrow undertook after finishing his graduate thesis at the Institute of Design illustrates his concern with a fundamental premise that an artist, as Kandinsky noted, must be of his own times. While he draws on the past and makes reference to previous works in art and photography, Barrow is guided by experimentation, not tradition. He also subscribes to the notion that contemporary cultural sources should be directly engaged by the artist.

The "fashion" series was a radical departure from the more documentary series on the automobile.[1] Unlike that more conventional group, the "fashion" series abandoned the mechanical apparatus of the camera and utilized the media-generated image as the primary content. Moreover, the series focused on advertisements, selected as cultural exemplars, implying their position as an aesthetic ideal. Although these photographs utilize fashion photography, they perform no service to fashion. These prints are intricate montages that are purposefully generated through a series of random and fortuitous occurrences. Robert Heinecken, well known for his experimental print-through prints using magazine imagery beginning in 1964, would seem to have been a direct influence. The montages of the "fashion" series, however, are really an extension of the photogram print-through process that Barrow had utilized several years earlier at the Institute of Design. The series makes use of several of Moholy-Nagy's proposals— abstraction and image, superimposed images, negative prints, photomontage, and solarization. Barrow returned to the problem of the photogram as a means of releasing photography from its traditional heritage and methodology. Furthermore, the photogramming process—placing material directly on the photographic paper—was a means of exploring the interaction between abstraction and image.

The inestimable resource of the George Eastman House collection was of enormous consequence, and Barrow and Robert Fichter, another member of the curatorial staff, took advantage of the relatively unrestricted access to the collections, examining thousands of prints. Exposure to the vast number of historical and modern photographs strengthened Barrow's resolve that photography should be used radically by artists. With firsthand familiarity with the Modernist experimental work from the 1920s and 1930s by Moholy-Nagy, Man Ray, and Francis Bruguiere, as well as with less pedigreed commercial photographs, Barrow and Fichter agreed that the photography medium has tremendous innovative potential if one can sever the bondage to more traditionally oriented photographic aesthetics and approach the medium more radically.

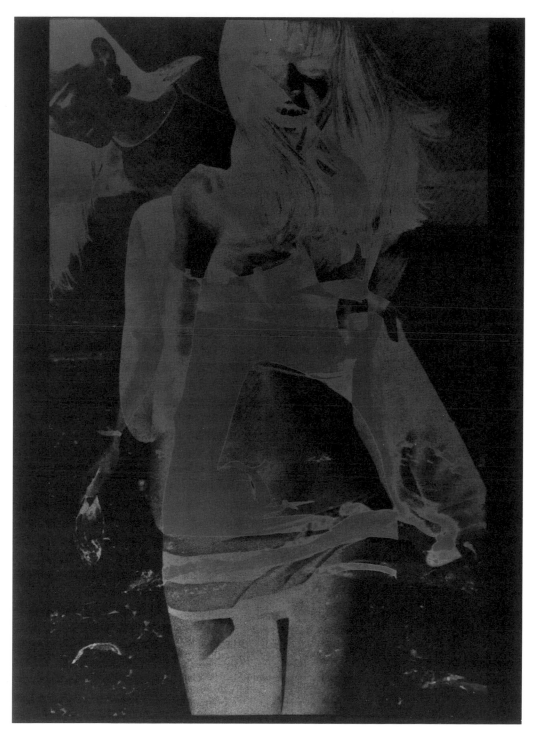

From the series "fashion"—
Untitled. 1967

35

''My mother ran a dress shop for a while

when I was young and she got all

those fashion magazines. I used to look at

them; they really interested me—they still do.''

The integration of image and abstraction is evident in *Fashion Triptych*, 1967. In addition to the convoluted composition, the tones are reversed, a technique that enabled Barrow to present visual information while simultaneously abstracting it. Additionally, there is an allusion to the reversed tones of the early paper negatives, where the compositions (though totally comprehensible), are shifted into a modernist abstraction through the negative rendition. Moholy-Nagy had experimented with the negative image in the 1920s. Its transmutation of precise photographic information to the abstract, set against a mysterious black background, made it a powerful device.

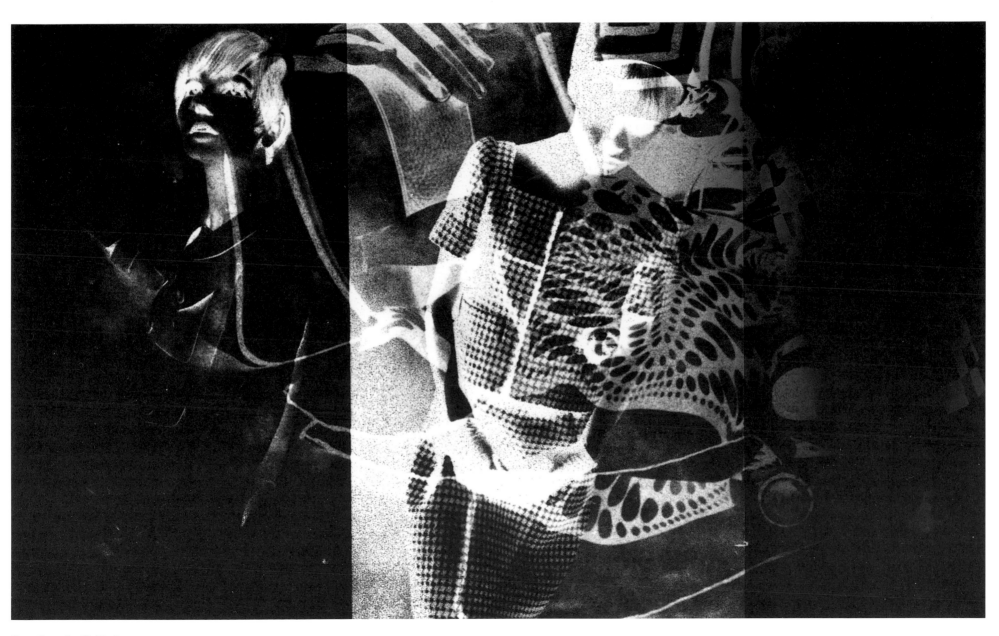

From the series "fashion"—
Fashion Triptych, 1967

Vogue and other fashion magazines were the source for Barrow's imagery along with pages ripped from the *New York Times*. He placed the chosen page (a few prints were the result of more than one page) directly on the photographic paper and then exposed it to light (the print-through method). The rich possibilities and the nuances obtainable by this process were far more interesting to Barrow than the single straight photograph. He was fascinated by the complex and equivocal relationships between the parts as well as the transmutation of the original.[2]

Barrow is interested in fashion as cultural anthropology rather than as women's apparel. For him, fashion is a curious and bemusing subspecies of a larger area, functional product design. Of course he is mindful of the role of fashion as a social barometer as well, one that marks rapidly changing cultural trends.

Barrow is also very curious about the disposable, vernacular image and language of the advertisement, propagandistic imagery generated expressly for a consumer society. Considering the ubiquity and power of photographic reproduction in our times, what better source material might there be for an artist who wished to examine his own era and culture? This self-reflexive approach—examining the mode of the photographic medium—is characteristic of much of Barrow's work. This series has nothing in common beyond subject with the works of Cecil Beaton, Irving Penn, or George Hoyningen-Huené, who emphasized splendid apparel and glamor.

Barrow worked on this particular series from 1967 to 1970, and fashion imagery reappeared in the subsequent Verifax prints and sprayed photograms, indicating the continued importance of fashion as an iconographic element.

For Barrow, the magazine and newspaper reproductions were the most accurate means of capturing the elusive cultural spirit. They are not only the means of visual communication, but the visual lingua franca. The fashion series is a direct response to the spirit of Pop art in which advertisement played a significant role. One prominent critic labeled the artists using such imagery "New Vulgarians," but ironically this perjorative appellation seems wholly appropriate for those who were experimenting with the visual vulgate. Marshall McLuhan also recognized advertisements as a valuable source for cultural analysis about the same time.[3]

Untitled, 1967, from the series "fashion," one of the few solarized prints in the series, illustrates the visual tension between abstraction and image. Despite the negative image and the montaging of pictorial elements, the model, with her sweeping long locks, is still readily apparent. The shifting tonalities from positive to negative, the reflectivity of the print, and the ghostlike abstraction extinguish any connection with *Vogue* magazine. In others there is more of a barrage of nonsensical images—often but not always in the negative—with dense overlays of details and full frames. Extreme contrasts of scale along with a use of the prominent Ben Day dot pattern attest that the imagery has been recycled from magazines. Spectral faces of the models gaze outward, severed from their commercial origins and function, severed from their message.

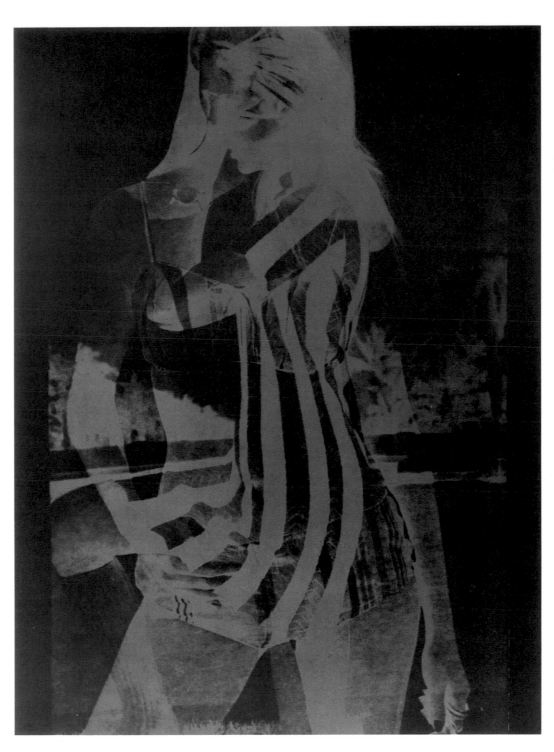

From the series "fashion"—
Untitled, 1967

Opposite—
From the series "fashion"—
Strange Room, 1968

Strange Room, 1968, is among the most graphic prints, dominated by the large white geometric shapes reminiscent of Cyrillic letters; they impart a Constructivist tone to the strident composition. The model's domain is demarked by white vertical lines, a graphic design element; however the figures seem secondary here, for the composition of reversed tonal extremes is considerably abstracted, changing the orientation to a formal array.

The disruption of the legible photographic image toward an inchoate abstraction is seen in a number of the prints, including *Vertical Triptych*. The separated frames indicate Barrow's concern with a multiple focus, in addition to a preference for the complexity of the multiple image. The clear inclusion of page numbers at the edge confirms that these images were scavenged from the print media and held a preexisting function and coherence that have now been permuted. The alternation of light and dark in the bottommost frame sets up a vibrancy, which works well with the appearance of depth in the frames.

The print-through method had a certain immediacy and physicality to it for the subject is in direct physical contact with final print paper. The negative and its processing are eliminated and production time is collapsed. Because of the process, the visual language is less preconceived, though not entirely accidental, and less certain. Unlike a print made conventionally with a negative, the outcome of which is predictable, and no matter how experienced the eye in foretelling the outcome, a print made this way always entails a random outcome.

In this series, Barrow has expanded visual language beyond the prose of documentary. He contradicts the veracity of the photographic image by visual crosstalk. In using the vernacular image rather than one of his own making, he examines the language of objects. As in Duchamp's ready-mades, choice and chance are interconnected.

The mass media photographic image that influenced so much of English and American art of the 1960s naturally seemed to be an appropriate domain for artists like Barrow who were working with photography. The commercial function of multiplicity and repetition was illustrated especially well by Andy Warhol, for instance. Yet Barrow looked less to Warhol and Rauschenberg as models than to certain English artists, Richard Hamilton and Peter Blake especially, who were investigating the manifold appearances of contemporary culture.

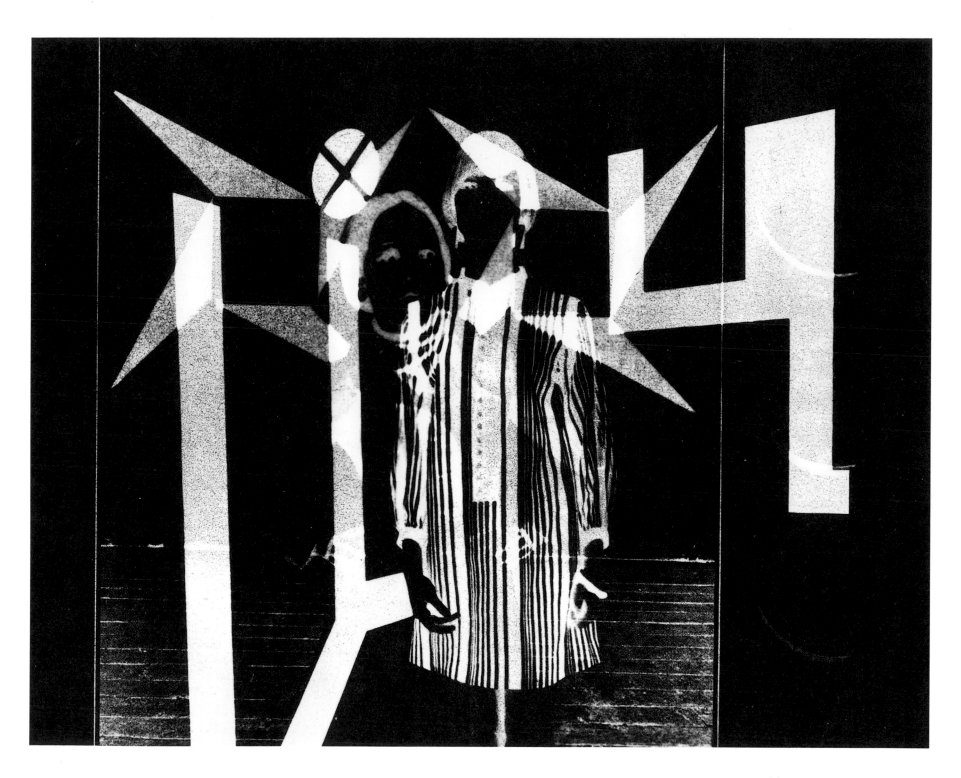

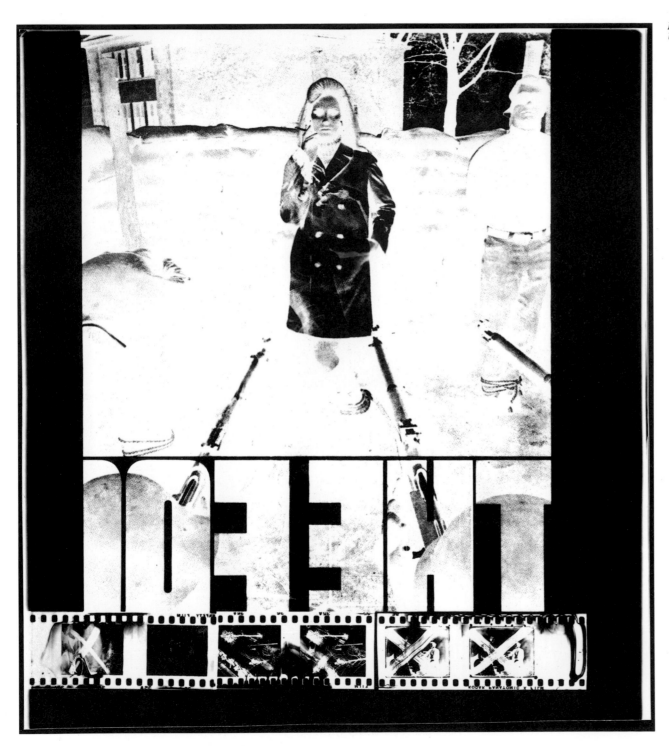

From the series "fashion"—
Untitled [The Fog], *ca. 1968*

The female models in these photographs are sexless androids for the most part, another example of the transformation of the subject. Abstracted and ethereal, the figures vacantly gaze out at the viewer; they are too removed to encourage identity, obviating the viewer-subject allegiance that is normally induced in fashion photographs.

Untitled, from the series "fashion," c. 1968 [The Fog], is a multilayered parody. Foremost, the fashion model is presented to us in the midst of a ludicrous tableau composed of a firing squad, complete with rifle-wielding soldiers and a blindfolded victim. The incongruity of the scene and its unreality are reinforced by the reversal of tonal values and by the appearance of the Ben Day dot patterns that further schematize the image. The negative rendition with its high contrast gives the piece an eerie, nocturnal aura that transforms the subject. In the background a stark white tree is set against a dark night sky. The model's eyes are glowing white sockets, scarcely offering the alluring, wholesome charm that the original presented, or providing a cultural stereotype. The reversed lettering which states "THE FO"[G] reads as a headline, yet it is

From the series "fashion"—
Untitled, 1967

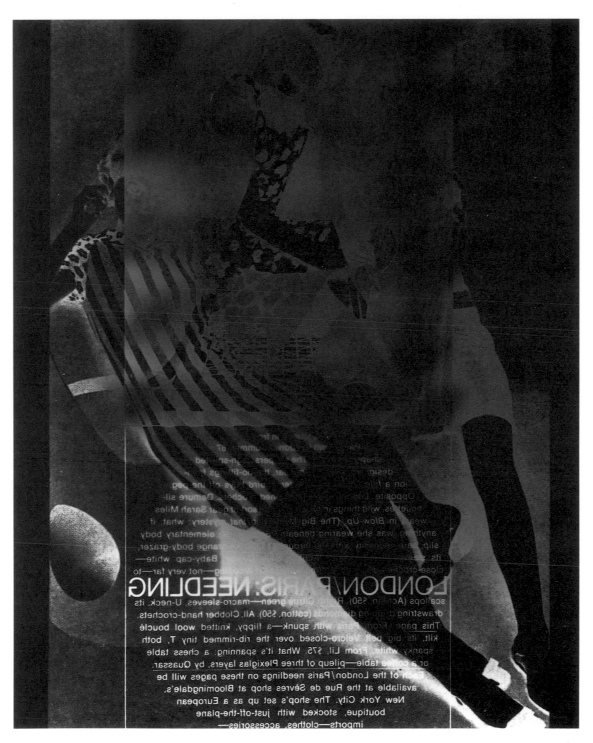

"The negative image gives you the representation,

but it's transformed."

incomprehensible, and becomes merely a graphic element without a true function.[4] Not unlike the preposterous contemporaneous Maidenform bra ads, this gratuitous advertisement utilizing military imagery glorifies the absurd. The combination of image and text here is highly reminiscent of Robert Heinecken's *Are You Rea*, 1966, where language and image similarly interact.

Beneath the central image is a strip of 35mm film, in which half of the frames have been cancelled out with X marks. The appearance of the defaced negatives along the bottom, an odd precursor to the Cancellations, recall in their wide brushy markings the X marks of Richard Hamilton's painting *My Marilyn*. They have a forceful sense of negation about them signaling Barrow's irreverence toward the sanctity of the photograph and the interaction of image and abstraction.

By the time that the series was well underway Barrow was also engaged in another series, one that also pushed at the perimeters of the medium.

From the series "fashion"—
Untitled, 1970

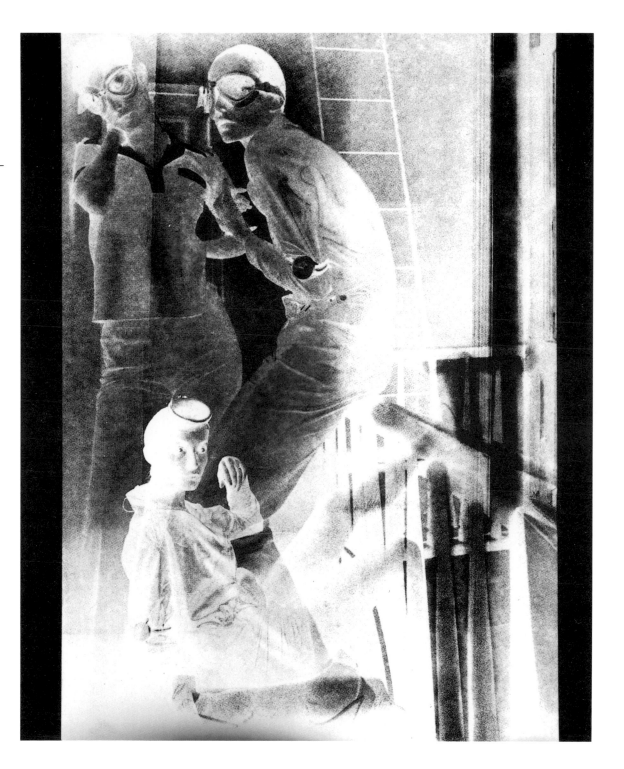

The Television Montages
Started 1968

The idea that a photograph could be made from any available light source was a part of the impetus for a group of prints that Barrow made during 1968 and 1969, shot off of television screens. Also central to this work was his recognition that the television set and its pictures provided an extraordinarily rich and provocative subject for exploration. And, like automobiles and advertising imagery, it gave representation to cultural data and issues of contemporary life.

The TV prints combined Barrow's many disparate ideas about the nature and role of the photographic image. These images function on a number of levels as cultural documents and collage, using the found object, the vernacular image, recycled imagery, random juxtaposition, and the conjunction of abstraction and image.

The television montages confirm Barrow's disinterest in the straightforward single image and his belief in the importance of interactive imaging. In spite of the absence of any handwork, the images evince a certain manipulated appearance.

Like the preceding series on fashion, the TV works also are based on found images, ones previously constructed by the director and film editor, and then excerpted from their context. And also like the magazine imagery, these too come from the public domain, a source that Barrow has continued to raid for his material. These are ordinary images, neither heroic nor deified, taken from the vernacular of mass media.

The TV photographs acknowledge the ubiquity of that medium in our culture as well as its formularizing, even codifiying visual imagery. The vast array of pictures and visual information spewing from the TV tube has affected our collective pictorial consciousness and has had an enormous impact on our conception of appearances,

history, and stereotypes. And as such television is the quintessential source for popular cultural icons. Indeed the television probably serves as the principal source of visual information for most people, who watch an average of five hours a day.[1] As the source of pictorial literacy the TV is certainly a bona fide subject, despite the banality of its content, which is determined by corporate oligarchy.

The TV photographs also bear witness to Barrow's fascination with the machine and technology. The TV is the perfect exponent of visual technology; it generates new configurations every several seconds, offering endless possibilities.[2] And too, the TV exemplifies the Bauhaus interest in machines and mass-produced design, though in this case Barrow is working not with a physical object but a visual product. The TV, though, is merely the device that throws the light, not unlike Moholy-Nagy's Light-Space Modulator, which he used to fabricate photographic works, or his Telehor, which evolved into television. The television, moreover, fulfilled Herbert Read's propositions that art can be produced by the machine, and that the artist must become an integral part of the industrial system.[3] TV as an art medium, "the cathode ray canvas," was beginning to gain attention at this time, with artists exploring video and other uses of the TV signal.[4]

These works are also concerned with the issue of the reproduction as original, where there is no tangible, permanent object, but a mere evanescent image temporarily projected onto the TV screen. Moholy-Nagy had addressed this issue of "production-reproduction" as early as 1922.[5]

The majority of the TV prints are based on the dimensions of the 35mm frame, although several compositions are elongated horizontal arrangements utilizing a combination of two or three undifferentiated or

"My work is much more about the day-to-day existence of life."

Opposite—
Material, Tabooed and
Refractory, 1968

unsegmented frames. The scale of the images and picture tube changes as does the position and axis of it, for Barrow changed locations as he shot, alternating lenses as well. The shifts in scale and orientation to the screen contributes substantially to the intrigue of the compositions, adding enigmatic details and images. The combination affects the interrelationship of commingled images. One sense of scale is insufficient here.

Extremely rich pristine black-and-white prints, the TV works are extraordinarily complex montages. Barrow achieved this complexity using multiple exposure in the camera rather than an enlarger. By rewinding the film and shooting several times on it, the resulting pictures thus become a function of chance, not design. This investigation of the order and relationships among the visual elements is an important component of the group. The possibility of careful calculation and previsualization is nullified by the randomness of combination. In this intentional juxtaposition of pictures and the acceptance of random connections, Barrow's series is similar to the numerous magazine montages of Robert Heinecken. The variety of sources yields startling assemblages of imagery. The prints are demanding but rewarding, offering new insights and combinations to the viewer. They contain many subtle connections and information that are not immediately discernible, but which are successively revealed with study.

The TV prints are not formally labeled as a series, although they are clearly a closely knit group. "Cathode Ritual" has been used by Barrow as both part of the title in a number of prints such as *Cathode Ritual V* and also as a title for a series within the larger body of television prints. However, this was actually a small subset consisting of only a few prints.

Material Tabooed and Refractory, 1968, is one of the most simplified and formal prints of the TV photographs. Here, the figure of the woman has been transformed from an innocent representation to one with a more loaded connotation by the chance black bar that runs across her eyes. This is not merely an abstracting element but a technical element instrinsic to the medium. We have become accustomed to interpreting the bar as an indication that the identity of the person is being withheld and that the situation is of an unwholesome, illicit nature. Masked as she is for anonymity, clad in a black slip, and also placed in a darked shadowy environment, the woman becomes the material tabooed. The recurrent spheres of light, etched around the edges by the lines of the TV set, demark the spatial planes in front of the figure. Their brilliance establishes a graphic contrast with the deep black that dominates the print. Lurking in the background is yet another TV screen, where the picture is reduced to a meaningless pattern. Barrow exploits the characteristic "lines" of the medium to give the figure a linear insubstantiality and to abstract the precise photographic detail.

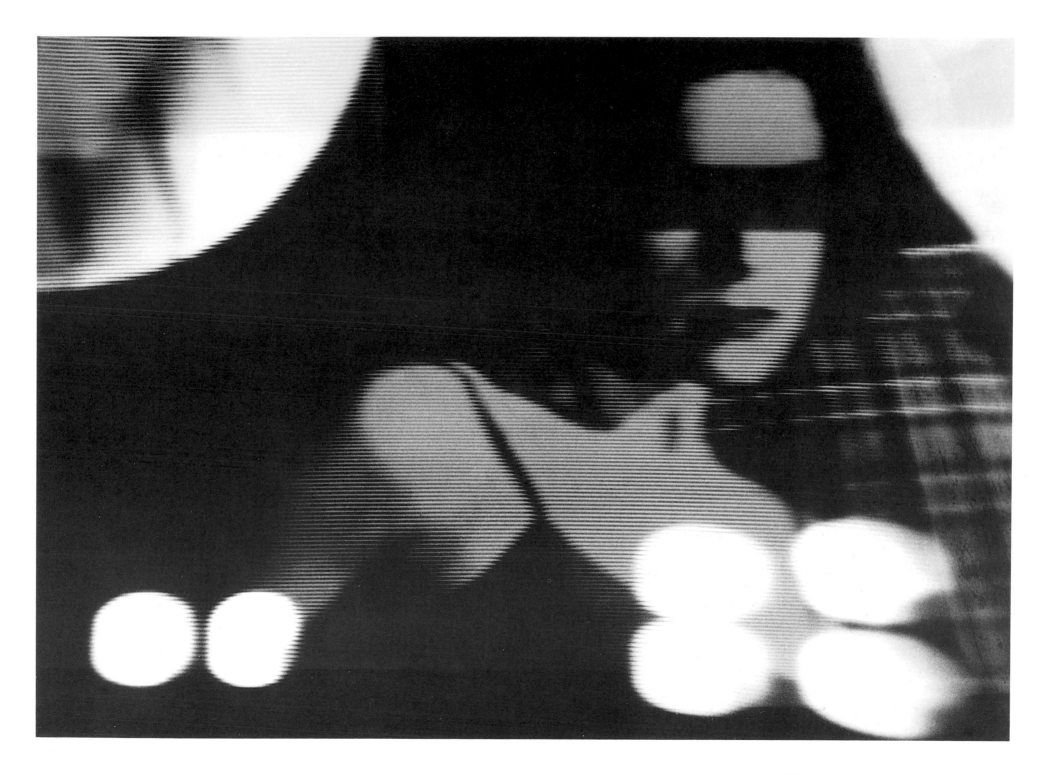

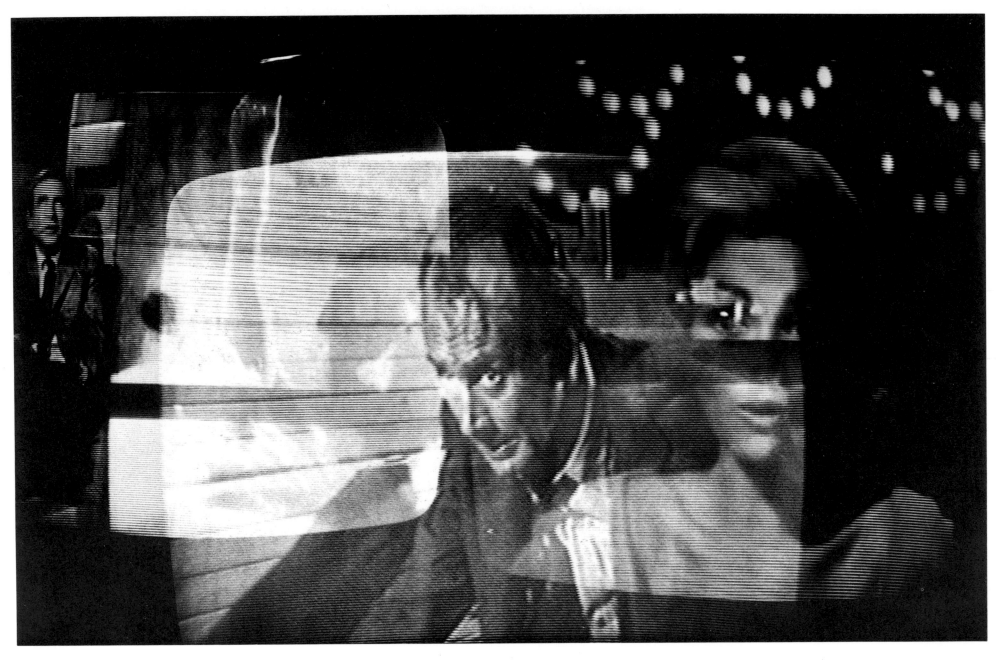

Cathode Ritual I, 1968

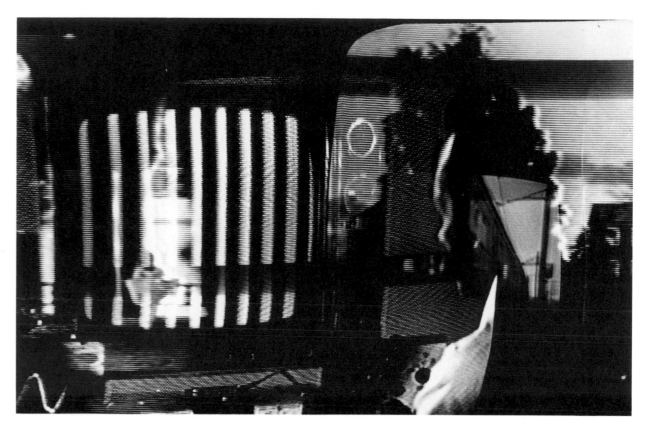

Untitled [TV with vertical bars], *1969–70*

Barrow uses the edges of the screen to give definition to the compositions, to signal the multiplicity of images, and to contrast with the utter blackness of the surrounding areas. He fully exploits the fractured image projected onto the screen, the inherent lines of the screen, and visual interference that distorts some of the pictures. Barrow has also shot the TV screen from odd, oblique viewpoints, which render the television screen a cryptic anamorphosis.

The corruption of the photographic detail that is clear on the TV screen but eroded with competing visual "crosstalk" is seen in *Cathode Ritual I*, 1968. Regardless of what was on the television screen when the film was shot, or its actual prominence at that time, some visual information or aspect from each shoot dominates over others in a way unforeseen at the time the film was exposed. Throughout this series there is a recontextualizing of the images, as original icons assume new identities among the surviving elements. For instance, in this work, the man and woman are prominent and discernible figures, and they appear to have been excerpted from a minor television drama. Close examination reveals that they were not originally paired together at all but were in different exposures (which accounts for the dark band running across the woman's nose). Additional scrutiny reveals that the composition was made from at least three TV screens, in different sizes and angles.

With these photographs Barrow's interest in photographic imagery of a nondocumentary nature becomes clearer. *Untitled* [TV with vertical bars], 1969, illustrates an underlying concept that remains in his work: the transformation of the photographic subject and the use of a potentiating montage that recontextualizes the icon, adding layers of nuance.

51

Photomontage, Walter Benjamin wrote, reveals the productive potential of collage to disrupt the context, countering the illusion.[6] Photomontage, previously seen in the series "fashion" is more fully realized here. Barrow utilizes this less with the programmatic intent that John Heartfield and Hannah Hoch had and more with their Dadaist sense of randomness and chance. Here too he subscribes to Moholy's theories about the power of montage and its ability to transform. But Barrow also had a considerable interest in the formal aspects of the prints.

Given the nature of these images—they are units removed from their syntagma rather than discrete, or solitary, photographic frames—the montage vocabulary from film has some relevance. This approach looks back to Sergei Eisenstein's theory of montage as an open-ended device that was in opposition to the narrative. As with film, photographic montage is able to transcend the realism of documentary, combining shots in a collision of imagery. But for Eisenstein montage was not simply to support existing narrative but rather to create new experimental ideas; ideograms combined bits of different meanings to create a totally new meaning. He regarded the ideogram as the model of cinematic montage, and actors represented mere types.[7] The recombined details again compete for comprehension, with the bolder elements assuming a presence that is progressively undermined by the less obvious images. Wrenched from their source, the images are left to each viewer for reordering. Here the subtle interweaving of visual bits enables us to discern a figure watching a TV screen. But is this really what is presented? The bold TV screen comprising vertical bands of alternating black and white—a technical difficulty—eliminates the narrative of the medium, replacing it with a bold Minimalist abstraction in contrast to the usual pictures on the TV.

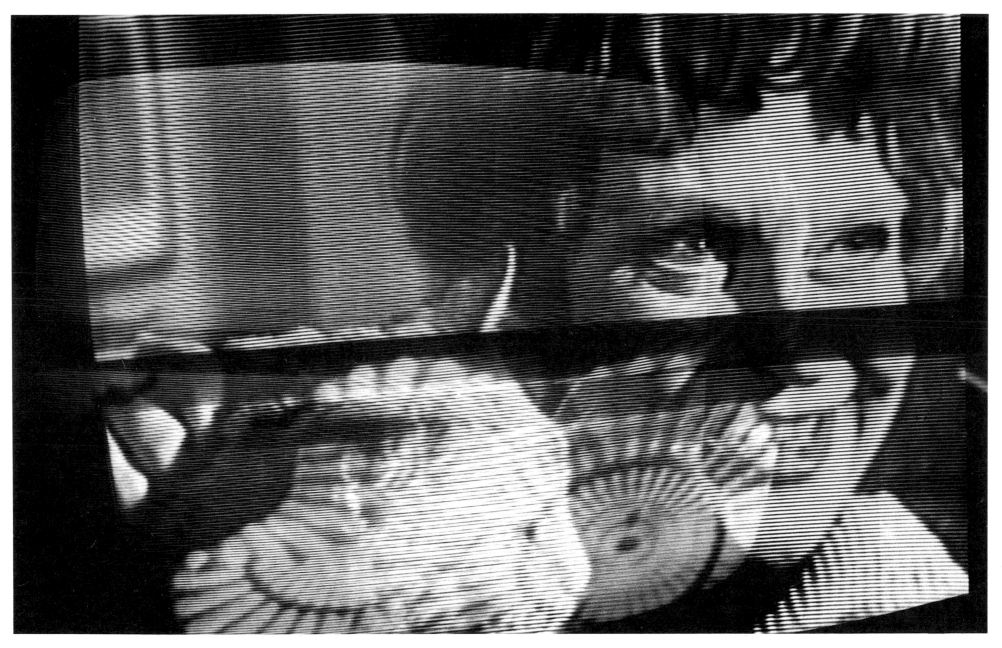

Parachute Woman, 1969

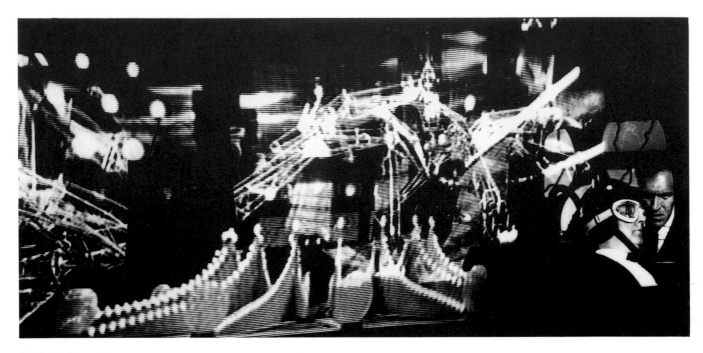

Art Mechanism, 1968

 Art Mechanism and *Art Mechanism II*, both from 1968, are among the elongated horizontal compositions. In these two prints the density of detail creates an intricate abstraction that subordinates all the other pictorial elements. There is considerable tension too between the expressionistic and formal elements in the works. *Art Mechanism II* furthermore introduces a perceptual problem as the visual information from one screen challenges the prominence of another, forcing our attention continually to shift from one to the other. Here the sum of the montaged parts is greater than the whole. This work further illustrates

Barrow's study of the relationship between the literal, realistic photographic image and formal abstraction, their balance of power and dialectic resolution. Hidden images, at first submerged in the composition, gradually become evident, some more substantive than others. *Art Mechanism* is darker and the most abstracted of the TV images, essentially making use of bright moving lights to create a graphic, reversed white-on-black pattern of visual static. Unlike the simple clarity of *Material Tabooed and Refractory, Art Mechanism* is far more agitated and indistinct in its discordant assemblage.

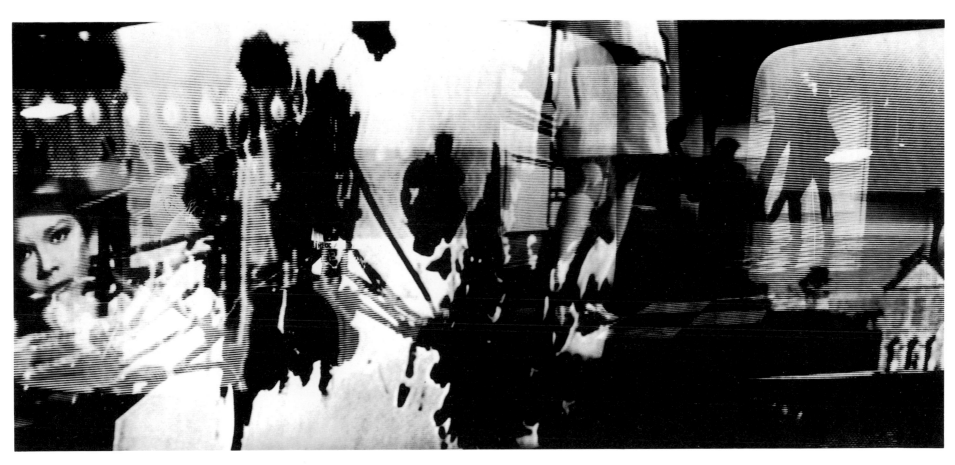

Art Mechanism II, 1968

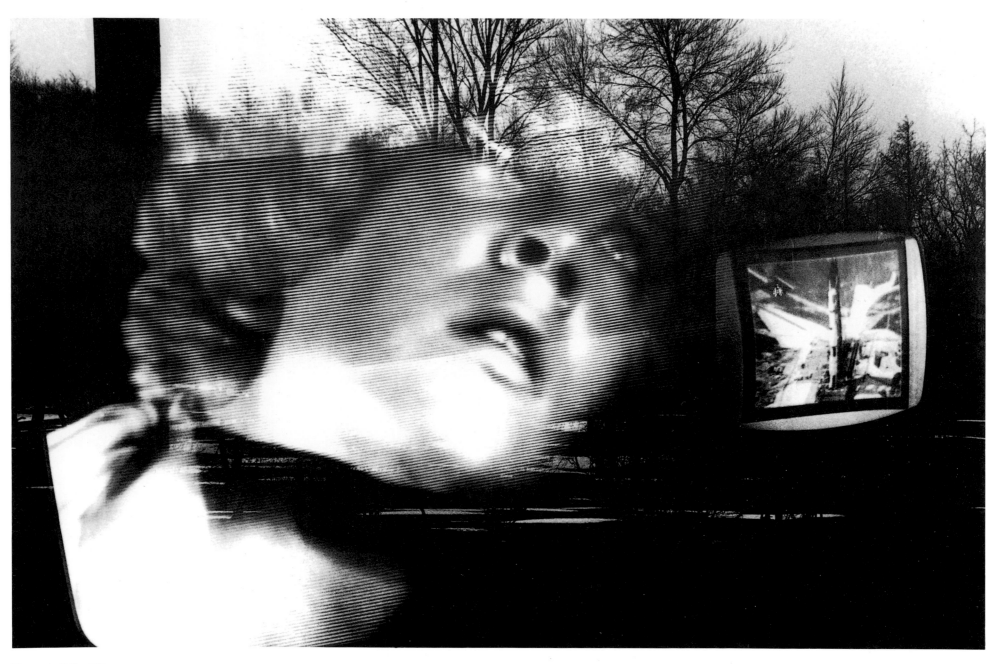

Homage to E.P., 1968

Homage to E. P., 1968, includes shots from the TV combined with landscape. "E. P." is a TV character, Emma Peel from the British television series "The Avengers," although that is not especially clear. There is a pronounced change in scale from the large close-up of Peel to the TV set photographed at medium range. Combined with them is landscape scenery, which makes the small TV set float in the midst of dark woods. Here montage is used, as in film, to connect images and make reference to passing time or recollections. The dramatic combination of black and white and the insubstantial face give this a dreamlike appearance. Emma Peel is the subject too in *Peel and Repeal*, 1968, a glittering abstract composition of myriad white lights, filmy spheres, and the face of Diana Rigg, the English actress who portrayed Emma Peel in the series.

A serial use of recurrent imagery appears in these pieces, among them *E. P. and G. B. Revisited*, 1969. The use of cryptic initials in the title,

another characteristic of Barrow's work, is allied to the concealed content that must be discovered. The Union Jack gives a clue for "G. B.": Great Britain. The large close-up of the face, paired with the twin figures of a bikini-clad woman and the torso of a nude woman, make this an evocative work. The TV lines streak horizontally across the entire image, linking the details.

The automobile shows up again, here in scenes from drag races. *Cathode Ritual III*, 1968, is of a car race, which makes use of distorting out-of-focus close-ups as an overlay to the two other screens. This shift from imagery in the foreground and background is also seen in *Catalogue Deuce*, where fashion models, an auto race and a large "2" placed on its side all vie for our attention. *Cathode*

Ritual II includes a man in an iron mask, a race car driver, and a bouffanted beauty queen. In this print Barrow adds to the complexity by utilizing the cast shadow of the man. The composition moves progressively from right to left deeper into the space, from the woman in the right corner close to the viewer, back to the driver, and behind him his shadow laid against what seems to be a projection of the face of a cyborg, part man part machine.[8]

57

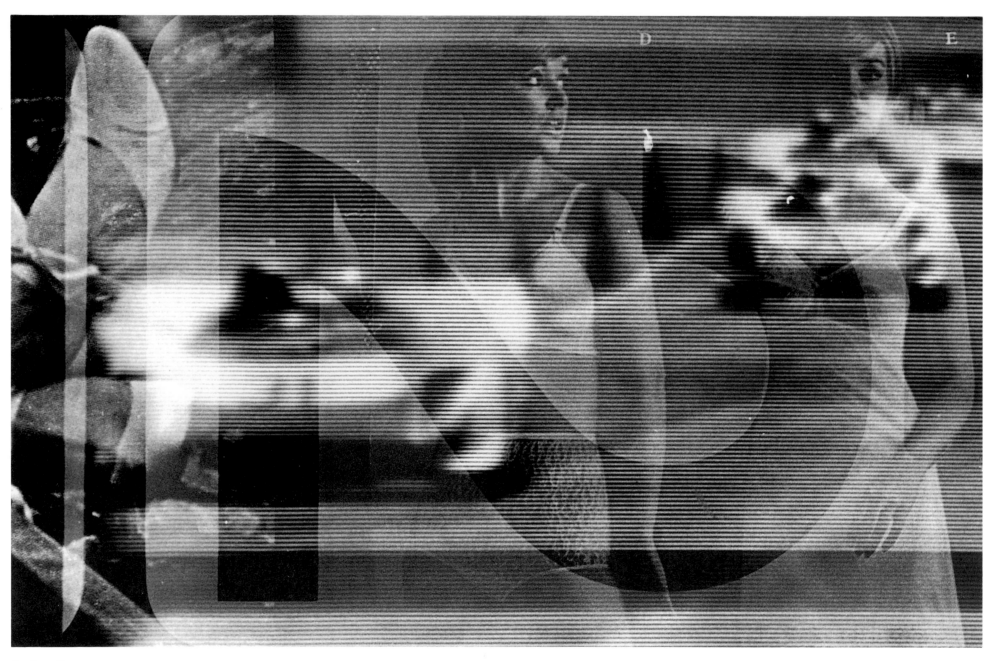

Catalogue Deuce, 1968–69

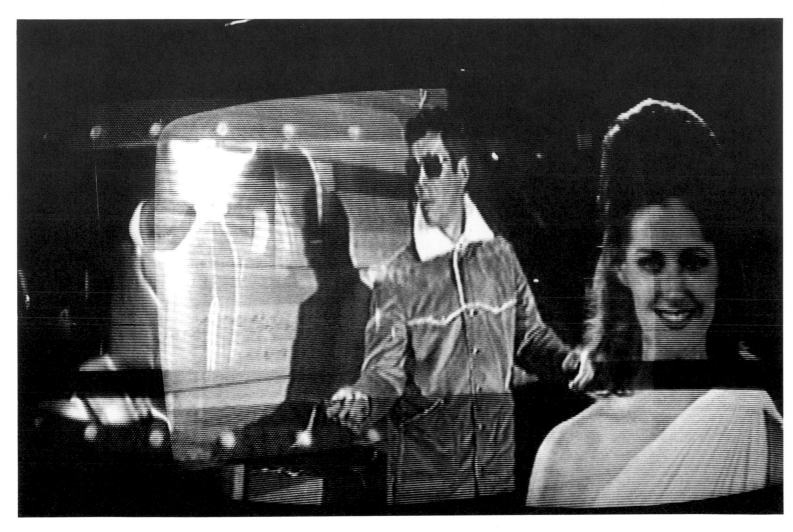

Cathode Ritual II, 1968

The distortion and transformation of icons is a manifestation of Barrow's ongoing attention to the concept of camouflage. Visual information is hidden within the dense visual "underbrush" of competing details, masquerading as something else. Appearance is transformed, and we may be deceived by the false appearance, overlooking aspects that are masked. The layering of frames corrupts the certitude of the photographic information, transforming the reality, as proposed by the television media, to an unworldly representation.[9]

The powerful influence of the
network news programs in shaping
events and political opinion is alluded
to in *"M"*, *The Late News Structure*,
1968. A stiff reporter, a seemingly
two-dimensional figure, is
overshadowed by a large letter M,
which is the same size as he. The
formalized figure and the uncluttered
frame and graphic extreme tones of
black and white invest the figure with
a severe authoritarian and hieratic
quality. The telephone pole at the left
reiterates the concept of information
transmission.

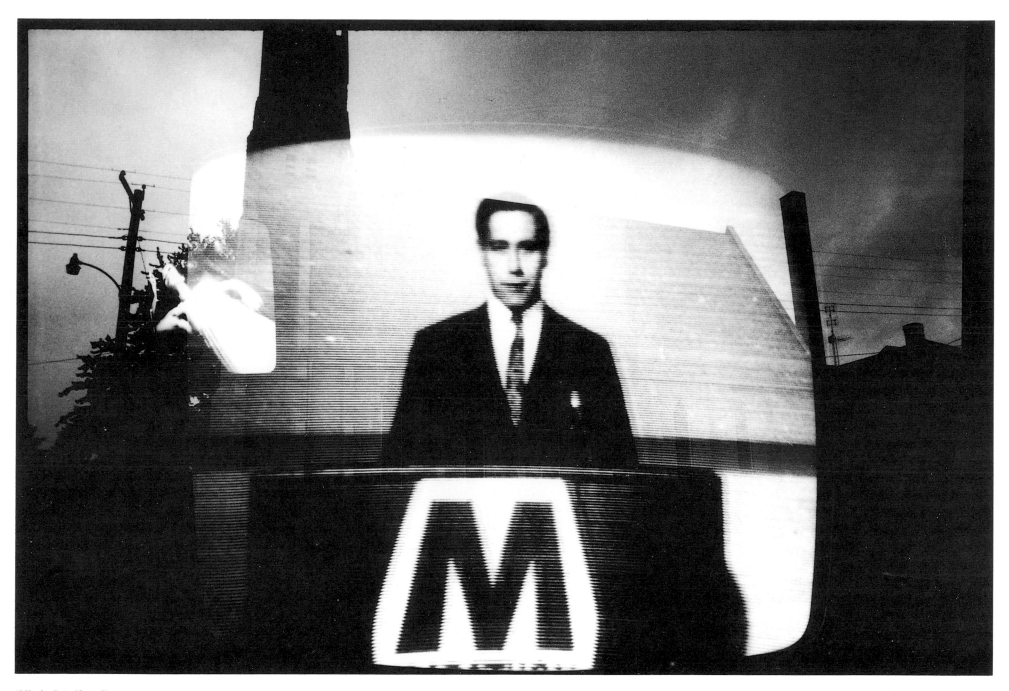

"M", the Late News Structure, 1968

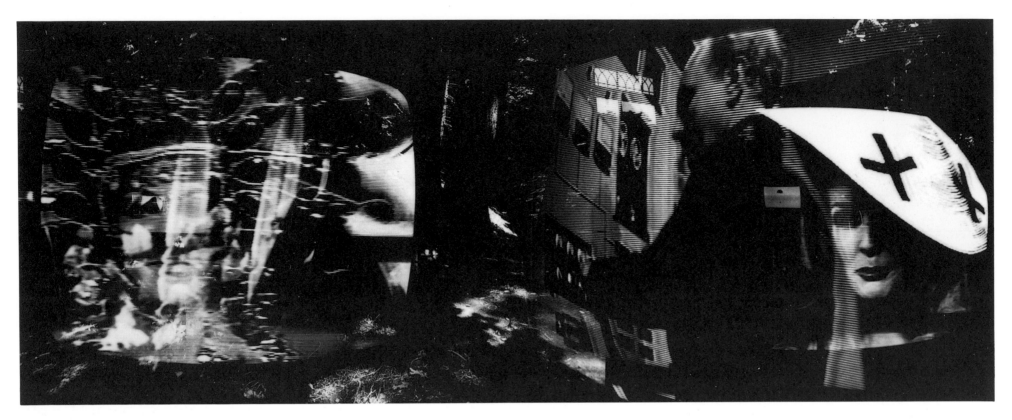

Computer Balloon, 1968

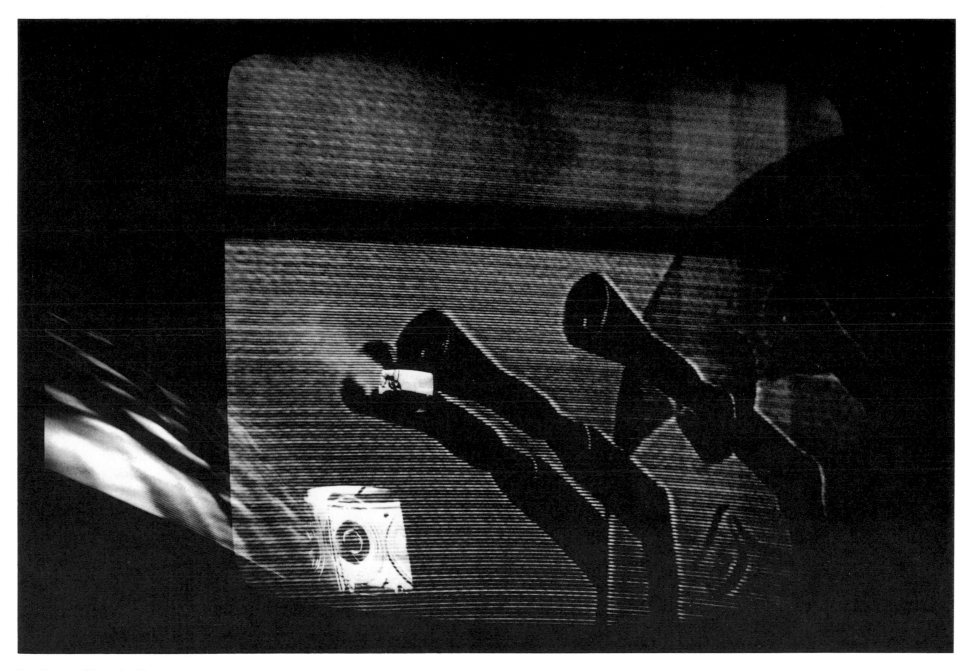

From the series War in Our Time—
Turret, 1968

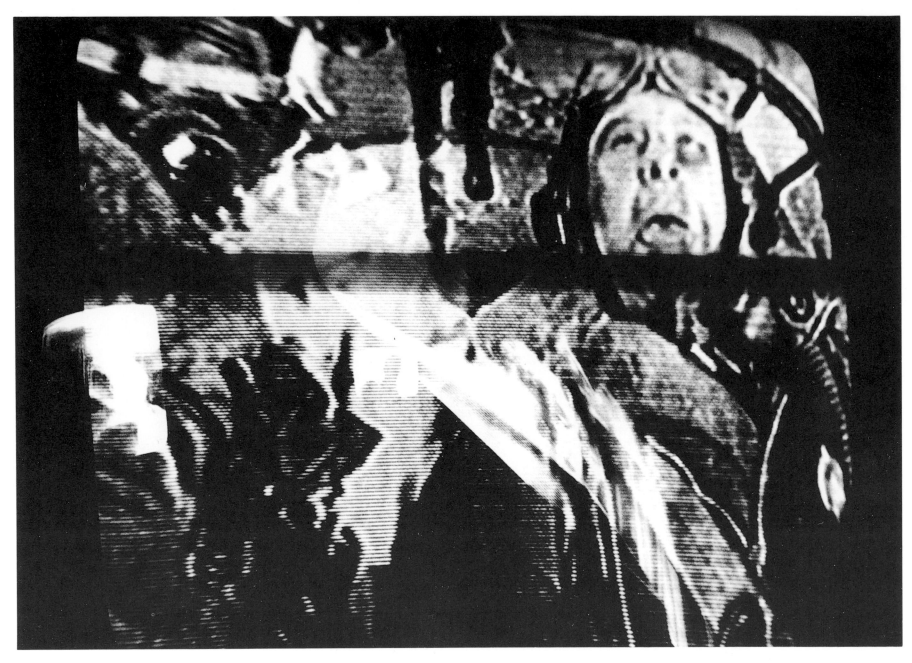

*From the series War in Our Time—
Tongue, 1968*

Though most of Barrow's photographs relate to aspects of contemporary American culture, he has never been especially interested in making political comment. The one exception to this perhaps is a subgroup of the TV photographs, the series "War in Our Time."

Although politically less involved than his closest friend Robert Fichter, whose own work has a biting, Daumieresque nature, Barrow in this series considered the impact of the Vietnam War and its presence in the television medium. The title of the series, like the images, is multilayered. Foremost, it is a clear reference to Vietnam. It is also an ironical comment on the peace-keeping effort of the United States, assigning the Vietnam War the nonsensical official status of an undeclared war. And finally it is a direct parody of the short-sighted, erroneous slogan proclaimed by Neville Chamberlain in 1938 ("Peace in our time"), in turn suggesting something about contemporary political duplicity as well.

Even these photographs, a small series of approximately ten images, are not stridently polemical as almost all of the imagery is drawn from old war movies broadcast on TV rather than from news footage, the factual document. Thus these photographs also have a media-derived, fictional origin, one where the narrative, images, and stereotypical icons are media ready-mades with Barrow recycling, reconstructing them.

These images draw upon the story of good versus evil that war so clearly delineated in films on World War I and II and Korea which shaped the public consciousness in the 1950s and 1960s, influencing those who grew up on those stories. The unblemished, heroic image of the American military as presented in the many war movies, and as popularly conceived by the American public, was tempered by the grim reality and unclear purpose of the Vietnam War. The series considers the disparity between the two. Barrow also notes that despite certain technological changes, many things remain the same, and that an image of a tank, a pilot, or a soldier is iconic and universal.

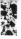

The Series Pink Stuff and Pink Dualities

Started 1968

In 1968 at the same time that he was making photographs off of TV screens, Barrow turned to a thoroughly different format, the diptych. Two similar but slightly different series ensued over the next five years, Pink Stuff and Pink Dualities. Small, understated works, these photographs are diverse and visually provocative. Barrow produced the two separate series concurrently, with all but a few errant images occurring between 1968 and 1972.

Robert Fichter, his close friend, had been working with the identical format just slightly earlier.[1] Along with other artists—Alice Wells, Betty Hahn, Robert Fichter—Barrow was working with multiple frame 35mm prints and other alternative forms and processes. But the diptych was by no means unique to Rochester, showing up in the work of Darryl Curran in Los Angeles at this time as well.[1]

Barrow points out that this dual format was not new; it is directly derived from the diptych configuration of the stereograph. The correspondence with this ubiquitous, pedestrian nineteenth-century model is more precisely manifested in the Pink Stuff prints than in the Pink Dualities.

His discovery of an antique toning process in old photographic literature prompted Barrow to use it on his prints. The choice of the relatively strident pink hue was made precisely because it was the farthest from the classical photographic canons of Weston, Adams, and White. And the egregious pink, unlike the brown tones or even cyanotype blue, was without any ameliorating and respectable nineteenth-century precedent. Because pink was an unseemly, unrealistic, absurdist color for black-and-white photographs, it prevented any association with the quaint, staid stereograph. The pink color has a negating, vandalizing effect, not unlike the X mark of the Cancellations.

Barrow and Fichter were never interested in making truly functional stereographic images, that is ones that actually created the three-dimensional effect. But the idea of harnessing images in tandem, as well as the very appearance of the dual images, intrigued them. Hence, the pink photographs irreverently masquerade as would-be stereographs, but in fact are not. That sort of disfunction of the ersatz stereo prints had a humorous appeal, parodying the craft-oriented photo enthusiast and the renewed but retrogressive interest in the stereograph format.

Like the concurrent Verifax works, the pink images reflect Barrow's encyclopedic fascination for the oddments and trivial products of contemporary culture: examples of architecture and parts of buildings, odd industrial structures, automobiles, images off TV screens, backyards and abandoned lots, and examples of industrial technology. In retrospect, the pink images seem to have been motivated by the same wish to establish a visual inventory as is more clearly seen in the successive groups, the Verifax prints, Libraries, and spray-painted photograms. He focuses on the vernacular subject and the found object.

The distinction between the two series is quite simple and consistent: prints in the Pink Stuff series are always multiples of the same image, while the Pink Dualities are of markedly dissimilar frames or subjects. Pink Stuff, in general, is much simpler, with the emphasis primarily on the subtle visual and perceptual interaction between the two frames. In some prints, the correspondence between the frames is more exacting, setting up an odd tension between the left and the right. In others where there are more apparent distinctions, one continually shifts the examination between the two, comparatively analyzing them for the scale and position shifts, for the differences

"We argued in the elevator at the George Eastman House about why didn't anybody change the color of photography. This is such a simple thing. Why was it always black and white? We debated about what would be the worst—the most unphotographic—color. Fichter said pink, a color very much out of favor then. Shortly thereafter I found some old instructions on how to tone prints pink."

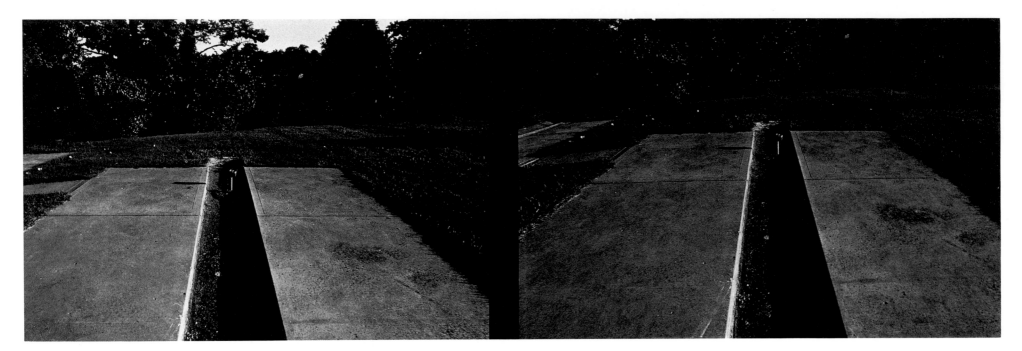

From the series Pink Stuff—
Channel, 1971

and similarities and change in perspectival approach.

The Pink Stuff images seem to be conceived with more attendance to formal issues and a careful balance maintained between the two frames. Typically, Barrow uses a classic centered composition, confronting his subject head on, its plane parallel to the camera. Rarely is there a complete landscape or vista in these views, the object of his attention being being excerpts and peculiar, common details. A prevailing sense of simplicity arises in these duos, where the camera has been trained on simple architectonic forms which are themselves somewhat enigmatic, like *Channel*, 1971, or *Interstate Span*, 1971. Landscape per se is not Barrow's interest with these works, although there may be occasional vistas. He chooses a single element and considers it in various ways to form a nearly congruent pair.

His penchant for ephemeral cultural trivia and quickly dated fashions shows up here. For example, *Pasadena Wedge*, 1974, and *Strap Sketch*, 1974, both disclose a perversely humorous attention to the ridiculous style of womens' shoes examined chiefly from a design approach and as a cultural and fashion bellwether. And naturally as time passes, the now outmoded style looks more embarrassingly quirky, but yet not quaintly antique. The pink images rarely become dated though, for few are tied to topical issues.

From the series Pink Stuff—
Box, P.S. 1972–73

Peculiar architectural structures are another motif in the Pink Stuff series. For example, *Box*, 1972–73, whose title recalls Malvina Reynolds's song about houses as little boxes, depicts the impoverished bungalow shape reminiscent of 1930s roadside cottage motels, company housing, or hastily constructed huts for migrant workers. The photograph is also an allusion and homage to Walker Evans, who portrayed this type of housing in numerous works such as *Company Houses for Steel Mill Workers, Birmingham, Alabama*, 1935. The change in perspective, the interaction of light and shadow, and the slight shift in scale between the two frames make Barrow's an energized image. Examining each half of the diptych separately reveals that the alliance between the two frames creates a combination with considerably more dynamism and visual interest than the single frame alone. The cinematic reference in the side-by-side format suggests some change in the stasis of the subject.

This restrained, simple work has a delightful resonance and vigor created by the multiplicity of ten identical structures that are reiterated across the two frames. *Box* realizes the Bauhaus principle of "simplicity in multiplicity," wherein the units are standardized and serialized. The severe modularity of the dwellings fulfills Moholy's statement about the serial image, which loses its identity, becoming a "detail of assembly, an essential structural element of the whole."[2] Additionally, this transformation of the subject using shifting perspectival points and multiple imagery was an element Moholy described in *The New Vision* as a fundamental of Cubism.[3] The repetition of elements, the reconstruction of the subject into a serial display, the design elements and abstraction in the Pink Stuff series can be traced to the formal explorations promulgated at the Institute of Design.

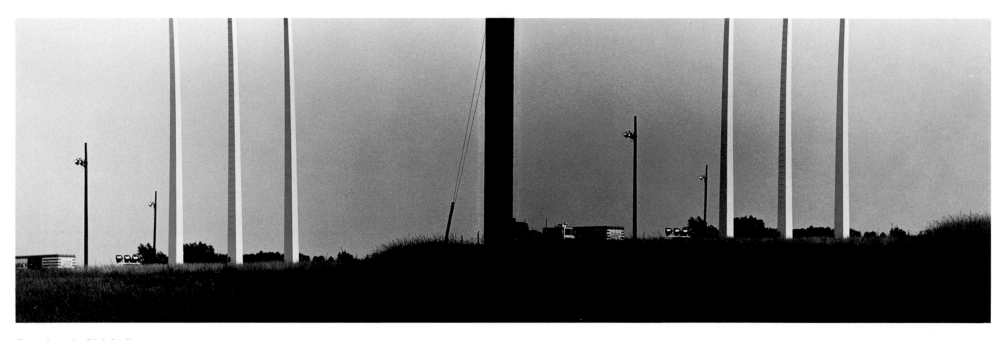

From the series Pink Stuff—
Interstate Span, 1971

Barrow's continuing interest in industrial architectural design is seen in a number of images. In *Interstate Span*, 1971, for instance, Barrow presents a highly minimalist pair of pylons that are virtually identical. The linear groups have a flatness that confounds their function, context, and scale. This is one of Barrow's closest fake stereographic images; it is an allusion to illusion, wherein the two-dimensionality that is so insistent here would burst into the third dimension if seen through a stereo viewer.

From the series Pink Stuff—
K.C. House, 1971

In contrast is the highly stereographic *K.C. House*, 1971, presenting duplicate facades of an ordinary middle-class home. The repetition of diagonal roof lines carries the eye from one frame to the other and then back again, while details emerge and recede as the eye shifts from point to point. The interaction of the nearly identical representations causes us to scrutinize the frames very carefully. This kind of visual riddle complicates the direct inventorying. The double frames enabled Barrow to continue his interest in the montaged image, layering information and meaning.

The automobile also appears in Pink Stuff. *Saltbird*, 1972, depicts a corroding Thunderbird, forlornly parked in a gas station, the victim of northern winters on the salted roads. In contrast to the careful pairing of *K.C. House* and others, Barrow uses two less similar views in this work— one close up, the other more at a distance and greatly overexposed, reducing the vehicle to a ghost of the left-hand image.

Barrow adds the theme of camouflage as a cheap vernacular design solution with *Camouflage Car*, 1971, and *Ur Camouflage Car*, 1971. Certainly, as the flamboyantly styled car is neither disguised or hidden in its urban environment, the camouflaging has only a vestigial purpose, paradoxically calling attention to the vehicle, not obscuring it. The temporal play of shadows in the background doubles the visual complexity, mimicking the painted camouflage pattern. In *Camouflage Car*, a lumbering 1940s ambulance is hidden not by the crudely painted graffiti but by the dense foliage and shadows. Barrow is cataloguing artifacts; he records another species of vehicle and another class of camouflaging with a good-natured parodying, for we readily discern that the paint job was never intended to approximate camouflage.

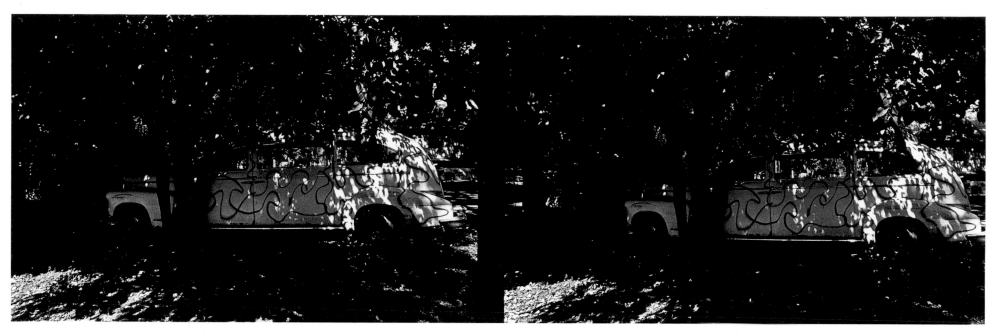

*From the series Pink Stuff—
Camouflage Car, 1971*

*From the series Pink Stuff—
Ur Camouflage Car, 1971*

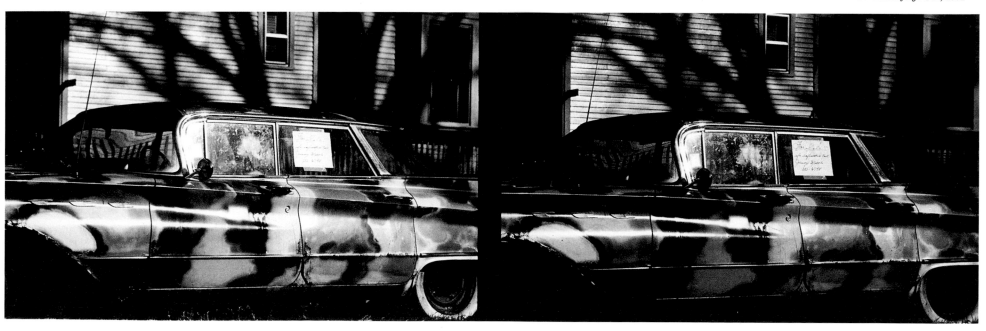

''Photography, in theory, is a totally reproducible

medium. I think it does relate to how we bang out can

openers, high heel shoes, and cars, for example, and

other products.''

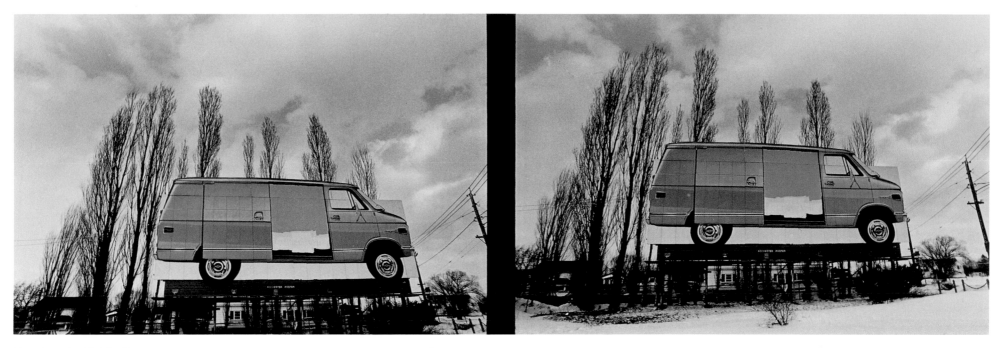

From the series Pink Stuff—
Dying Poplars, 1971

Barrow introduces a trompe l'oeil of sorts in *Dying Poplars*, 1971, detailing a flat, monumental roadside billboard of a van. The ubiquitous presence of the automotive culture extends even to the heavens, for here it is aggrandized, portrayed hieratically. Changing the point of view, the vans in the diptych seem to be a rolling pair, set against windswept poplars. The scene is an homage to Alfred Stieglitz's studies of the poplars at Lake George while it is also another example of visual ready-mades.

From the series Pink Dualities—
Ohio, 1971

The rigid optical orientation of the Pink Stuff prints is expanded in the Pink Dualities, where the pair comprises dissimilar frames with a rich, continuing interconnection. Some, like *Houston Stack*, 1971, show a direct correspondence between the left and right. Here, the verticality of the building and a central motif of windows are the dominant elements, carrying the eye between the two frames, back and forth. Like cinema, where frames shift from one scene to another, rather than the single stationary monocular view, these prints work to expand the time element, space, and context. Rather than selecting one iconic image of an object, a plural is used, increasing the visual information.

From the series Pink Dualities—
Houston Stack, 1971

The majority of the Dualities create a whole that is more than the sum of the parts. The rich, continuing interconnection between the pairs contributes to the success of the Dualities. The piling up of disparate, seemingly irrelevant visual information is much more akin to the Verifax print. And the notion of montage is more evident. The Dualities are less visually didactic and more personal. This synthesis of disparate elements creates an uneasy dialectic that makes them more challenging than the Pink Stuff prints, more open-ended and enigmatic and less accessible. Barendse cites the Dualities as offering a subtle argument between the propositions posed by each frame, resulting in a third conclusion drawn from them. Barrow too has cited photography's unique ability to place the observed questions in opposition to each other to create not only a dialogue, but an argument.

From the series Pink Dualities—
Interior Thoughts, 1972

Interior Thoughts, 1972, takes its name from the interior on the left, which is not photographed in an actual room but made from a reproduction in a publication. Paired with it is a dark, enigmatic black frame that continues to bring one back to the peculiar living room. Not an example of haute design or style, the middle-class room signifies a pedestrian domestic orientation rather than a refined design style. The image discloses Barrow's fascination with the reproduction as the paramount source of visual imagery today. The reproduction here is equivalent to the original for Barrow. The use of a generic modern interior, where particularity is of no consequence, emphasizes his desire to represent a generalized class, rather than a specific subject. In this selection the generic suffices for the specific, and the reproduction for the original, an attitude reflecting the multiplicity of objects today.

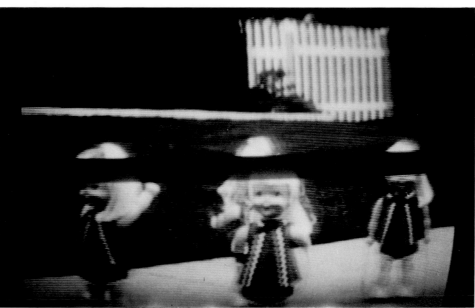

From the series Pink Dualities—
Scarsdale, 1970

The combined images in Pink Dualities are sometimes resistant to analysis, however. *Scarsdale*, 1970, for example, pairs a Mobil gas station with a picture of three dolls on a TV screen. Using a long shot of a landscape with a common commercial structure together with a close-up of an artificial image juxtaposes the real world against the transient video image. Both images, however, are of commercial commodities, one rather essential, the other absurd. The utter banality of the doll image makes it an unlikely choice, yet it illustrates his curiosity about the proliferation of products thrust upon the consumer, from the well-designed and functional to the ill-conceived and bizarre. This work again reveals the importance of the television image for him as another depiction of reality to balance the more typical documentary shot.

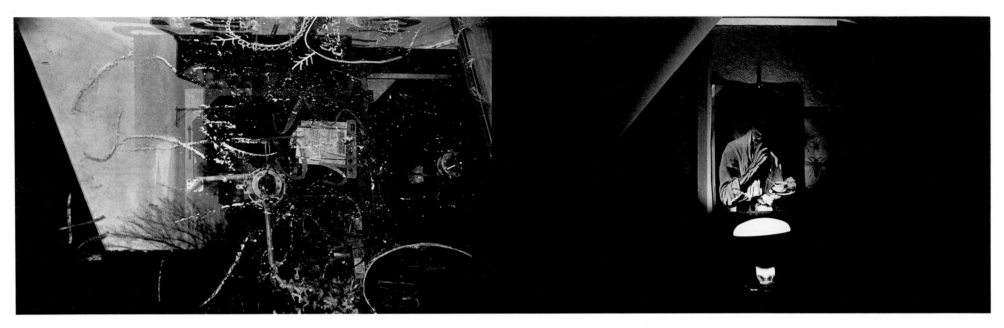

From the series Pink Dualities—
J.C. Chaos, 1971

From the series Pink Dualities—
Interior Thoughts, 1980

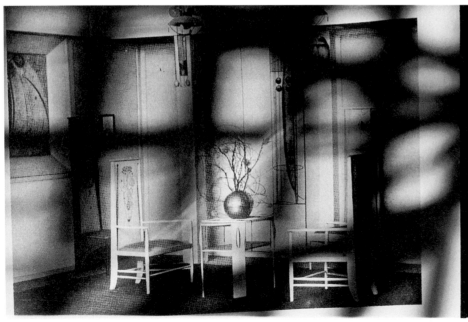

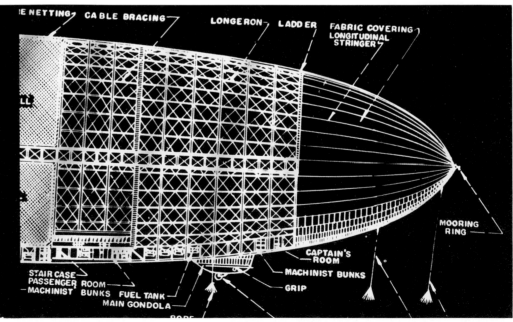

The Pink Dualities, characterized by the density of information, emphasis on nuance, use of associative elements and oblique reference, and obscure connections, are extraordinarily rich, although less accessible to casual perusal. And as with other groups, they are demanding of the viewer.

J.C. Chaos, 1971, exemplifies the rich visual density concealed in these photographs. The left half, though seemingly a cluttered abstraction, is in fact a shrewd intricate montaging of a store window, reflections, and a view beyond. The initial visual chaos discloses with closer study the complex scene of a Rochester street behind a graffiti-ridden surface of glass. The surreality of the allusions and layering in the left frame are supported by the right frame, a mysterious dark homage. Presented much like a votive image, the portrait is dramatically lit from below, with black shadows obscuring the identity of the sitter. The title though offers a clue to the identity. Adduced by the familiar bony wrists is the writer Jean Cocteau. The curious scale, mystical lighting, sense of expanded time, and preponderant blackness contribute to the dreamlike atmosphere, all of course in keeping

with the subject. As with the other works that are an homage, the connection is slightly veiled.

Although confined chiefly to the early years of the 1970s, Barrow did make occasional isolated pink prints later on, such as *Interior Thoughts*, 1980. A pendant to the 1972 work, it again explores aspects of modern culture and functional design advances of the twentieth century. The interior, on the left, is a Charles Rennie Mackintosh room, also from a reproduction. The functional and forward-looking designs of Mackintosh, one of the geniuses of early twentieth-century design, are honored in this work. The random pattern of shadows cast over the room both suggests Stieglitz's 1889 photograph *Paula, Berlin* and reiterates the gridlike rib pattern that forms the skeleton of the zeppelin in the right panel.[4] The streamlined airship recalls the thirties, the period of classical modern design and the

rise of technology and consumer engineering. The faint continuity of gridlike shadows playing over the airship further strengthens the visual interrelation between the two images, with the grid device carried from one frame to the other.

By 1973 Barrow was engaged in another area that had been concurrently progressing. His interest in the pink prints diminished as he shifted back to his unabashed cultural cataloguing and moved away from the camera and lens.

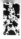

The Verifax Prints

Started 1968

While Barrow was making montages from TV images, he also began making photographic prints using a photocopy machine. The subject matter includes all kinds of vernacular imagery: magazine and newspaper ads, excerpts from catalogues and articles, maps, schematic diagrams, and cartoons. The Verifax prints extend Barrow's interest in the media-derived photographic reproduction. These prints are "time capsule pieces" that gather up assorted bits of societal trivia, recording them for future scrutiny.[1]

Barrow was by no means unique in his interest in the photocopy machine to make prints; several artists, notably Keith Smith and Sonia Landy Sheridan, were exploring this vehicle concurrently. With access to a Verifax machine at the George Eastman House, Barrow and Robert Fichter experimented with its potential as an alternative medium. Barrow was expecially intrigued by the opportunities to recycle extant imagery and by the wry appropriateness of using the duplicating machine to reproduce reproductions. It was for him the most ideal means of cultural documentation, simultaneously embodying the technology, the common object, and original source data culled from mass media. Often overlooked because of their humble medium and sometimes dubious appearance, the Verifax prints are nevertheless highly significant in Barrow's early oeuvre, for they illustrate most clearly his interest in contemporary culture, machines, consumer products, montage, an experimental approach to photography, and his disregard for the camera.

Also the atmosphere of experimentation at the Institute of Design and its easy assimilation of the mechanistic surely contributed to his interest in working with the machine. His mechanical bent is seen in the choice of imagery as well: machines and circuitry, schematic diagrams, oddball inventions and apparatus, and unintelligible instructions.

The Verifax machine was an Eastman Kodak product developed in the 1940s. Its resulting print, unlike the clean, dry Xerox copy, was, as Robert Fichter observed, "a wet mess that no secretary in her right mind would want," with the additional drawback of having an overall brownish cast.[2] This primitive, outmoded process held more potential for artists than for office workers, however, since it utilized a special matrix, or master, which received the negative image. Acting like film, or, more correctly, like a paper negative, the Verifax matrix image could be transferred to treated copy paper. Barrow, however, frequently utilized the original negative as the finished print. The process had a certain appropriateness for Kodak, for it utilized a fundamental negative/positive system, giving it an affinity to the traditional gelatin silver process. The wet process, however, was doomed by the high resolution, speed, and cleanliness of the dry process. The Verifax machines were discontinued in the early 1970s, and the dwindling materials became increasingly scarce and ultimately were no longer available.

Using a reproduction as a work of art necessarily invokes Walter Benjamin's essay "The Work of Art in the Age of Mechanical Reproduction." The prosaic product of the copy machine, material drawn from the public domain, as it were, scarcely embodies the "aura" of the precious objet d'art, yet these unusual prints have their own kind of aura. In these unique sheets scavenged from common public sources, society assists as cowriter.

Barrow first began making Verifax prints around 1968 but did not seriously turn his attention to the process until 1970. The Verifax prints demonstrate his increasingly iconoclastic attitude toward photography. Rather than the clear, crisp negative and refined silver print, Barrow's

Visor, 1972

Verifax product was a grainy, murky assemblage, a cacaphony of diffused details without a central component, focusing on seemingly insignificant imagery. The prints contain no heroicism, no mystical atmospheric qualities, no dramatic vistas, no classic and elegant abstraction, no poignant portrayals of people on the street, in short, none of the prevailing interests in photography. Moreover the Verifax prints reject the notion of photographer as creator; instead, he is an accumulater creating *pasticci*, prints made up of fragments from various sources.

But more than alternative process, for Barrow the copy machine offered the opportunity for social comment, the conjunction of vernacular subject matter with a vernacular process, wherein ubiquitous mass-media imagery was allied with the ubiquitous copy machine. The common process thoroughly befitted the subject.

The copy machine product was clearly important to Barrow, for he continued producing these works through 1975, a period of over six years. Representing much more than a fascination with simple gimmickry, or a brief passing fancy with copy machines, the Verifax process instead struck a special resonance in Barrow as the suitable vehicle to address his concern with material products. Barrow also liked the homogeneity that the machine provided, organizing the material into modules with a consistent surface appearance. This kind of work has a historical basis in the Bauhaus interest in the machine and the increasing influence of technology on art. Others perceived the influence too; the British critic Herbert Read, for example, observed, with some prescience, that art could be produced by machines.[3] Lewis Mumford called attention to the numbing multiple image and product in 1952, citing the mechanical reproduction process as a substitution for reality,[4] and this is how Barrow employs the reproduction.

Unlike the camera, the copy machine was instantaneous and, more important, unencumbered by any of the camera's historical associations. The photocopy afforded an immediate and casual approach and sidestepped the fixing of the image in a negative. It afforded more opportunity for trial and error. The paradox of the medium was not without interest to Barrow. For although the Verifax print is photographic, it is not a photograph. And it has an affinity to Moholy-Nagy's experimental, cameraless images. Here was a technological machine to make photographs; it was unburdened by the aesthetic of the medium and intrinsically allied to the notion of the multiple and the mechanistic.

Walter Benjamin early on recognized the potential of montage to create an allegorical language and its ability to create wholly new understandings by its connection of dissimilar elements, as seen in the work of Hannah Hoch and John Heartfield. There is a satirical humor and a flippancy in the Verifax print here recalling the distorted photomontages of these Berlin artists as antecedents.

Other influences are evident in the assemblage sensibility as well. Robert Rauschenberg was seminal in his use of vernacular sources, the casual assemblage of parts, the "random order," and photographic details in his paintings and prints. His copious use of the cultural rubbish in the 1950s and 1960s prefigures Barrow's interest in banal montage, and Rauschenberg doubtlessly informed Barrow's work.

But perhaps more than Rauschenberg or any American artist of the 1960s, English artist Eduardo Paolozzi exerted the most influence on Barrow and is a source he has always

Terminal Boop, 1971

''The Verifax matrix

wasn't designed

to be saved.

Working

with the reject,

the disposable

part, had a certain

appeal.''

acknowledged. Both Paolozzi and Barrow continually addressed the media imagery of popular culture and noted the increasing mechanization of life. Language was an essential element of Paolozzi's work as in Barrow's, and many of his prints reveal the influence of Ludwig Wittgenstein and the shifting of syntax and exploration of language and meaning. Additionally Paolozzi was among the first artists to explore advertising images, looking at sociological concerns and utilizing montage and vernacular imagery. Kurt Schwitters's use of montage was pivotal to Paolozzi, just as his use of typography and dada-like collage attracted Barrow. Although much of Paolozzi's work antedates Barrow's, there is a surprising concordance between Barrow's Verifax prints and Paolozzi's prints that were executed at the same time, for example, *Zero Energy Experimental Pile (Z.E.E.P.)*, 1969–70.

The Verifax prints also reflect the inquiry that began in the 1960s around the country into the interaction of art and technology as exemplified by the Experiments in Art and Technology, in which artists worked directly with scientists or technology on experimental projects. As acceptable forms of art expanded from sculpture and painting to include light and neon sculpture, video, performance, computer-generated imaging, and kinetic works, numerous individuals explored the potential of technologically oriented machinery to serve the artist. Artists working with photography naturally were challenged by the possibilities of the common copy machine. And while the Polaroid camera matched its instantaneousness, those prints were small, glossy, and still tradition bound. Unlike the portable Polaroid camera that could be taken anywhere, the copy machine required that the subject matter be brought to it and essentially composed on the glass.[5]

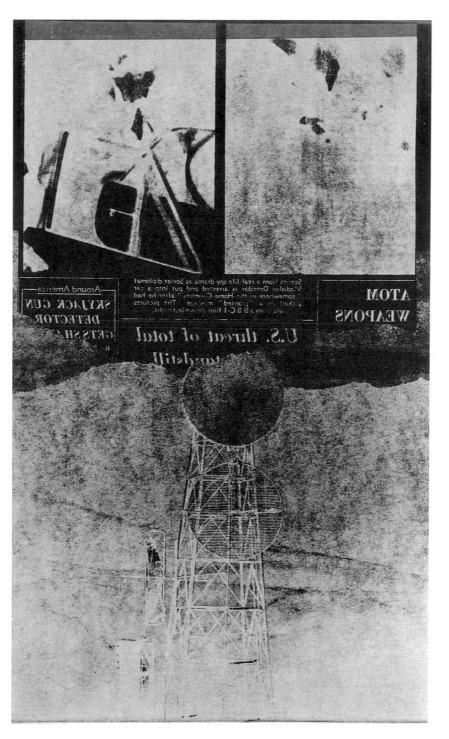

Homage to R.H., 1972

Making Democracy Work, 1971

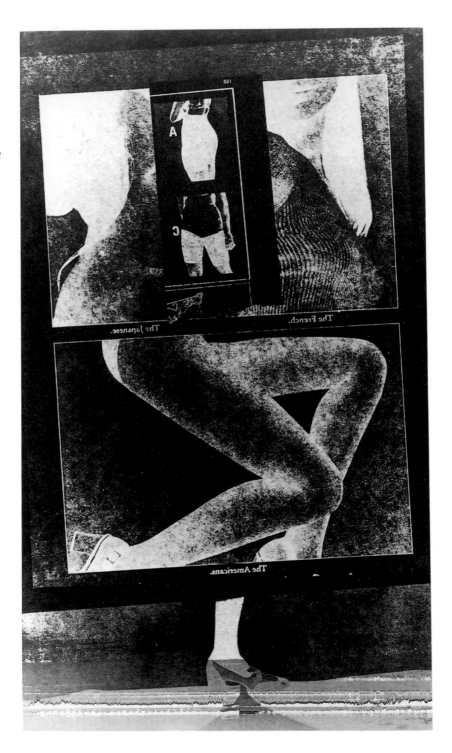

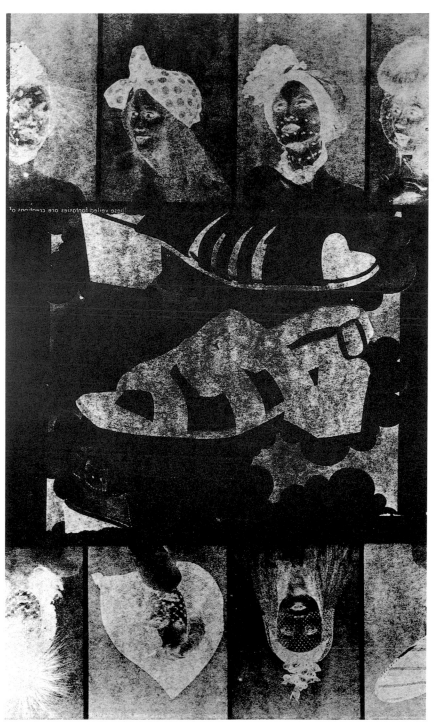

Chiropodist's Dream, 1971

Firing Fogger, 1972

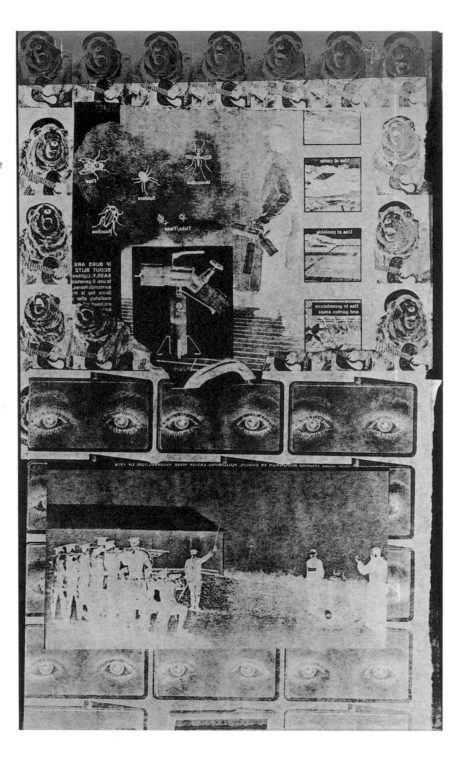

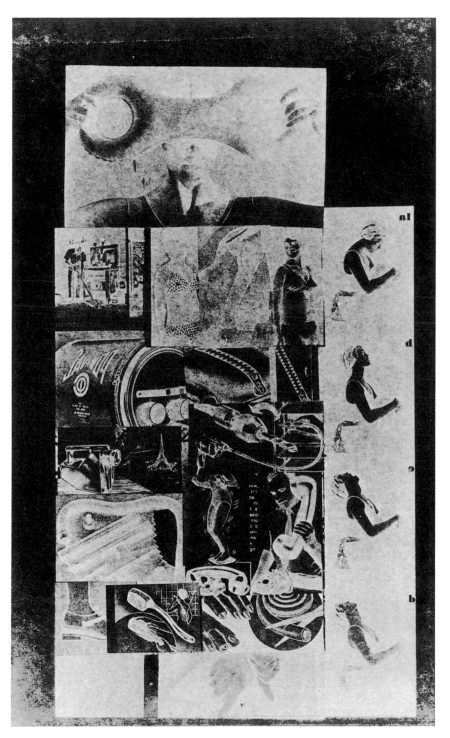

From the series Product News—Reduction, 1971

In 1971 Barrow undertook a specific series that, perhaps more than any single group, articulated his ongoing interests. "Product News" seems no more distinguished than the other Verifax groups, but the title provides a significant clue. Barrow is obsessed with the diverse products and objects of our times, from art deco items, books, cars, and machines, to clothing, household gadgets, and on and on. This free-flowing content is not unlike John Cage's *Theory of Inclusion* wherein all "sounds" were acceptable. For Barrow, all objects are valid subject matter worthy of scrutiny no matter how ordinary, banal, unattractive, or lacking in formal qualities.

The title of the group, "Product News," narrows the focus for these images, further linking them with the original media image whose function was to advertise news of the product. Barrow invents his own form of product inventory and advertisement, using the photocopy medium to spotlight curious inventions and products. By using advertising imagery Barrow not only accumulates the latest output of society but uses images that have their own preexisting signs and messages.

The objects that Barrow selects have a validity and aggregate importance far beyond their own existence. The collage-style works accomplish more than the roving photographic eye out on the street; they provide clues about our society, for they scrutinize random cultural artifacts of twentieth-century civilization, trivial as they may be, examining them as if they were as significant as monuments and great architecture. The Verifax prints were the first clearly to represent Barrow's concern with a wholesale cataloguing of the materialist impulse of our culture. Barrow does not view this material interest perjoratively, though, but rather with the reserved detachment of an anthropologist or archeologist examining the functional artifacts of a culture. The prints reflect his fascination with the agglomeration of minutiae.

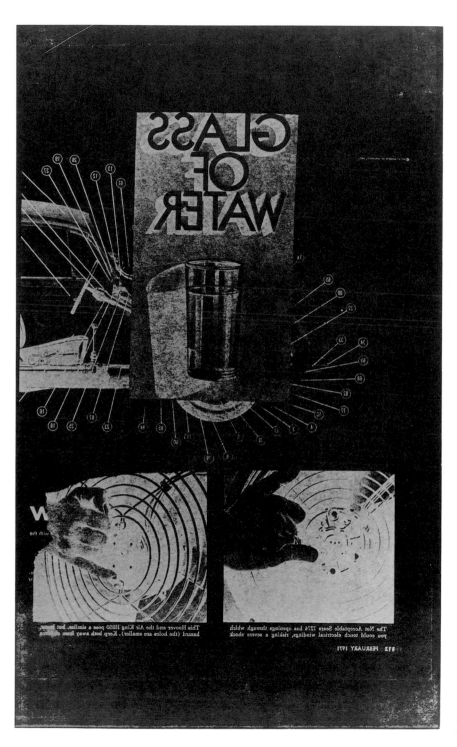

The Verifax prints, as noted, are most often the negative matrices, not the positive prints. The negative image has held an interest for Barrow as a permutation of the positive and also for its ability to abstract. *Fan*, 1971, from the Product News series, for example, includes several negative images in the composition. The original was excerpted from a publication, certified by the date, February 1971, at the bottom. The two bottom frames illustrate consumer analysis on different types of fans, thus providing the title. The larger illustration at the top, of a new Volkswagen, is partially obscured by a cut-out illustration bearing the legend "Glass Of Water" in reverse.[6]

From the series Product News—
Fan, 1971

*From the series Product News—
Lunch Lunokhod, 1971*

Certain items are recurrent in the series, including the esoteric Lunokhod, a strange multiwheeled Soviet space vehicle. Appearing in at least three works, this peculiar machine takes on the role of an ungainly, grotesquely designed lunar auto, utterly unlike anything that Norman Bel Geddes or Raymond Lowey would have conceived for the future. Barrow includes the schematic drawing as well, further amplifying the photographic image. The random association between pictures, as in *Lunch Lunokhod*, 1971, is explored, as a column of negative images is set out together. The irregular murky background tones contribute to the esoteric appearance of the bizarre items of Barrow's scrutiny.

The products that Barrow has selected are, for the most part, quite ordinary, though they often take on a unique appearance as negative prints. They are the "group icons," items emblematic of mass production propagated through mass-media advertisements. Barrow uses ads to parody the objects, and his concern is just as much with the reproduction and its role as with the objects. Unlike Jasper Johns, Roy Lichtenstein, Robert Morris, or Claes Oldenburg, however, Barrow never

aggrandizes or deifies the ordinary object; rather he provides the refuse pile for us to scavenge through, just as he has. Instead of removing the object from its context, Barrow leaves it situated, as in daily life, in the midst of other multiples.

Barrow began to consider assembling the Verifax images together as a book because of his interest in books and issues of seriality and scale. In 1973 he received a modest $1,500 grant from the National Endowment for the Arts for the Verifax book project he had proposed.[7] Barrow used the funds to acquire a Verifax machine and supplies. *Trivia* and *Trivia 2* were each produced in an edition of ten, yet each book was actually unique, for Barrow did not make identical prints of each image. The Verifax prints clearly required a presentation different from the portfolio with its aesthetic scaled-down prints, encased in mats and held in a handsome case. Their emphasis on information made them appropriate for the book format in which the work became a denser, richer montage as one flipped through the pages. Barrow sequenced each book so that data commingle from one sheet to the next. Concatenation is especially significant in the Verifax

prints for it describes not only the linking or visual progress of the parts in the sequence of sheets but also the content itself, diverse as it is. Thus the primacy of the single photographic image is obliterated in these works, for variation, multiplicity, and repetition become the dominant elements. The prints are occasionally visually unsatisfying because of their murkiness, yet they are captivating in their attention to forgotten minutiae, news, and obscure objects. The physical aspect of the book format was of interest to Barrow as well. Unlike the rarefied presentation of prints on a wall, the sheets in the books have an immediacy that is suited to the recalcitrant nature of the content. Moreover, the format encourages comparative reading, as discrete objects on the wall do not. Because of the complexity of the images and the volume of textual information, the works are perhaps more correctly read than viewed.

The prints are of uniform size, $8^{1}/_{2} \times 14$ inches, mostly vertically oriented. The two volumes share a close correspondence. *Trivia* was bound conventionally in buckram. Barrow's interest in commonplace industrial materials, however, led him

to bind *Trivia 2* between pieces of yellow vinyl carpet protectors, the kind of sheeting used in commercial spaces with high foot traffic. The cover was bolted together with screws so the book could be unbound for exhibition and then easily reassembled. This arrangement was functional, if not wholly appropriate for the work. The ready transformation of the object from one state to another—from the intimate to the public—appealed to Barrow.

The expectation that photocopies are, by definition, multiples, and that multiples are all the same, is one of the issues that Barrow addressed. The slow pace of the machine enabled him to make alterations on the glass, varying and reordering his subject matter so that each copy was not the same, despite the intrinsic nature of the duplicating process.

From the series Trivia—
Political Trinkets, 1973

In *Political Trinkets*, 1973, from *Trivia*, the face with glasses, though wholly recognizable, has a ghostly, futuristic appearance. The text above is not especially informative, a mere excerpt on Yugoslavia. The schematic diagram for an electron gun–equipped microscope contributes to the technological appearance. True to form is the column of small drawings: underwear, baskets of tomatoes and seedlings, toy birds, and jewelry— silly "trinkets" found in catalogues. This work illustrates Barrow's simultaneous denial and acceptance of the cultural flotsam for what it says about our society.

Barrow explores his interest in typography in many of these works. For example, in *Untitled*, from *Trivia 2*, 1973, the text contributes to the complexity of the montage. The map in the background seemingly locates the image of the power plant, while the numbers and lines are linked to the lists above and below, elements that are not as they seem by the random association. A map of the southeastern United States is overlaid by a financial chart showing high and low prices, earnings, Standard and Poor ratings, and so on. The montage in front is from a newspaper photograph of a power plant in Oregon. The abstraction of detail and the lack of clarity help recombine these separate layers as one. Here Barrow discloses the potential of the reproduction to corrupt the original.

In 1975, after a year's hiatus, Barrow returned to the Verifax machine and produced a short series, the Enigma Cipher Machine. These twelve prints again focus on products, technical gadgets, and text, all taken from existing printed material. In this group, Barrow includes a constant motif, the Enigma cipher machine, a remarkable cryptographic device used by the Germans in World War II, pairing it with his usual range of peculiar and far-ranging excerpts. The Enigma Cipher Machine prints are more ordered than the others, for each composition is formed around the same recurrent picture of the machine, each concerned with a specific theme.

The series illustrates Barrow's fascination with machinery and invention, but it also reveals a humorous attention to the oxymoronic. Pedestrian and insignificant bits of advertising are combined with the esoteric machine. The theme is public address versus private correspondence. Barrow also uses the Enigma machine as a symbolic reference to language and photographs as coded messages that require deciphering. He considers the connotative and denotative power of language systems, both written and visual. The device itself is a cipher, for unless the image or title can be translated to reveal its true purpose, the text and the reproduction are empty. In order to appreciate the cryptographic invention, one must first know its function. Similarly, the prints evoke questions of photographic meaning and the way information is translated from its original context to another. In these works, the original object has been coded (the advertisement) and recoded (the reproduction) and finally recontextualized (the Verifax print) to be deciphered by us, gathering momentum at every stage. Though not perceived at once as documentary photography, the Verifax prints nevertheless have a veracity as cultural documents.

From the series Trivia 2— Untitled, 1973

From the series Enigma Cipher Machine—
O/O/S, 1975

In *O/O/S*, 1975, a mechanistic face peers out at the viewer from above the machine, like something from *Metropolis*. But with closer scrutiny, one sees that the ominous cyborg is but a model demonstrating an optical device. Enhanced vision through mechanization and the decoding of indistinct information are certainly alluded to. The background "field" of flowers is a visual pun, and it neutralizes the face. This image exists in both negative and positive versions, illustrating the change in character between the two. The negative is far less humanistic, appearing more schematicized, while the positive, of course, is more comprehensible. The print is a reference to Raoul Hausmann's *Tatlin at Home*, 1920, where a machine is collaged onto the forehead of a man, and to Paolozzi, who similarly used a "mechanomorphism" in an earlier work, *Z.E.E.P.*, 1969–70 (Zero Energy Experiment Pile).

From this series, *#7, 1975,* continues the inquiry into transformation of information and interpretation of visual language, for it incorporates the well-known image of 1950s movie audiences wearing Polaroid 3-D glasses. This image is itself a cultural icon, recalling the experimental efforts of the film industry in the 1950s to keep viewers from staying home in front of their TV sets, and the use of an apparatus to allow the audience to decode the film image into 3-D. Surmounting the picture is an enigmatic image of an experimental tent, while below, Barrow includes his typical catalogue tidbits, this time an ad for furniture transformed by covers.

After the Enigma Cipher Machine Barrow suspended his use of the Verifax medium. He produced one more work, a multiple, in 1976 for the School of the Art Institute of Chicago portfolio *Crackerjacks.* In addition to being preoccupied with two other concurrent series, Barrow found that his unused Verifax materials had deteriorated, and thus the medium for him was at the edge of extinction.

From the series Enigma Cipher Machine—#7, 1975

The Series Libraries
Started 1974

The Libraries series began almost concurrently with the Cancellations, and it is telling that Barrow's contribution to a 1975 festschrift for Beaumont Newhall also addresses the book in relation to photographers, suggesting that the topic was much on his mind.[1] He has authored scores of book reviews and designed a dozen publications.[2] His home contains thousands of volumes stuffed into bookshelves on three floors, running from first editions, M.F.K. Fisher cookbooks, and mysteries to books on architecture, design, the 1930s, photography, art criticism and history, literary criticism, industrial design, graphics, and consumer information. A voracious, encyclopedic reader, Barrow has an esteem for the book both as an object and as a means for the dissemination of knowledge and information. He had produced his own artist books, *Trivia* and *Trivia 2*, and found the book an ideal vehicle for his cultural inventorying. His interest lies not only in how the volumes look in formal terms but in the broader picture cast by the accumulation of volumes to reflect contemporary culture from a literary standpoint.

In writing on his work, Barrow found a statement by John Ashbery on the author Raymond Roussel to be an apt description of his own output. It is particularly relevant to the Libraries series:

> Each [work] is a gigantic dose of minutiae: to describe one is like trying to summarize the Manhattan telephone book. Moreover, the force . . . is felt only gradually; it proceeds from the accumulated weight of this mad wealth of particulars. A page or even a chapter . . . fascinating as it may be, gives no idea of the final effect which is a question of density; the whole is more than the sum of its parts.[3]

Like a number of Barrow's photographs, the Libraries are homages—to language, knowledge, intellectual discourse and inquiry, to conceptual works as opposed to visual ones.

Although they are textual in orientation, it would be incorrect to consider these works as conceptual art. Such definition would misinterpret him, Dana Asbury also noted, as his photographs have little philosophic relation to contemporary idea-oriented photography. "However conceptual the work of Barrow is, it is also emphatically pictorial. The idea is paramount, but so is the finished print."[4] Conceptual art stresses the primacy of idea, with disdain for the final object (hence many works existing only through the ancillary documentation referring to the concept).[5] This emphatic rejection of art qua object contradicts Barrow's concern for visual appearance.

These are deceptively simple compositions that function in several ways and are the most serial of Barrow's groups, deriving depth and complexity from each other. Although each work may be read discretely, when considered comparatively the images take on a richer meaning. The concatenation of the objects and prints in the series formally looks back to the Institute of Design style: seriality, repetition, patterns, multiplicity of parts.

Barrow offers certain information in these pictures, but they carry far more content than that which is visually described. He mingles the denotative with the connotative. The books denote language and knowledge in a generalized manner through the visual representation. Yet the specific content of the volumes can be connoted only through the titles. By representing the object and title, as opposed to a list of titles alone, Barrow is making clear reference to the content. The title is a synecdoche for the whole book, seen and unseen. These simple images thus contain a wealth of explicit and implied information. The series started with photographs of the libraries belonging to close friends and

colleagues, but as he progressed Barrow became intrigued by the endless permutations and possibilities evident in different collections with their similar, but unique structure, appearances, and importance. Thus, while the subject of books is consistent in all of the photographs, the physical manifestation and character of the collections are never the same, changing from one locale to another.

The Libraries are the most reportorial and formal of all Barrow's photographic groups. These straightforward silver prints are neither toned nor manipulated in any manner. He adopted a standardized format in this series, utilizing a fairly consistent distance from his subject, always facing it head on. In many ways the uninflected neutral photographs allow the subject to assume a paramount role. Although the individual pictures look similar at first glance, they reveal a rich variety and subtlety of information when examined more carefully.

These photographs are essentially about language. Many of them set up an interaction between language systems, one visual and one verbal. One provides a physical representation of an object, describing its formal, physical properties, the other gives definition to the object. There is a shifting rivalry between the two. While the written text is but a detail of the larger visual picture, it nonetheless competes against it, drawing attention away from the actual visual representation to the unseen connotation of the content. The interaction changes with every volume, depending upon what the viewer brings to the image. The titles function like brief photo captions, directing the interpretation. Thus, to fully decode the visual image one must decode the verbal language. In the case of books whose titles cannot be read, being obscured or indistinct, or too small, we still ascribe a certain calibre to those unidentified volumes, based on those around them.

It may be inevitable that the Libraries are interpreted as portraits of the owners, although this is not Barrow's principal intention with them. Hardly definitive portrayals, the photographs of book collections nonetheless do provide salient clues about the owners. Barrow is by no means the first to document collections of books, and he makes frequent reference to his historical antecedents. The correspondence with Fox Talbot's *A Scene in a Library* from *The Pencil of Nature* is not at all coincidental, and Barrow fully expects this allusion to be recognized by those conversant with photographic history.

Like other series, the Libraries are characterized by dense montaging of information, fascination with cultural products, and the accumulation of disparate data, although here there are no overlapping layers. Vernacular material is not a source for this series, though; rather it is concerned with a cataloguing of more sophisticated and less visual data.

Having designed books from time to time, Barrow is obviously interested in the differing appearances of the publications and finds in each library an array of approaches to typography, scale, and design. Barrow was also curious about the diverse physical appearance of the various libraries. Despite the general similarities of the books, their arrangement and organization always was different. Some collections were carefully placed in closed cases, on finely crafted bookcases, while others were casually stacked in a jumble on makeshift shelving. One wonders about how the books are stored and what that reveals about the owner, and how the books are viewed as possessions, as decoration, as a resource.

Most personal book collections, rarely catalogued and numbered, are often shelved randomly; at best an alphabetical system is employed, or classification by

From the series Libraries—
V.S., N.Y.C., 1976

subject or size. Book collections always vary in organization. Despite the static quality of the subject, the collections are not inert, their arrangement not fixed. The possibility of transformation intrigued Barrow. Books are often not replaced in the exact location they were taken from, and as new volumes are purchased, the libraries change in appearance. Thus, Barrow's photographs illustrate their arrangement only at a particular time.

In *V.S., N.Y.C.*, 1976, the changeability of collections and the chance interaction between casually placed objects is illustrated. A Kleenex box, for example, resides atop the Petit Larousse, stowed there temporarily, indicative of the way that many people shelve books too.

From the series Libraries—
Albuquerque, N.M. (TFB & Friend),
1978

In focusing on the content of each picture and the variations in the series, it is easy to overlook the sheer beauty of the prints. *TFB, Albuquerque,* 1978, uses the luminosity of the flash to emphasize the lustrous silvery quality of the plastic drape concealing the books and their titles. This work recalls Barrow's interest in camouflage and his taste for a dense montaging of information.

103

From the series Libraries—
E.B., Riverside, Ca., 1976

From the series Libraries—
J. Deal, Riverside, Ca., 1977

The nature and character of book collections change with every owner, providing a visual transformation of the rows of books. *Dr. J.S., Santa Paula, Ca., 1976*, presents a view of a tidy, well-organized library of classics contained in a handsome bookscase. The beautifully bound multivolume sets and the globe are the most prominent items, giving the collection a distinguished, but bourgeois tone. This library seems to have been acquired through subscription, with a concern for the correct statement that the objects would make in adding to the tasteful furnishings.

Contrarily, in *E.B., Riverside, Ca., 1976*, the dog-eared jackets and dated graphic design identify these volumes as old cherished books of importance not for their appearance or reputation, but for the significance of the content. The simple shelving of cement blocks and boards further suggests that we see only a portion of the collection of a bibliophile who has neither the inclination nor the funds to elevate the display of his books.

From the series Libraries—
Dr. J.S., Santa Paula, Ca., 1976

From the series Libraries—
R.W.F., Culver City, Ca., 1977

From the series Libraries—
L. Baltz, 1977

A methodical fastidiousness is
evident in the image *L. Baltz*, 1977,
with the precise order and formal
presentation of the library. Contained
in a glass-doored cabinet, the objects
and impressive stereo equipment are
presented more preciously, as items
very carefully preserved for the
future.

From the series Libraries—
Gun Club Road/South Wall Variant, 1978

From the series Libraries—
N.C. Jr., 1975

A provocative cross-fertilization and the relationship of the visual arts to other cultural realms are seen in *N.C. Jr.*, 1975, where a wide range of disparate topics interact. The pictorial potential of a row of uniform book spines is demonstrated in *UCR Special Collections*, 1976, depicting an enchanting series of antique adventure stories for boys. Although a physically uniform group, the various quaint drawings on the spines and the typography give it vitality. This specialized class of literature reflects a bygone sensibility, style of prose, and cultural attitude.

An important influence on this series was R. B. Kitaj's portfolio *In Our Time*, a group of fifty screen prints of book covers. This set of prints raised similar questions about the visual representation of literature, although in a different format. Presenting the book as an object, Kitaj used large colored images—the book covers—to emphasize

books' varying appearances. Both Kitaj and Barrow consider what can be conveyed by one image and what can be achieved by the aggregate, serial representation of literature. Barrow, however, focuses more on books as collections and their interaction, cumulative effect, and mutability.

From the series Libraries—
Virgil Mirano, 1976

Although many of the libraries have considerable textual information and content, some are more oriented toward formal concerns, such as *Virgil Mirano*, 1976. Numerous books can be identified among the shelves, but for the most part, the material is unrecognizable. Considering the clarity of the others in the series, this collection has an unusual reticence, an anonymity, that hides the identity of the volumes but gives the collection a special character.

Barrow completed the series in 1978, closing with photographs of a massive collection he titles with the address of its owner. The Gun Club Road set is shot with more distance, befitting the staggering size of the library. These images, such as *Gun Club Road, South Wall*, 1978, perhaps best illustrate Barrow's concept of the significance of literature in intellectual life, the tremendous range of material available, and the dynamics that these

static objects create with their hidden contents as one shifts from Martin Luther, to Augustine, to phenomenology, to the *Other Victorians, Semantics, Principles of Art History*, Freud, Frye's *Stubborn Structure*, Herbert Read, *Hegel to Nietzsche, A Manual on Bookselling*, and *Art Against Ideology*.

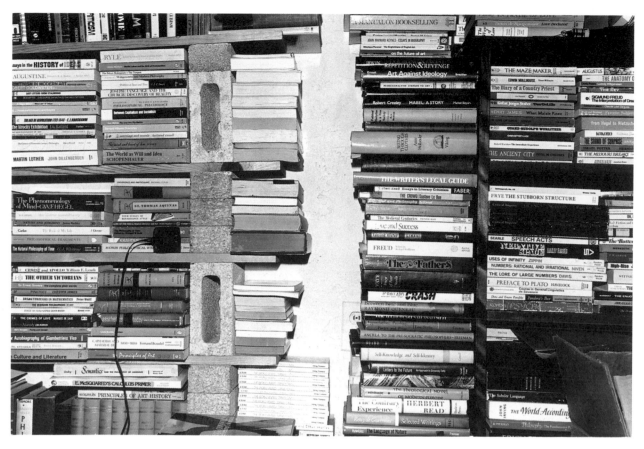

From the series Libraries—
Gun Club Road/South Wall, 1978

The majority of the Libraries prints were made during 1976 and 1977. The series is Barrow's homage to the book in general, and to specific volumes that have influenced, described, and defined our culture. In this group he acknowledges books as the keepers of culture and as multiples in the age of information with visual as well as intellectual impact.

The Series Cancellations
Started 1974

In December 1972 Barrow left his position as assistant director at the George Eastman House to join Van Deren Coke at the University Art Museum in Albuquerque as associate director. Barrow had worked with Coke during his short tenure as director of the Eastman House during 1971 and 1972, and after seven and a half years there was ready for a change and an opportunity to broaden his orientation to other areas of art beyond photography. In the process of establishing a photography program, Coke also brought Beaumont Newhall and Betty Hahn to the faculty of the University of New Mexico, which included Rod Lazorik, Anne Noggle, and himself.[1]

In 1974, a little more than a year after moving to Albuquerque, Barrow began a group of photographs he called the Cancellations series. Perhaps his most widely known photographs, the Cancellations at once seemed to capture the two incompatible, indeed antithetical, trends in photography during the mid-1970s. A literal, documentary approach that focused on the American landscape was joined with an iconoclastic, manipulative aesthetic that was rapidly gaining ground particularly among photographers in the West. The former approach drew upon the classic tradition of American photography, while the latter drew from contemporary art sources and sought to utilize photography in a more exploratory, radical fashion, often with very little regard for the reportorial uses of the medium.

With their patent corruption of the straight photograph the Cancellations investigate the issue of the original and the reproduction. Because of the accuracy and verisimilitude of the photographic image, it is frequently equated with the subject. By altering the print Barrow distinguishes it as a reproduction, calling into question the distinction between the thing and an image of it, between reality and illusion. Here Barrow reminds us that we are looking at a facsimile of reality.

Barrow's change of venue from the Northeast to the Southwest naturally occasioned a shift in work. The Cancellations reflect a particular attention to his new locale. In their emphatic focus on the Southwest there is also a concomitant severing of the approach and scenery he had previously used in the Northeast.

The Cancellations share certain affinities with the Pink Stuff and Pink Dualities. Both are series of oddly toned silver prints with landscape as subject. They are more photographically oriented than the other series, using the medium for literal description, the radical toning or markings notwithstanding. The two series share certain similar visual issues not present in the other series. The pink and brown prints are the least visually abstruse and the least allied to mass culture and language. But far more than the Pink Dualities and Pink Stuff, the Cancellations are based on a direct response to the landscape itself.

The brown toning is clearly a reference to the aridity and tonality of the New Mexico terrain. Moreover, the images have an emptiness and detachment that is also consonant with the vast expanse of land. The views Barrow selected are of mundane, open terrain. As seen in *Albuquerque Platform* and *Average View*, Barrow selects wry, trivial views of the land. He often photographs empty, overlooked lots rather than examples of the sublime, majestic West. Far from being picturesque, these images of the contemporary cultural landscape are a comment on urban development. Insignificant buildings or structures, architecture in various guises, frequently are the subject. The vacant deadpan appearance of these scenes has prompted erroneous criticism that these images are not carefully contemplated. Yet they are selected by

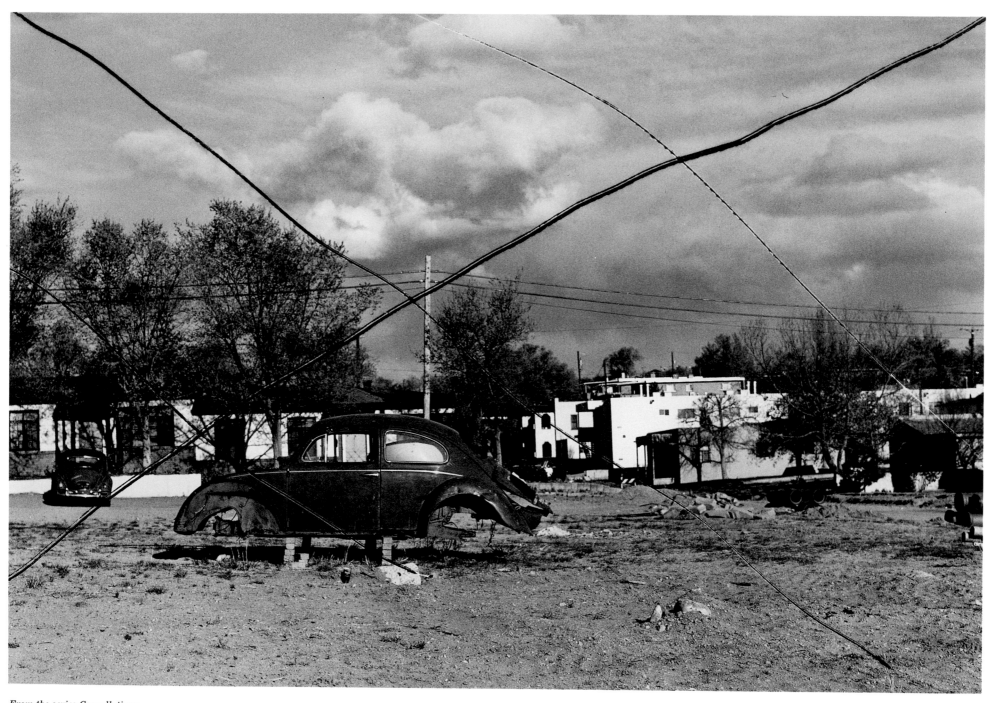

From the series Cancellations—
Albuquerque Platform, 1974

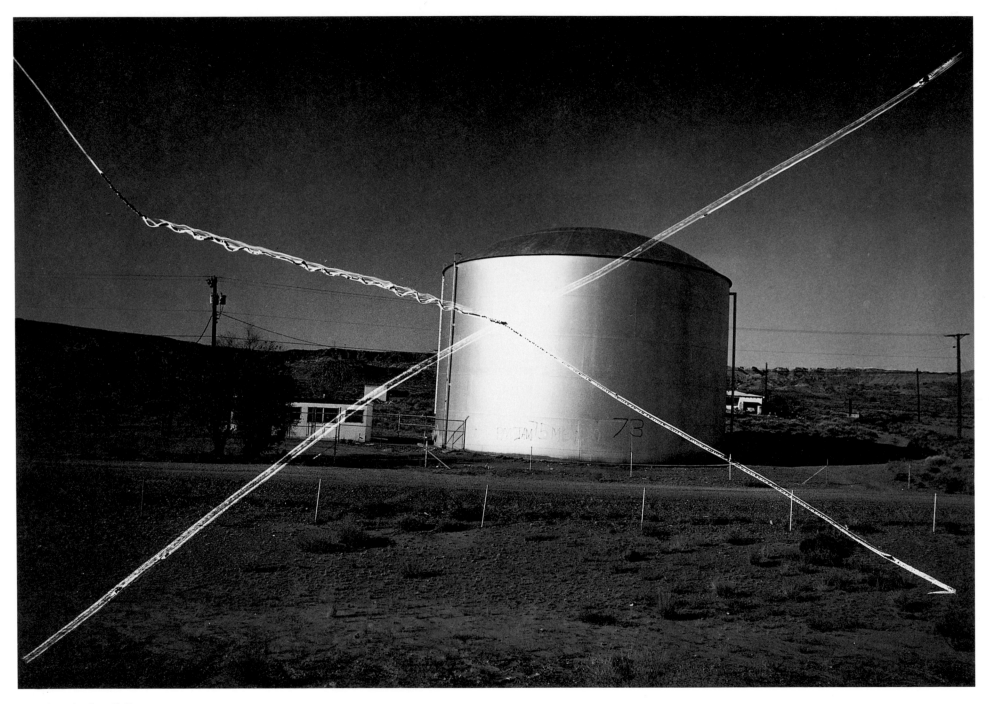

*From the series Cancellations—
Tank, 1975*

From the series Cancellations—
Sash, 1978

Barrow precisely for their representative atmosphere and details. He acknowledges that they are very much about the character of the Southwest region, limiting the views to New Mexico, Arizona, and California.[2]

In early works from the series, "brown" was noted parenthetically in the titling on the prints. This seemingly superfluous information, however, differentiated them from the few Cancellations that had been toned pink. After these few prints, Barrow switched to brown toning, choosing not to duplicate the color of the previous series and other prints made during the early 1970s. He felt that the new concept, format, and location required a new appearance. Barrow also briefly experimented with green toning, using vegetable dye, but found it at odds with his intentions and subject. The Cancellations exist in small numbers, some just one or two, but no more than five each. Only a few exist in more than one size.[3]

These warm, brown-toned prints make obvious reference to nineteenth-century albumen prints and the renewed interest in the survey photographs of the 1860s and 1870s. The neutral brown-toned topographic images by William Henry Jackson, William Bell, A. J. Russell, and others brought the spare, unencumbered aesthetic of the nineteenth century into the contemporary photographic vocabulary. Despite their similar tonality, Barrow's images, though, are not in the least antique or romantic. They do sometimes share with those early views certain impersonal, vapid views or a scrutiny of odd minutiae. As modern-day records, the Cancellations have the same intellectual and emotional detachment and lack of apparent style as the survey photographs. They also share a circumspection and reserve with a contemporaneous photographic aesthetic, the New Topographics, that was characterized by the same neutrality.

As exemplars of the manipulated image, the Cancellations seem to contradict the intrinsically photographic works identified as New Topographics. Yet, beyond the obstruction that Barrow manually places in his frame, his uninflected views have a decided affinity with the photographs by Joe Deal, Robert Adams, and Lewis Baltz. Like Barrow, these artists chronicle the altered landscape in a reserved, almost authorless manner. William Jenkins's description of their photographs also aptly describes the Cancellations before marking. "The pictures were stripped of any artistic frills and reduced to an essentially topographic state, conveying substantial amounts of visual information but eschewing entirely the aspects of beauty, emotion and opinion. Regardless of the subject matter the appearance of neutrality was strictly maintained."[4]

But, given Barrow's experimental bent, he would not be satisfied with straightforward record-making. And given his predilection for dense, multilayered, interactive works, it is not surprising to find him again testing the medium to see what it will bear and exploring the uneasy balance between the straight mechanically produced image and the interventive hand of man.

The interaction of the mark and the image heightens the visual orientation of the work. The aggravation of the neutral object by the volatile gesture, as Henri Barendse noted, results in a "torque" that makes the pictures "anxious objects."[5] These works are concerned with visual language and the transformation of information. Throughout the series Barrow poses the issue of illusion and reality. By using separate spatial planes he toys with the two-dimensionality of the photograph and our readings of three-dimensional space. Thus he renders the image as though it were shot through a cracked picture window. Or,

From the series Cancellations—
Sun Sign, 1974

From the series Cancellations—
SLAB (Pasadena), 1974

as William Jenkins noted, the slashes "like Brecht's insistent proscenium arch are constant reminders that we are not looking at reality but at a *photograph*."[6]

Like his other works, the Cancellations are multilayered. The X, a simple visual device, raises numerous issues. Marking and defacing of the negative, usually considered sacrosanct, continues Barrow's criticism of the fine print aesthetic. Although the images are carefully considered and precise, the marking is not. Barrow is aware of the approximate detail in the negative, but his marking is unrehearsed, invoking the laws of chance as the stylus moves over the surface. The X mark is not the only form of defacement Barrow utilized. He punched circular holes out of the negatives for a short while early in the series but soon dismissed them as too regularized and formal and lacking the spontaneity and dynamism of the rough diagonal lines.[7] Barrow also made several Cancellations using broader surface abrasions, which resembled a comb dragged over the negative surface.[8] In some prints extra cross marks have been added to the larger X mark, as in *Albuquerque Platform*, 1974, or *Dart*, 1974. Barrow often used an ice pick to tear away at the emulsion, sometimes going back over the first marks again. Some of the cancellation marks are made on the emulsion side, some on the reverse side. Some of the X's are just pressure marks; others are actual tears in the emulsion. The irregular gouging at times appears like a zipper across the surface. Rarely is there a clean sweeping line; most often it is an agitated, meandering wire diagonally cutting through the picture frame.

Apart from the formal and visual issues, the cancellation mark itself implicitly carries an art heritage and a wealth of diverse meanings. Clearest, of course, is the reference to the printmaker's cancellation of the plate after an edition is completed, a guarantee that no other prints could be made. Traditionally, a print is pulled after the plate or stone is cancelled, serving as a record of the plate's destruction. The marked print is essentially worthless and is never confused with the unmarked original.

Barrow parodies this tradition by producing images that appear to be illegitimate. These marked negatives draw attention to the fact that photographers do not cancel their negatives, and are quite free to reprint at any time. Furthermore, Barrow comments on the burgeoning photography marketplace of the mid-1970s, where there was scant appreciation for the distinction between prints made contemporaneously with the negative and those made later, wherein prints of all vintages are equally legitimate. Photographers can continue printing old negatives, on order or whim, without limitations, offering prints in various sizes to suit the pocketbooks of consumers. Thus the emphasis is simply on the image, not on the object.

Barrow's X marks are also an important means for him to inject into the photograph the expressive hand of the artist. Although not painterly, they invigorate the images much as the broad gestural sweeps of paint did for the canvases of the Abstract Expressionists. They infuse emotion, spontaneity, and chance into the placid views. The marks were a direct response to his dissatisfaction with the lack of physicality of the medium. Furthermore, by altering the photographic negative, Barrow not only expands the execution time, but also shifts the decisive moment away from the moment the shutter falls to the artist's studio or darkroom. The Cancellations offer him a chance to make an image rather than take it.

The incorporation of mark/making or drawing by photographers has its origin almost at the inception of the medium. From the 1850s on, cliché-verre prints by Corot

and others indicate the potential of loose gestural marks on a photographic negative. The intent of nineteenth-century artists, and even that of Frank Eugene in the early twentieth century, was different: they wanted to make their photographs look like prints. Aware as he was of this method, Barrow resembles them in his straddling photography and printmaking. His intent is radical, not retrogressive, making his reference to photographic history wry and oblique.

The X mark itself in art works has some antecedents. Rodchenko, for example, utilized the X-marked photograph, neatly cancelled from corner to corner in 1923 for the cover of the second issue of *Lef*. The X mark is also a prominent element of Richard Hamilton's 1965 painting *My Marilyn*, standing as a clear negative comment on the content.

The alteration of Barrow's negative in such a blatant and undisguised manner unquestionably stamps the image with a personalized mark. Thus, the marking defines a stylistic approach to an otherwise commonplace image and functions like a signature, a simile further supported by the validity of an X as an authentic, albeit illiterate, signature. The obvious marking, the attempted destruction of the negative carries a veiled humorous allusion to the historical tension between craft and machine. The mechanically derived landscapes are highly rational and formal, rendered with a dispassionate approach that contrasts with the slash marks. The primitive defacing introduces an element of intellectual discord aimed against the refined mechanistic photographic image. The marks are akin to graffiti and suggest a repudiation, a tweaking of the subject that recalls Marcel Duchamp's alteration of the Mona Lisa.

The interaction between the mark and the mechanical image was also explored repeatedly by Rauschenberg in many of his prints, although they're there on more painterly ground. Painter Malcom Morley as well worked with the cancellation mark in contemporaneous work.

The defacing cancellation lines in *San Clemente Bluff*, 1975, actually have a grotesque resonance with the subject of the picture. In this peculiar view, Barrow sardonically depicts the California demand for ocean-view housing and the renowned nonchalance about impending natural disaster. Here, a building under construction sits at the edge of a precipice, adjacent to a dwelling that has already lost part of its backyard. The five columns bolstering up a patio or pool point to the devastating erosion and land slippage all about them. In this view of present-day American culture, Barrow clearly remarks on the peculiar pitting of nature against civilization.

From the series Cancellations—
San Clemente Bluff, 1975

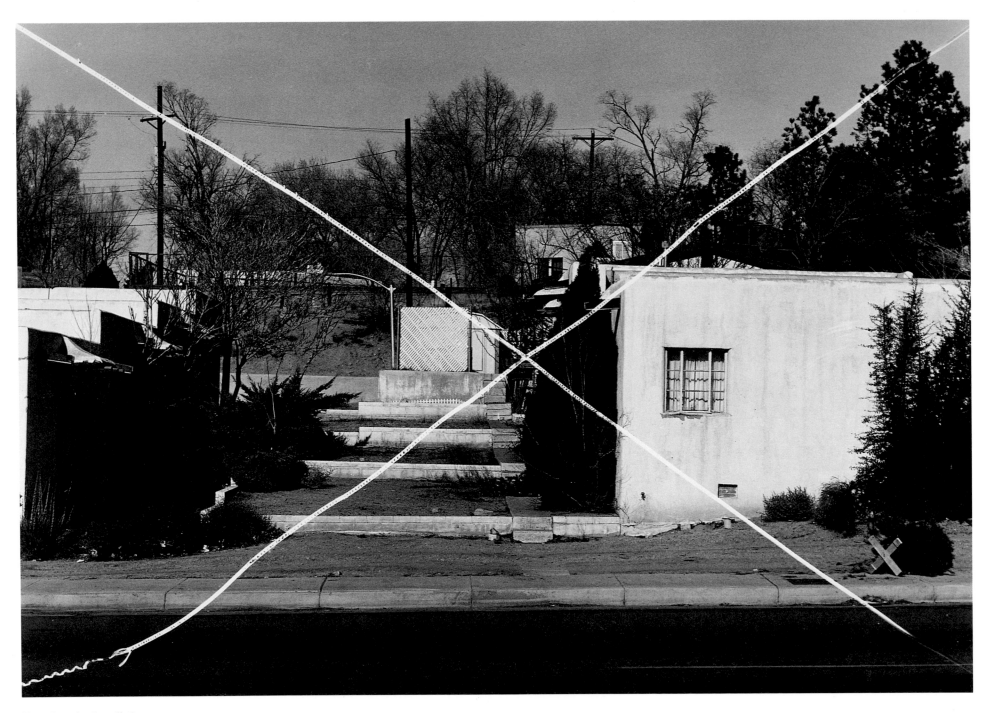

From the series Cancellations—
Terrace, 1978

Architecture is one of the major focal points in the series, especially vernacular commercial structures or anonymous water tanks, facades, and industrial buildings. Frequently presenting them with a frontal and symmetrical view, Barrow both comments on the form, style, and the evolution of the architecture and examines the relationship of the mark to the picture plane and the structure of the building.

Terrace, 1978, depicts a humble 1930s-style apartment complex in Albuquerque, which contradicts the title laden with implications of luxury, gentility, and well-manicured hedges. Barrow selects the subject and then cancels the image with his emphatic X mark.

The odd corrugated form in *Horizon Rib*, 1974, indicates the confluence of Barrow's humorous architectural cataloguing with visual puzzles. But it is also a reference to noted antecedents such as Lewis Baltz's *West Wall Unoccupied Industrial Structure*, c. 1974, and a much earlier, often-reproduced photograph by Walker Evans, *Corrugated Tin Facade*, 1936. But Barrow displaces the static, symmetrical equilibrium in those photographs, for his building is crazily askew. Additionally, the vibrations of the black-and-white cancellation marks mimic the siding.

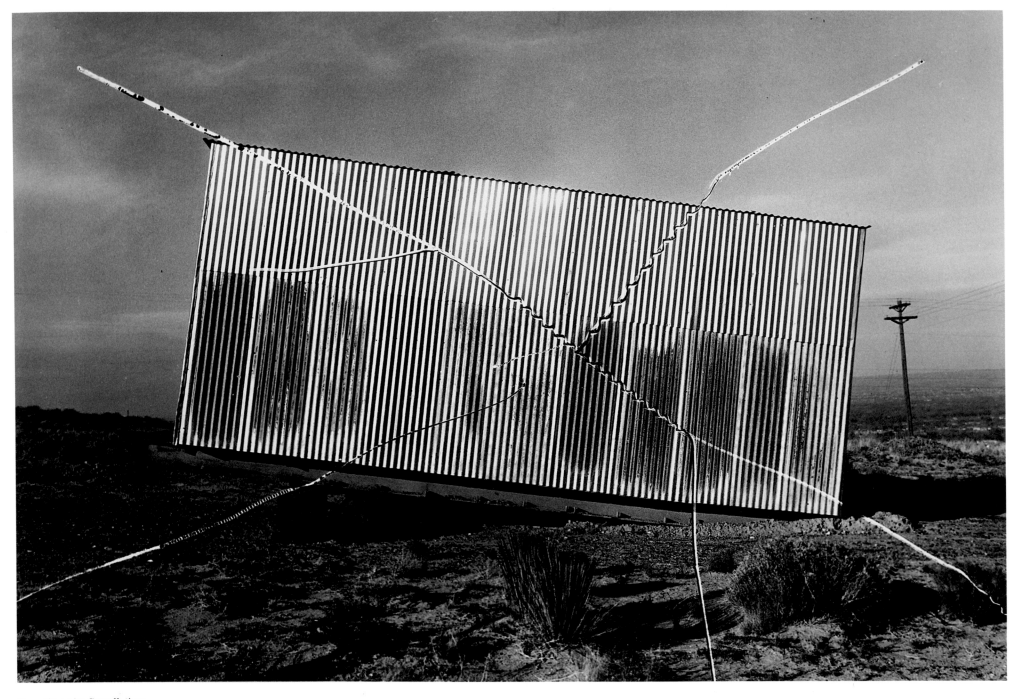

From the series Cancellations
Horizon Rib, 1976

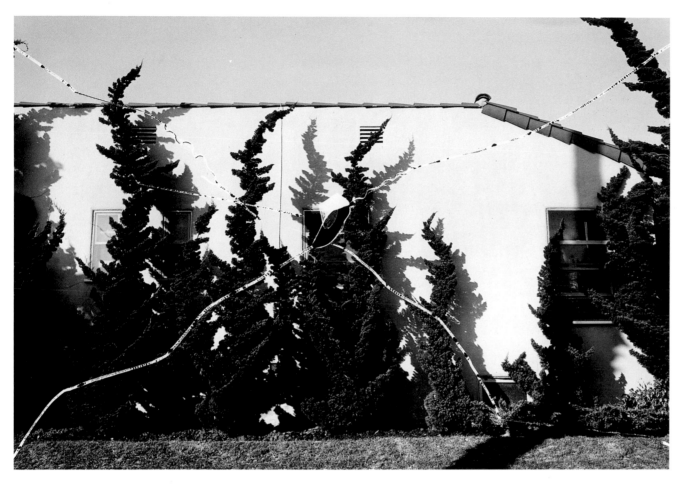

From the series Cancellations—
Plate Variant, 1975

The innocuous view over a roof in *Homage to E.W.*, 1978, slyly uses the lenticular compression of field to join the immediate foreground with the midground so that complexities are camouflaged within a seemingly simple composition.

Although the Cancellations are usually medium-to-long-shot views, there are occasional variations.

Formal abstraction predominates in *Plate Variant*, 1975, an image focusing on construction materials and flattened planes in the foreground showing shadowy wall textures. Barrow has stuck a piece of transparent tape to the negative, which further disrupts the clarity of the view. His interest here though is not with the abstracted planes, but

with the material elements of the structure. The construction notations work with the white cancellation marks, calling attention to the scribbling. Unlike most of the images, this one of a building in progress is not as descriptive as it is perceptually disorienting.

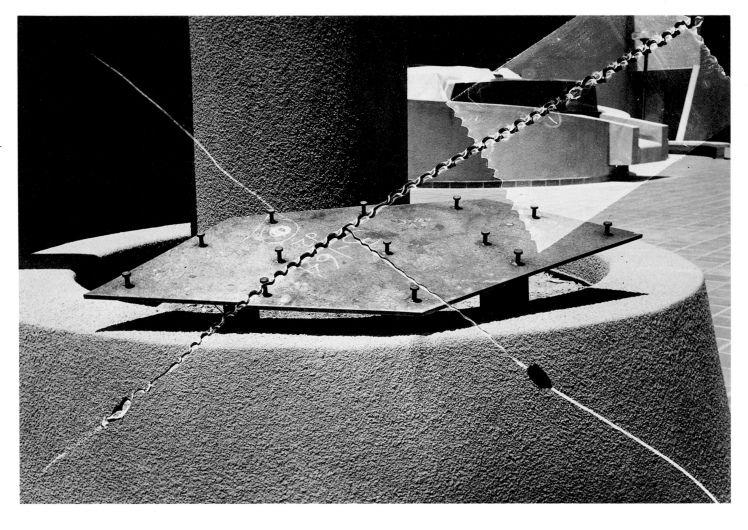

From the series Cancellations—
Santa Monica House, 1974

The inaccuracies and trompe l'oeil of the medium are examined further in *Untitled*, 1976, which seems at first merely an empty Southwest landscape.[9] The diagonal cancellation lines, however, establish a visual tension between the flat, receding terrain and their emphasis on the picture plane. In spite of this tension, though, the two are read together. Moreover, the image is punctured in the lower right, making the entire view seem to be a reproduction rather than an actual landscape, as if Barrow had photographed a billboard or picture with a hole in it. With this work he distinguishes between the reproduction and the thing before the lens, as he does in *Santa Monica House*, 1974. In this photograph the negative has been so brutalized that it seems as if a hole had been punched into the building, thus questioning its three-dimensionality.

From the series Cancellations—
Dart, 1974

From the series Cancellations—
FLW Dusk, 1978

From the series Cancellations—
Homage to M.W., 1977–78

Homage to Paula, 1974, is one of the few interior views in this series. The dramatic raking bands of diagonal light and shadow on the wall make this one of the most graphic images. It is primarily a bold abstract composition, with content subordinated. This photograph is a direct reference to Stieglitz's *Sunlight and Shadow, Paula, Berlin*. Propped on a shelf are three earlier photographs, two from the series Pink Stuff and an early Cancellation. All are irradiated by the Stieglitz light pattern, signifying his enduring influence on the medium. In this work, the thin white cancellation lines work in tandem with the raking pattern diagonally slanting in the other direction. The combination of the two form the X marks. This subtle use of shadows to "cancel" the subject creates a perceptual tension between the light and the markings, which contributes to the complexity of the photograph. The shadows are an integral part of the depicted scene, unlike the added white marks. They are read as being in front of the scene, fracturing it.

Typically, Barrow has used the clear, intense desert lighting. *FLW Dusk*, 1977, is one of the few night images Barrow made. A reversed, negative image of white on black is suggested here, for against the dark field, only the barest details are discernible. The unsymmetrical cancellation is at once within the landscape and before it.

The majority of Cancellations were made between 1974 and 1976, with a few more in 1977. Those that date from 1978 and after are relatively isolated prints, produced only when the subject seemed to fit in with the group. But by late in the decade Barrow was once again turning his attention in another direction.

The Lithographs
Started 1976

Barrow's interest in lithography transcends the challenge of utilizing a different medium, experimenting with the boundaries of photography, and altering the physical photographic image. Lithography provided another means of achieving a transformation of the subject. The lithographs represent an important bridge between several of the series and illustrate his experiments with process and medium, with reproduction of the photographic data. The lithographic process interested Barrow as an alternative medium. The ability of the process to permutate the original photograph is invoked in his first lithograph.

In 1976 Barrow was invited to make a lithograph at Tamarind, the well-known printmaking atelier at the University of New Mexico. In the next six years Barrow made four lithographs, each considerably different from each other and from his photographs.

The earliest, *Revisions*, 1976, illustrates his interest in language, advertisements, copy machines, consumer products, and books. The principal subject is Stonehenge, evident in four diverse examples making reference to, or using the name of the ancient monument. The title refers to several kinds of revision that are seen in the work—visual revision through printmaking as a reproduction, as well as revisions of meaning and associations, and the revision of historical and scientific knowledge.

But more significant is the notion of revision as transformation. In the four quadrants of the sheet are reproductions of four different images floating against a field of grayish blue, each implying a kind of revision. In the upper left is an advertisement for Stonehenge dinnerware by Georg Jensen; below it is a reproduction of a Verifax print with origami napkins and a souvenir of Stonehenge, another commercialization of Stonehenge. In the upper right is a photocopy of pages from an 1890s book on prehistoric stone monuments in Britain. In the lower right is a page filled, over and over, with the word *stonehenge* crossed out with a large X mark. Since the nineteenth

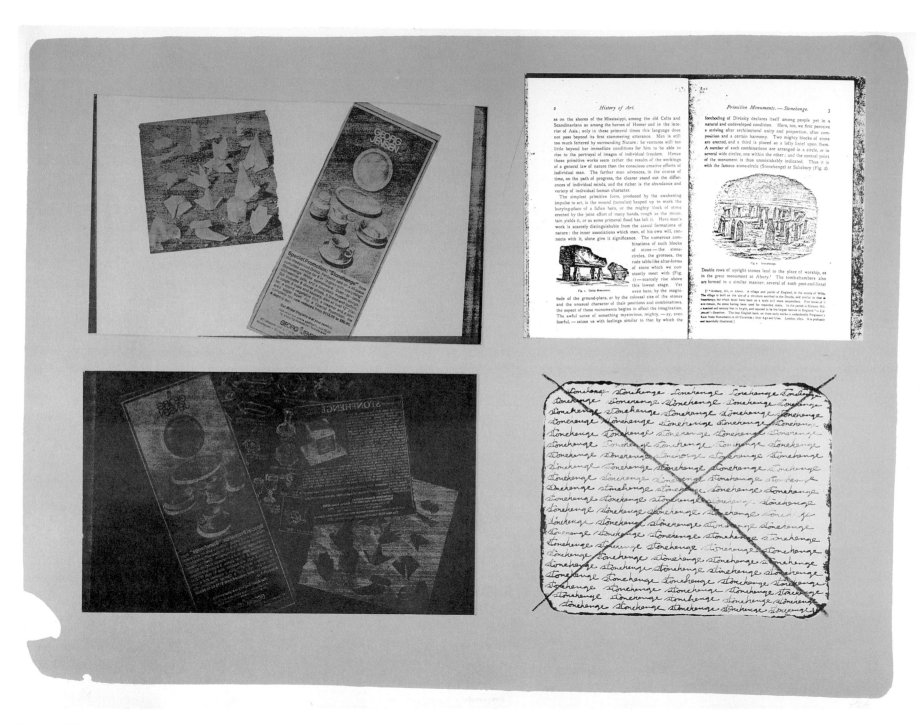

Revisions, 1976

century, knowledge of Stonehenge has been revised, its place and significance not only revised but commercialized. Thus Barrow uses Stonehenge as an example illustrating the way in which information, names, and meanings change.

In this print Barrow notes the significance of Stonehenge as the prehistoric monument and then the additional, secondary levels of meaning it has attained in the popular imagination as meaning is transformed, no longer evoking the original.

The book, the advertisement, the cancelled sheet, and the Verifax page are all different kinds of reproduction (the photocopy, the multiple scribbling, the newspaper clipping of objects), each of them constituting a revision of the original. The print draws its strength from the unlikely connection between the four sheets, evident chiefly through the written text, rather than through purely visual elements. Barrow emphasizes language and the connotations implied in the texts, not only in written language, but in the static composition and visual impact, much as he did in the Libraries.

A second lithograph, *Films*, 1978, is perhaps the most revealing of

Barrow's works. It is significant for it discloses, perhaps more incisively than any other single work, the insistent syncretism that characterizes his work and his daily preoccupation with disparate and far-ranging visual and textual data. *Films* is the most autobiographical for it does not simply draw upon some random visual detritus, but depicts an excerpt from his own daybooks—his artistic diary as it were—reflecting both details that were of importance or interest to him and his personal method of record making. While the appearance of this print differs from most of Barrow's photographs, there is nonetheless a strong connection with the Verifax series and other works using collage.

The frenetic montaging of the Verifax is sorted out here into a cleaner, more legible composition, presented in a balanced manner with all of the material confined within the perimeters of several concentric borders. Yet despite the overall regularity of the composition, the freewheeling informality of the Verifax prints is maintained through the casual placement of the excerpted texts and illustrations.

These two lithographs illustrate Barrow's growing disinterest in the

late 1970s with the photographic information and the approach he used in the Cancellations and Libraries.

Like other works, *Films* illustrates Barrow's concern with cataloguing the diverse data and information available in our culture. The sublime and the absurd that come back to us through these channels are universally available and unedited, much like common objects unearthed in an archeological dig. The various tidbits montaged together form a complex layer of information, not unlike the melange format of newspapers where documentary photographs, text, and advertisements for products are combined by chance.

Concern with the cultural artifact as an indicator of our society has dominated Barrow's work from his earliest examination of the automobile. In *Films*, Barrow presents his interest in cultural artifacts using an artist's diary. The diaristic mode, especially as utilized by photographers, has fascinated Barrow. While he has never truly focused his work emphatically in that direction, the diary in *Films* is taken from the pages of his voluminous notebooks. Beginning in the early 1960s Barrow began keeping volumes filled with periodic, if not daily,

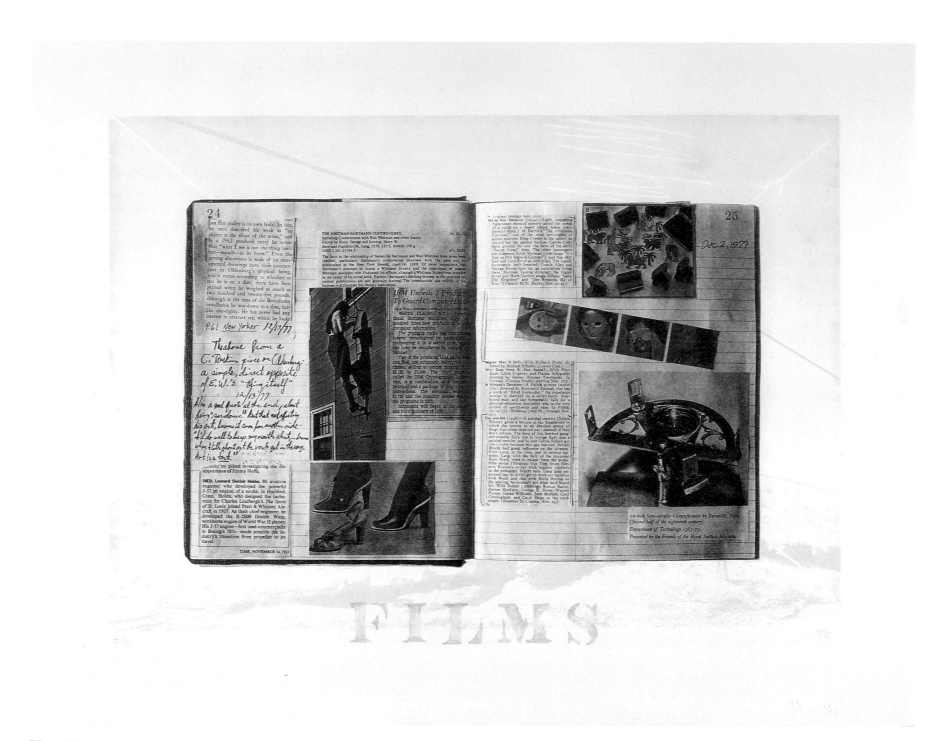

Films, 1978

notations. About 1973 the character of these volumes changed to a form more closely paralleling his visual output. The books have become a conglomeration of assorted trivia: postcards, bits from articles, illustrations, reviews. They are full-tilt collages, reminiscent of Schwitters. That the text and images from mass media are more important in his journals than his own comments supports his approach to art making, where he adopts the same posture, the same diversity and attention to disparate material.

Despite his use of assemblage and found printed matter, Barrow is recording the zeitgeist just as accurately as any documentary photographer. In his interest in the plethora of manufactured products, technology, and printed information, Barrow does not choose heroic, highly applauded objects, but the insignificant, the banal and obscure. That *Films* serves as a transitional work is also evident in his use of a Cancellation print as the ground behind the diary. Printed in pale gray rather than brown, the cancelled image is faintly visible for several inches beyond the edges of the diary.[1] Only the calligraphic white squiggles and bits of diagonal lines identify it as

a marked print. Instead of the X mark, Barrow cancels out the view in the photograph by placing the diary and the stenciled word *Films* in front of it, obscuring the image.

At the far right, an homage to the eighteenth-century age of scientific enlightenment is seen in the reproduction of a "Circumforator" taken from a Royal Scottish Museum catalogue, while on the opposite page is information about IBM, and the obituary of an aeronautical engineer, citing his technical contributions. These elements reveal Barrow's interest in the role of scientific knowledge and technology in society, and their diverse modes.

A string of four small advertising images depict an absurd blue mask. Doubtless a beauty aid, it has a macabre, nonsensical appearance and serves to remind us about the extraordinary, sometimes bizarre products and devices that one can find advertised at the back of magazines. At the left are two images, one of strange shoes and the other, adjacent to an article on IBM guarding computer data, of a woman descending a safety ladder, as if there were a connection between them. The shoes are an allusion to the cataloguing of women's footwear in

the Verifax prints, as well as an indicator of passing fashions. Rubber-stamped pictures of animals are another example of the reproducibility of an image and another kind of print medium. These prosaic items make this image a storehouse of pedestrian elements montaged together in what seems to be a random manner.

In the upper left is a small excerpt from a *New Yorker* article about Claes Oldenburg, with an annotation by Barrow (the only inscription in this entire piece) recording certain points from the article, and drawing attention to Oldenburg's quotation in the excerpt, "What I see is not the thing itself—but myself—in its form," which further underscores the autobiographical nature of this print.

Despite the absence of an obvious link between the title and the content, the word *films* does refer to several things: to the essential medium of still photography and also to the brief snippet of film reviews taken from *The New Yorker* and a reminder that all reproductions are made possible through film.

Barrow's last lithograph to date is *Springerville Variant*, 1982. A surprisingly small work, it is the most aggressive of the lithographs. *Springerville Variant* illustrates

"I think my work may be closer to a type of novel, not so much a narrative one

but one with a listing, an inventorying, and the resulting tension between the details."

From the series Cancellations—
Bilingual Communication, 1980

Barrow's fascination with process and materials and his experiments in cross-media combinations. The print looks much like a Cibachrome photograph of a caulked color Xerox print, but it is a lithograph with a glossy black border added using the screen print process. Working with the printers at the Print Research Facility at Arizona State University, Barrow was interested in making a straightforward nonphotographic print of one of his slightly three-dimensional caulked photographs, demonstrating the transformational possibilities of different media. It should be noted that a black-and-white photograph used in the caulked work is first transformed by being torn up and put back together. Further transformation is achieved when the print is spray-painted, and again when it is presented in another medium. In this work Barrow depicts the three-dimensional landscape in a two-dimensional photograph, then adds into a third dimension (the caulked reconstruction), and ultimately reorganizes and subdues it into a two-dimensional lithograph. Barrow intentionally juxtaposes the black border, achieved with two runs of high-gloss lacquer, against the soft, slightly diffused color image to add to the confusion and transformation. The idea of camouflage recurs again as Barrow shows in this print that things are not always as they seem.

Although Barrow was interested in the look of the photo-lithograph and the challenge of a different medium, the relevancy of it diminishes as he moves away from the multiple.

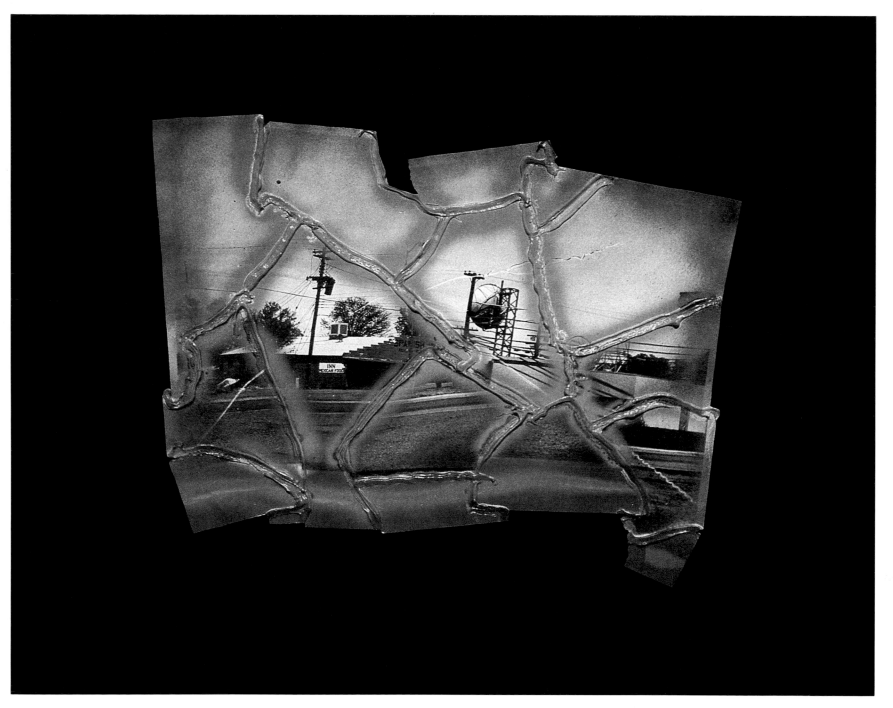

Springerville Variant, 1982

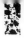

The Spray-Painted Photograms
Started 1978

In late 1977 Barrow began experimenting with the photogram process using assorted ordinary, but somewhat offbeat objects to form the compositions. Later he began applying spray paint to the surface of some. A dozen extant 11 × 14 inch photograms from that year indicate the problems he was to engage more fully in the next body of work. *Homage to Picabia*, 1977, is an example of these small, tentative works that Barrow informally called "spray sketches." It comprises a simple photogram of film, bottles, a plastic clip, and an ice pick in a composition that acknowledges the Bauhaus notion of industrial design and Moholy's photograms. *Spray Sketch*, 1977, utilizes green day-glow paint and a heavy silver paint splattered on in the crachis process.[1] These small-scale, simple compositions suggest only the beginning of a more resolved and complex form that would not emerge until spring of 1978. The spray-painted mists of bold color are one of the most apparent features of these prints. The paint transforms the plain black-and-white photographs and moves away from the strictures of a staid monochromatic range to an adventuresome, sometimes raucous palette.

Unlike the preceding groups that were executed within the confines of an identified series, Barrow did not view the spray-painted photographs as a series. They were unique pieces that could not be duplicated; more important, they did not seem to be of a serial nature, enhanced by their association with each other. Though lacking definition as a series per se, they are nonetheless very identifiable as a group and for convenience are identified by their process as spray-painted photograms, or simply as spray prints. Barrow's multidirectional interests are given full rein in the spray prints. More than any other group, they afforded him the latitude he required for his complex ideas, enabling him to investigate concepts of representation, abstraction, cognition, and language. For Barrow, the spray prints were like blank canvases; he was free to add whatever he chose, considering each part, each layer, and the interrelationships of all the elements. The spray prints summarized many present and past interests and allowed him to move in numerous directions simultaneously, incorporating diverse material, processes, and references. Like the Verifax prints, these prints directly use original source materials for the composition and do not depend upon the apparatus of the camera.

A basic premise of these works is that the photographic information is merely a starting point; its transformation in the application of paint is equally important. The spray painting is a more genteel manipulation than the rude cancellation mark. The sanctity of the pristine print is again renounced as Barrow reiterates his belief in the necessity of the artist to move beyond the reproduction of what lies before the lens.

Like the Verifax prints and the Libraries, the sprayed prints form a catalogue of cultural data, but on a wider and more complex scale with greater variety of presentation

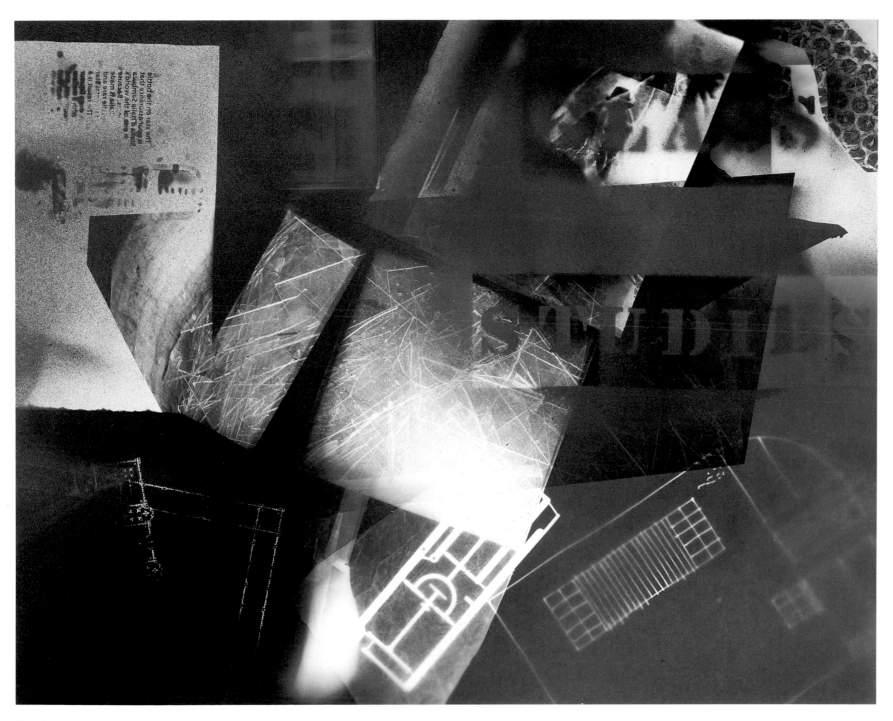

Glass Studies, 1977–78

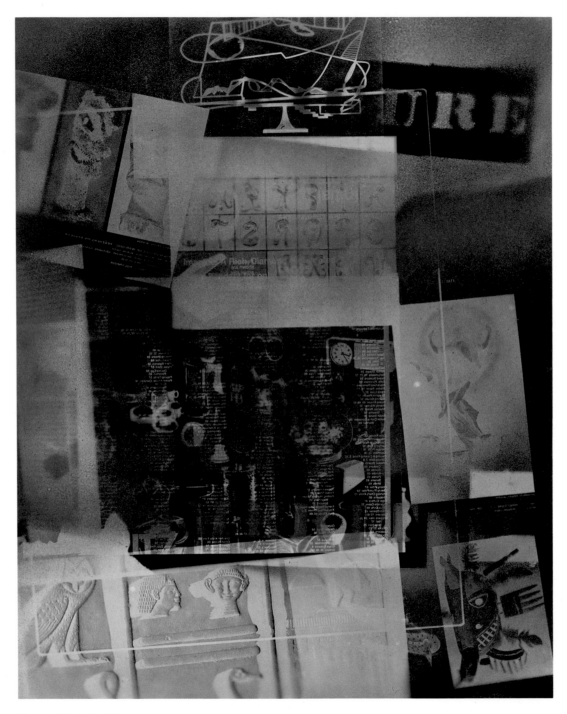

Figure of Merit II, 1979

and appearance. The spray prints are content oriented, and each one is about the title concepts illustrated by the objects, texts, and imagery. The works collage the common physical object with esoteric theoretical ideas and analyses, joining the material with the cerebral. Objects are selected in part for their appearance but mostly for their intellectual appeal as representatives of the world about us. Removed from their function, abstracted, and montaged in an intricate assemblage, they are no longer discrete objects but part of the larger assembly.

The innovative manipulative impulse evident throughout Barrow's work comes full circle in his exploration of the photogram, looking back to the cameraless print-throughs of the late 1960s and even earlier to experiments done at the Institute of Design.

For Barrow, working without a camera and composing directly on the photographic paper was liberating. Any prospect of previsualization was subverted by the randomness of the process. Chance and random appearance were part of earlier work as well: the TV images, the Verifax prints, magazine print-throughs, and the Cancellations. Here though the opacity of each object determined its appearance, making the rendition more uncertain.

Besides allowing a reconnection with some of his own earlier work, the photogram process allowed Barrow to investigate the cameraless experimental mode that Moholy-Nagy had employed. Barrow was cognizant of the place that the photogram held in the pivotal innovations of the 1920s and 1930s, its position in Modernism, and its symbolic value in articulating the experimental uses of photography as distinct from its functional uses.

Barrow was greatly influenced by the theories and writing of Moholy-Nagy. In his great experiments, Moholy had employed aluminum and other industrial materials as the ground in his paintings, thus working with both light and color. In Barrow's prints the conjunction of color and light similarly illustrate Moholy's concept that pigment provided the material component of the image, while light provided the immaterial.[2] The photogram, Moholy observed, transforms an everyday object into something mysterious. Eliminating the camera's "perspectival representation" allows light to be "a new creative means," like color in painting and sound in music.[3] This transformation of the object in an indefinable space also renders it timeless. For Moholy, the photogram represented "the most completely dematerialized medium which the new vision commands."[4] Photography, he noted, is essentially the manipulation of light. For him the photogram offered the opportunity to bring the painterly to photography.[5] The importance of the photogram for Barrow, as for Moholy, is that it embodies the unique nature of the photographic process—forms produced by light. Furthermore he agreed with Moholy who felt that experiments with photograms provided richer insights into the photographic procedure than those using the camera.[6] Thus the photogram was a means of utilizing the photographic process to transcend its typical reportorial function. The innovative prospects of the process, the simultaneous concern with abstraction and cultural elements, made it ideal for Barrow. Moholy too had been influenced by richness of "magazine culture" and his volume *Von Material zu Architektur*, with its diagrams, textural photographs, typography, reproductions of art, scientific photos, aircraft and machine parts, anticipates the range of images in the spray prints.

In his photograms Barrow's primary concern is the character of the objects and material rather than an exact

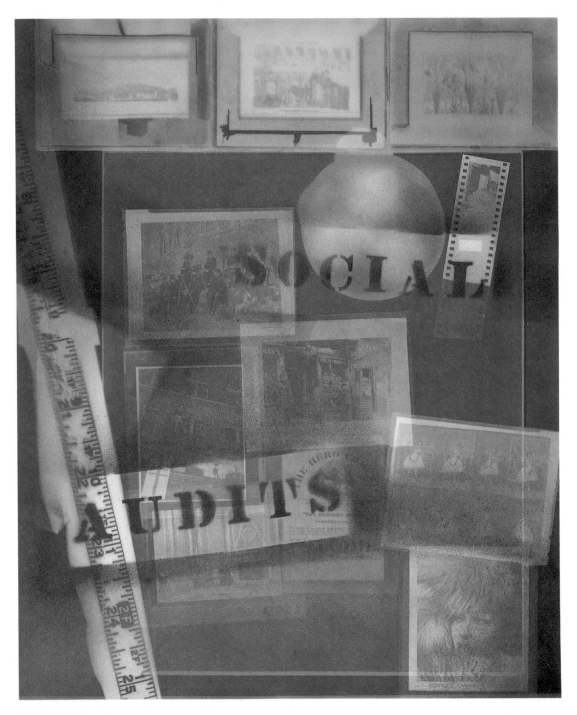

Social Audits, 1979

replication. The wealth of material, much of it with little in the way of comprehensible visual properties however, suggests that his concerns are much deeper than simple graphic formal imagery. The photogramming process (including the direct print-through of printed text and illustrations) allows him to quote directly from his cultural sources and also to pile up material much like he did in the Verifax prints. Much like collage, wherein the actual object is included in the composition, the photograms also capture the essence of the object. Here, though, the photogram process enables Barrow to make "transfers" of the material.

The photograms in the spray prints can be divided into two distinct types. First, there are abstract formal photograms derived from three-dimensional objects and second, print-throughs derived from the print media. These function concurrently within the compositions.

The three-dimensional objects yield baffling images of provocative though indecipherable shapes. Created from a wide range of common materials, they are often the refuse that comes with consumer products. The extraordinary diversity warrants an extended list here: plastic vacuum-formed wrapping, extruded plastic strips, junk from model toy parts, machine parts, disposable plastic fruit baskets and other containers, remnants from children's toys, parts from decals and stick-on labels, wire grids, chicken wire, styrofoam packing protectors, knotted twine, toy animal stencils, sprinkler parts, plastic boxes and containers, sticks, utensils, gaskets, tubes, broken boxes, model train tracks, glass, strips of paper, and plastic cones. Other banal, mundane objects he uses in the photograms include: drafting rulers and tape measures, stencils, shoes, photographic film and contact prints, records, plastic cylinders, plastic bags, and drinking glasses.

The printed material is placed directly on top of the photographic paper, so its content is printed through, but in reverse. Barrow considers each element as he works with it, occasionally altering the clarity of the text and reproductions intentionally. Sometimes he uses the original; other times he photocopies the chosen article and then photograms it. And other times, he uses the photocopy with the blank side in contact with the paper (this then renders the image correctly, but with greatly reduced clarity).

The range of printed material is just as varied and includes fragments of articles and advertisements, line engravings, pages from art books, mechanical drawings and schematic diagrams for machine parts, instructional drawings from products, advertisements, children's drawings, receipts, warning labels, doodles, pages from mail order catalogs, architectural illustrations, consumer report notices, quiz games, newspaper photos, comics, record album details, typological charts from design books, medical diagrams, reproductions of photographs, lingerie ads, real estate articles, AAA Triptik maps, swatches of fabric samples, didactic material for children, Spanish illustrations and diagrams, military aircraft identification pages, children's quizzes, instruction sheets, grocery store coupons and games, furniture ads, sports pages, important art objects and art history texts, consumer analyses of products, and old photographic portraits. Advertisements and excerpts from newspapers and other publications make up the majority of material.

Much like the English artist Richard Hamilton, Barrow focuses on reality as put forth by the mass media with the reproduced image and the reproduced text forming the basis of these works. He juxtaposes his personalized photographic imagery and painting with a nearly

disorienting plethora of mechanically produced, preprocessed images. These works speak of the commerce of our age and the overwhelming ubiquity of objects—machined, designed, and mass produced in stupifying multiplicity.

The collages of Kurt Schwitters are clearly an antecedent. Schwitters serves as a precursor with regard to content and attitude in numerous ways. His fecund collages of insignificant bits of found materials—the refuse of wastepaper baskets and junk—granted a status to the irrelevant trivia of contemporary culture, which he saw as representative of the restlessness of the times. Banalities, like bank notes and bus tickets, were mixed with cultural by-products to form both a historical document and a denial of high art. While this muddled assemblage is acceptable within collage, it is not immediately comprehensible and seems contradictory to the simplicity and legibility that are still expected of the photograph.

Schwitters's title for the group, *Merz* (from the word *Kommerz*), seems to parody capitalism as Barrow does in using the multitudinous products and rubbish produced by our affluent society. And just as Schwitters's collages were intentionally an affront, a denial of conventions, the spray prints similarly are a repudiation of the canons of straight photography, which to Barrow seemed outmoded. Nonetheless, these sprayed prints still demonstrate the capacity of photography to serve as the faithful witness, just as it did for Timothy O'Sullivan and Walker Evans.

Collage has been cited as the most revolutionary formal invention of the twentieth century, and in numerous works since 1978 Barrow has utilized this visual strategy, disrupting and transforming the photographic illusion.[7] Collage, or more accurately for most of these prints, montage, transforms the objects from their literal realm to a more ambiguous presentation removed from context.

As in the Libraries, the sprayed montages make use of the relationship between the photograph and language. In addition to the large textual titles montaged over the surface, each of the prints is littered with many other forms of textual material. These elements of language compete with the imagery, abstract forms, and color, demanding attention to the small details. In the midst of the painterly abstractions and formal constructions, bits of text struggle against the larger formal elements. The interplay between image and text contributes substantially to the visual tension of the spray prints. The texts provide clues to the imagery and help link the stenciled title legend with contents, offering allusions and connections. The textual material too is often camouflaged, either because of its scale or because it is occluded by other details or reproduced backwards. Barrow intentionally keeps the text submerged, making it available if one wishes to undertake a detailed scrutiny. In this way the prints release their contents to us slowly.

The prints are produced in several stages over a period of time. Each print begins with the photograms of the text, images, and objects that Barrow has selected to be included. After the imprint of this information is fixed on the photographic paper, he considers the selection of the title words (choosing from his inventory of phrases), and then the various surface paints are applied. Typically Barrow makes a number of photograms at a time, then puts them aside for future consideration, perhaps ignoring some of them or recycling them later.

The airbrushing of pigment onto the photograph is directly influenced by Barrow's abiding interest in industrial design. The delicate spray of paint harks back to his adolescent experience doing slick feathery paint jobs

"There is a combination, a balance of the classic photogram

a

kind

visual

chaos."

for cars, both in technique and in his choice of automobile paints. Working with an airbrush, or pressurized cans of paint, Barrow applies the automobile enamels and lacquers in thin veils, subtly intertwining or blending the colors. The spray technique too recalls Moholy-Nagy's inquiry into the experimental possibilities of using spraying devices and color application.[8] Barrow frequently uses unusual colors, ones that contradict the reserved black-and-white tonality of the original print. Vivid and sometimes shocking day-glow colors are used. Others may be somber earth tones, dark green, or rust, which bring forward his continuing interest in camouflage. Typically, though, the colors are bright blues, pinks, orange, magenta, silver, and green. In some prints the paint blends into the composition working harmoniously with it, while in others the paint is in opposition. A very important function of the spray paint, aside from adding color, is to enunciate the stenciled letters of the title that are superimposed on the photograph, for this is what creates the letters.

Titles have always been important to Barrow and hence are carefully chosen. These photographs are about issues beyond the literal information that is depicted, and the distinctive stenciled titles underscore the visual elements, perhaps registering dissonance between the visual and the verbal. The letters, $1\frac{1}{8}$ inches high, are formed with metal stencils placed on top of the sheet and then spray painted. Much like the textual data contained in the photograph itself, these large superimposed words interact with the image and the text in various ways depending on color, clarity, boldness of imagery, competing elements, and hidden letters. In certain works the title is extremely clear; in others it is maddeningly indecipherable, again recalling Barrow's fascination with camouflage. The spray-painted text adds yet another layer of information, further

contributing to the denseness of the montage. The titles in fact provide less assistance deciphering the work than might at first be supposed. They work parallel to the imagery, rarely providing obvious solutions to the visual maze behind the superimposed words. They do offer clues, but, for the most part, they become yet another part of the multilayered, multireferenced puzzle. Nonetheless, the titles do put forth the suggestion concerning the concept addressed in the work, such as in *Struggle for Identity* or *Species Identification*. The titles are derived from actual book titles, again making references to the Libraries, and almost all are taken from various technical volumes—engineering, mathematics, physics, computer science.[9]

The technical references of the titles often have a more general association with art and society at large. In *Glass Studies*, for instance, the title refers to the placement and study of objects upon the glass and is also an oblique reference to Duchamp's *Large Glass*. Other titles make reference to art history—*Disjunctive Forms*; anthropology—*Species Identification*; technical—*Recent Advances*; physics—*Elemental Particles*; mathematics—*Nonlinear Interactions* and *Location of Zeros*; mechanics—*Optimal Control*; and information—*Low Density Codes, Semantic Information, Reliable Knowledge, Composite Index*. The change in the title's orientation from the original esoteric reference to its use here is yet another manifestation of transformation as well as its universality.

An intricate work that includes figures by Matthias Grunewald, illustrations of African art, David Smith sculpture, Assyrian reliefs, and pages from consumer catalogues is *Figure of Merit II*. The title comes from a technical, scientific lexicon concerning the rendition of the human figure but also has obvious implications for art history with its study of significant representations. The title poses the question of who the figures of merit are in our society and the comparison to historical figures. *Window of Vulnerability* illustrates the transformation of titles from the particular to the general, in a phrase that five years ago had only military application but is now entering the general vocabulary.

Barrow's choice of lettering is not accidental. It is a widely available stencil form, but also one with historical associations and references to early twentieth-century posters and experiments with typography and art by Bauhaus, Constructivist, and De Stijl artists. Similar typographic style can be seen in Theo van Doesburg's 1922 publication *Mécano* and El Lissitzky's 1924 self-portrait, *The Constructor*.[10] The combination of this stencil typography and the photogram is strikingly represented in a 1924 Pelikan Ink poster by El Lissitzky.

Barrow's attention to type is also reminiscent of Moholy's. "The printer's work is part of the foundation on which the NEW WORLD will be built," he noted. Furthermore, Moholy believed that the combination of typography and photography "is the visually most exact rendering of communication." "The form, the rendering is constructed out of the optical and associative relationships," which is how Barrow has utilized these elements.[11]

From his early study of product design Barrow has never relinquished his ardor for mechanized products, and these works reflect his interest in the ethos of the machine age, a subject that concerned Futurists, Constructivists, the Bauhaus, even Dada artists like Duchamp. As noted above, in several of El Lissitzky's works, the stencil typography combined with photomontage was also part of the Constructivist vocabulary. The Constructivist

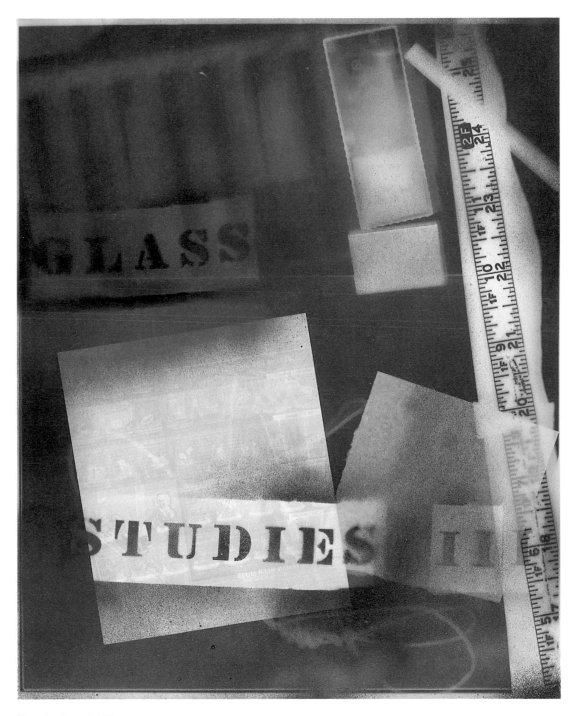

Glass Studies III, 1979

technological orientation and the attention to the "mechanical man" are echoed in the sprayed photograms. So too is the very notion of constructing as well as the attention to industrial materials and mechanistic content despite the more emotional application of paint and the unsystematic composition.

There are other references in the sprayed photograms to the machine aesthetic. This is discernible from the lustrous metallic car paints and lacquers applied to the surface, to the exactitude of the die-stamped stencil form that gives the titles their emphatic consistency, and in the mass-produced content. Barrow uses hard-edged, glossy photographic paper to underscore his interest in the machine aesthetic. His frequent use of forms derived from plastic acknowledges it as a quintessentially modern material. The machine product is voluminously evident in every print, indicating the importance of the machine in twentieth-century culture. And furthermore, in these works Barrow recognizes that photography itself has been perceived largely as a mechanical process.

Perturbation Theory, 1979, is an early spray print that illustrates the straightforward clarity seen in the initial period. Diverse photograms have been formed from a drinking glass, plastic boxes and bags, and other disposable remnants. Rectilinear photograms predominate, making the background composition chiefly formal. Nonetheless the work is not devoid of text, for complementing the bold title is a subdued print-through photogram of a page of text. This work also illustrates Barrow's adroit, subtle spraying process. Red, blue, green, and ochre are shown in their original color and then also commingled to create new combinations. The spray paint creates a thin misty veil, restrained in coloration, working harmoniously with the warm-toned sun print. While the title may well come from a geology text, it alludes also to the many societal perturbations in modern life, ranging from the political to domestic, and to profound shifts in art. The connection with the photograms suggests the emphatic change that cameraless experimentation of Man Ray and Moholy-Nagy, and the Bauhaus artists induced in the photographic field amidst the pictorial realm.

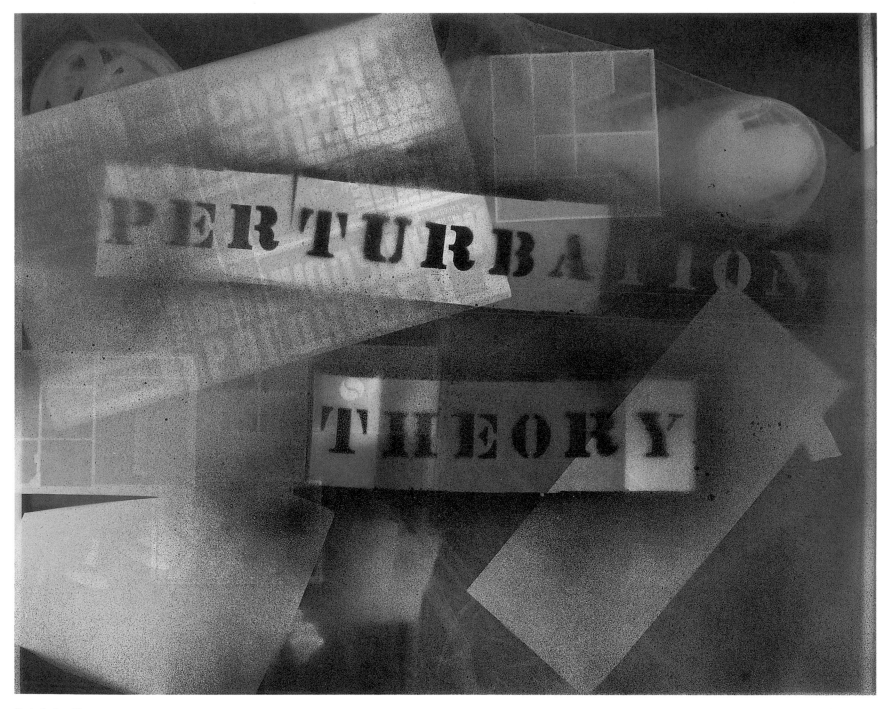

Perturbation Theory, 1979

A graphic clarity and a minimum of detail are also seen in *Optimal Control*, 1980, which utilizes metallic spray paints, as do many of the works, giving the surface a shimmering diaphanous veil. Like the spray print *Recent Advances* and *Interior Thoughts* (an errant late print from the series Pink Dualities), the primary subject is the metallic skeleton of a dirigible. The large photogram of the airship has had a plastic ruler laid over it, further increasing the profusion of linear architectonic details. This work alludes to the innovative design era of the twenties and thirties, when industrial designers naively envisioned a grandiose utopian technology, and radical new design was embraced. Set as it is against a black void, the ship has a phantomlike character. It is apparent from the clear lettering at the bottom that this rendering is a schematic mechanical diagram, indicating such details as the captain's room, fuel tanks, main gondola, and staircase. The strange skeletal lines along the top of the print have a Constructivist sensibility and reiterate the structural elements of the dirigible. These molded plastic strips, by-products from a toy model set, are an excellent example of the type of esoteric flotsam that Barrow uses in these compositions. The long, thin plastic oddments found in the sprayed photograms recall the wire-like shapes that Moholy used for his title page of the journal *Foto-Qualität* in 1931.[12] Here they are strewn across the paper and piled on top of each other, as Barrow intentionally juxtaposes their regularized serial form against their random placement. Barrow has purposefully chosen primary colors to recall De Stijl. The title letters float insubstantially against the photograms. And, as in the majority of the spray pieces, the words are partially hidden within the composition. This work is a wry comment on control in life in general, technical equipment, and an antique but doomed mode of air transport.

Solarization, as seen in *Nonlinear Interactions*, 1983, has been used by Barrow to contribute to the visual transformation and camouflaging of his montaged data. The silvery, reflective areas set against the dark background make this a haunting work. The silver paint, applied in the crachis method, further adds to the density and gives the surface a lustrous appearance, unlike the majority of prints. Working in tandem are the irregular templates, perhaps from children's games, that enhance the abstraction of the composition.

Certain titles that seemed especially significant to Barrow have been reused several times, such as *Conceptual Distortion*.[13] These titles are ones that have a particular resonance for him, seeming to be key to life and thought in the twentieth century. Moving away from the simplicity of the earlier spray works, the prints became increasingly more iconographically loaded, reflecting the volume of information around us. In *Conceptual Distortion 2*, 1981, different kinds of material and experiences are compressed together. At the center a positive image supplants the customary negative: an image of an art publication, open to sculpture by Archipenko and Malevich's black paintings. This comment on twentieth-century modern art is substantiated by the background beneath the book. The caning of the chair immediately invokes an image of the classic Cesca chair by Breuer, now in ubiquitous reproduction, and is another reference to design. But it is also a direct reference to the early Cubist collages of Picasso and Braque that incorporated printed matter and chair caning. The open mesh is further

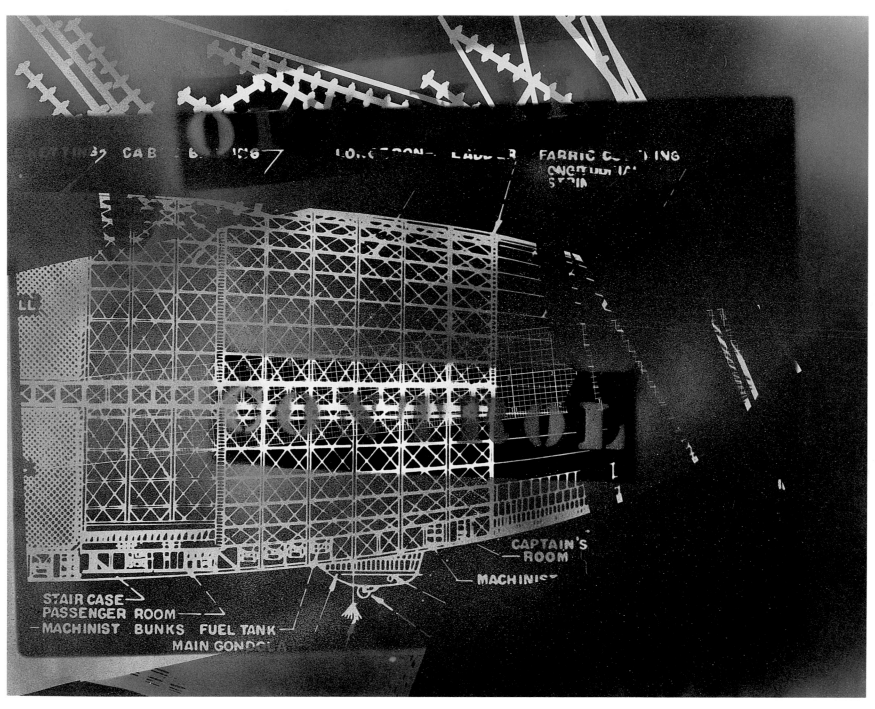

Optimal Control, 1980

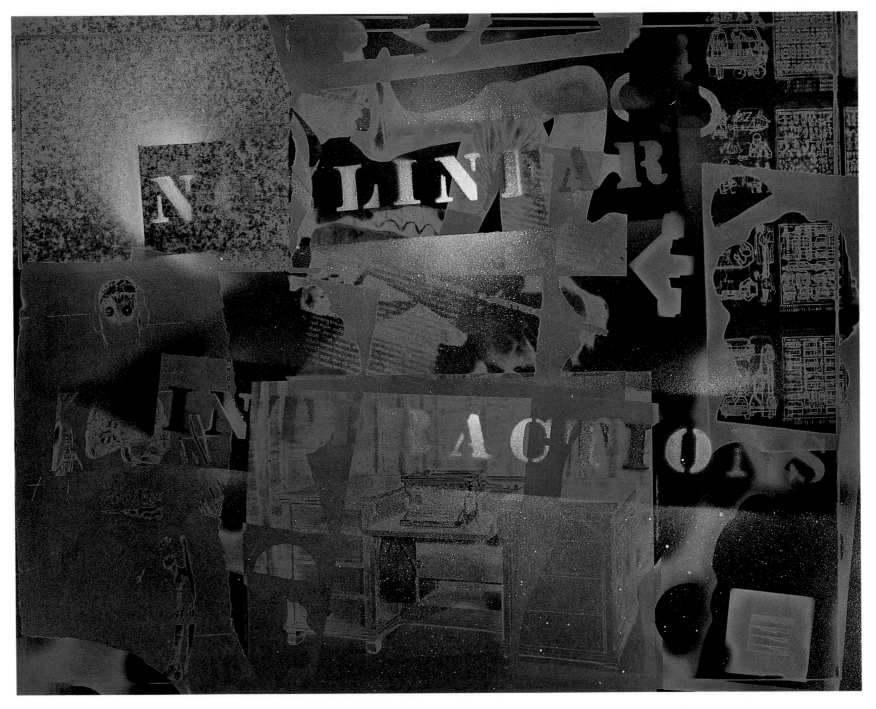

Nonlinear Interactions, 1983

reiterated in the right, produced by the photogram of what is most likely a small molded-plastic fruit basket.

As with many of the prints, other translucent three-dimensional objects have been placed on the sheet to create the bizarre photograms. Barrow uses prosaic detritus to give the work the imprint of ubiquitous mass-produced miscellany; thus they become abstracted emblems of a culture characterized by superfluity. The photogrammed pictures are not particularly helpful, being more baffling than illustrative. Two roasts side by side with meat thermometers in them are surmounted by images of an ice cube and glass of water—enigmatic and seemingly disjunctive data. In fact, Barrow uses the magazine page to demonstrate technology in domestic life, for it contains hints for improved microwaving of foods by discussing experiments on deflecting rays. This page is reminiscent of the sort of consumer ads and ephemeral domestic trivia found in the Verifax prints. This banal material is the background for much of Barrow's work, just as it is the backdrop for the artist today.

The landmark works of art are represented in this print by a mechanical reproduction, exemplary of the way we apprehend most art (paintings, photography, and music) and the world—indirectly through reproduction. And this is one of the conceptual distortions to which Barrow alludes. Certainly the transformation of art in this century, as illustrated in the open book, is another distortion of aesthetic conception, one highly significant to Barrow. Third is the visual transformation of three-dimensional objects when photogrammed, distorting their appearance and our conception of them. This work is a frenetic combination of white and black, obscuring the title lettering. Barrow has applied the paint sparingly—a patch of orange, a band of red, and a hint of green and magenta. The metallic flakes suspended in the paint and the crachis application along the left edge add to the surface dazzle. Although quite dense, *Conceptual Distortion 2* illustrates Barrow's syncretic approach and the richness of allusion that is hidden in each print.

The spray prints have alternated between handsomely colored works with engaging hues, such as *Location of Zeros 2* and *Perturbation Theory* and those with cluttered frames and gaudy, aggressive colors. It would be incorrect to assume one approach superior to the other. But yet the richest prints are those more heavily laden with abstruse data, although they are less visually appealing.

Another recycled title is used in *Location of Zeros 2*, 1981. In this catalogue of cultural flotsam, the formal interests override the textual, chiefly because of the strong repetitious abstract patterns and coloring. Strange photograms of circular and elliptical shapes predominate and give representation to the title. This title is closely associated to the numerous circular forms, a rather facile relationship atypical of the spray prints. The identity of the materials used, however, remains elusive, but among them are a plastic spindle and what seems to be a fan, plastic containers, toy railroad tracks, jewelry holder, and printed pages and a scrap from a map of Colorado. The monochromatic black and white of the print is an austere counterpart to the hot yellow and red spray paint along the left side.

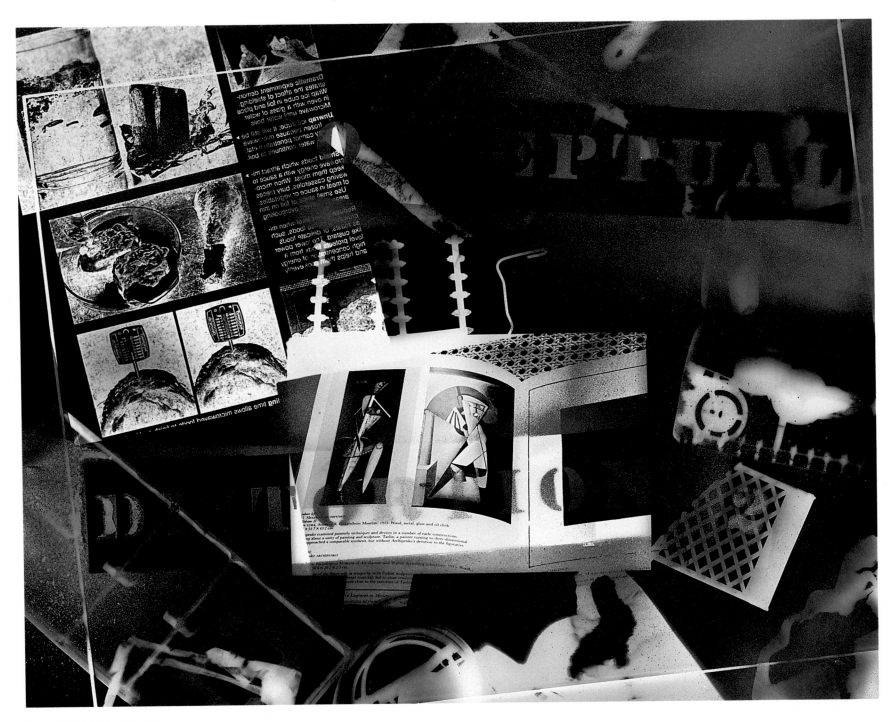

Conceptual Distortion 2, 1981

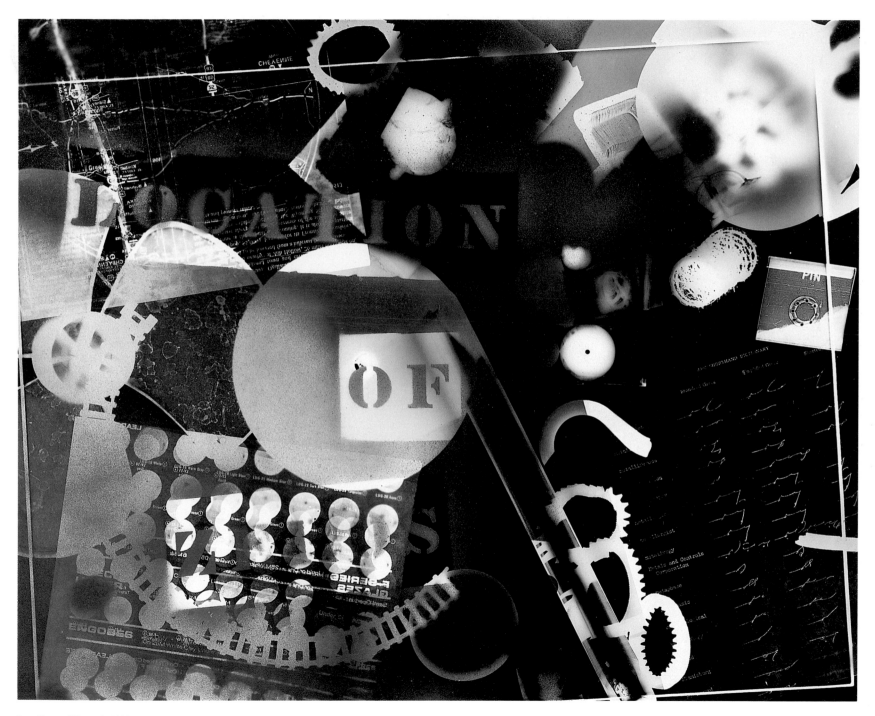

Locations of Zeros 2, 1981

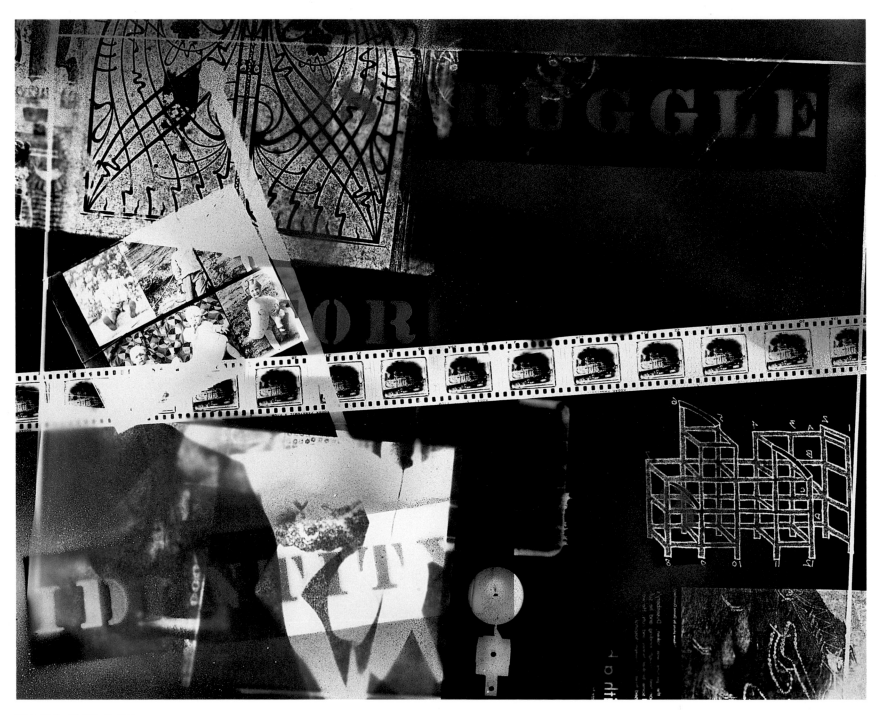

Struggle for Identity 3, 1981

Struggle for Identity 3, 1981–82, is indicative of many of the mid-period spray prints. The struggle begins at the outset with the attempt to discern the title and then to uncover the identity of the visual information put before us. At this point Barrow is moving away from the simplicity and clarity of the first sprays toward more compacted, denser works. Art nouveau gates, a plastic wand, old photographs of children, a roll of 35mm film with the same image reiterated fourteen times across the sheet, a schematic drawing for some structure, indistinct bits from articles, and photograms of odd three-dimensional objects make up the contents. The bluish green color is unexpected here and seems jarringly at odds with the intense whites of the sheet. Yet the metallic rust tones and gold pick up the purplish tones and blend with the dark black background ameliorating, in part, the violent green. The title, appropriate for a sociology text, is apt here where much of the data can formally be identified, although its meaning is still hidden. It is also a comment on the problems of the artist and the individual in these times.

Found drawings occasionally make their way into these works, adding a humanist touch to the volume of mass-produced reproductions and objects that form these prints. These disparate items do not form a cohesive image in a linear fashion. *Conceptual Distortions 3*, 1981, for example, contains a whimsical child's pirate map adjacent to a schematic plan of a more sinister nature, an MX missile site, hidden in the dark green black background and dense layers. The most prominent motif in the composition though is the peculiar late art nouveau chair, combining a lyrical curvilinear back with an angular rigid base, a distortion of two divergent conceptions of form. We can still decipher the Campbell's soup label for won-ton soup, despite its being reversed. This ordinary bit illustrates the corporate and consumer shift to a wider concept of cuisine and an attendant alteration of the original for marketing. But beyond this, the content is distorted, in part by occlusion. Thus Barrow chronicles our culture by using firsthand evidence.

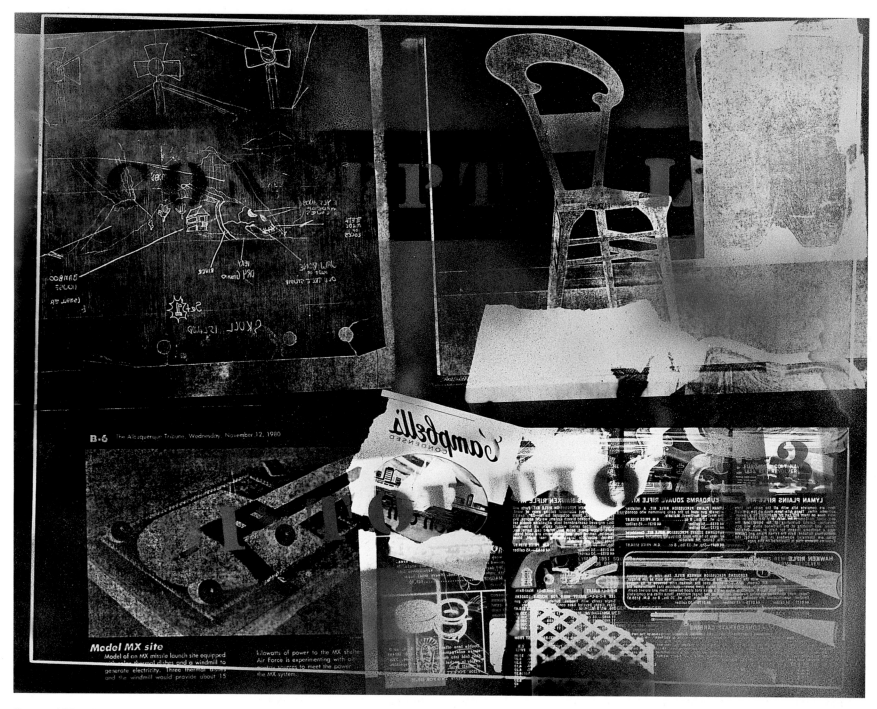

Conceptual Distortion 3, 1981

The spray prints changed in other ways also. Initially, the addition of the Polaroid prints to the spray prints seemed to be an intermittent experiment. The Polaroid prints, however, have played an increasing role in Barrow's work and its changing character in the past six years, offering an expanded physical involvement with the work.

The Polaroid prints are never wholly integrated into the composition. They stand out as a special collaged element despite the way that Barrow has camouflaged their high-contrast white borders by spraying them with dark-colored automobile lacquer. This camouflaging in turn tends to emphasize the content of the Polaroid, masking its unique appearance without minimizing its physical presence. Clearly it is still a discrete object that has been appended to the sprayed print.

Barrow enjoys the incongruity of form and scale between his sprayed print and the small Polaroid prints. He was especially intrigued by the disjunctive interaction between the small Polaroids and his artificially colored black-and-white print. The straight print, detailed and precise, collides with the negative image of the photograms, which is vague, oblique, and textual.

The Polaroid prints are often autobiographical or anecdotal and contain abstruse details that relate to the piece, or strange, nonsensical bits clear only to the artist. They transport the work into the present, personalizing it with insignificant visual trivia drawn from Barrow's daily life. The Polaroid prints are quite unexpected, appearing randomly in the works, dislodging any predictability, and they mitigate the earnestness of the prints with their casual placement.

Recordmaking with a camera has held less and less interest for Barrow.[14] He prefers to work with found images, principally those excerpted from publications. The Polaroid prints, however, are straight representations; they mark the inclusion of personalized information into the composition, yet their appearance is too often recondite. These instant prints confirm his wish to inject a measure of spontaneity into the works and to add, quite literally, additional layers of information.

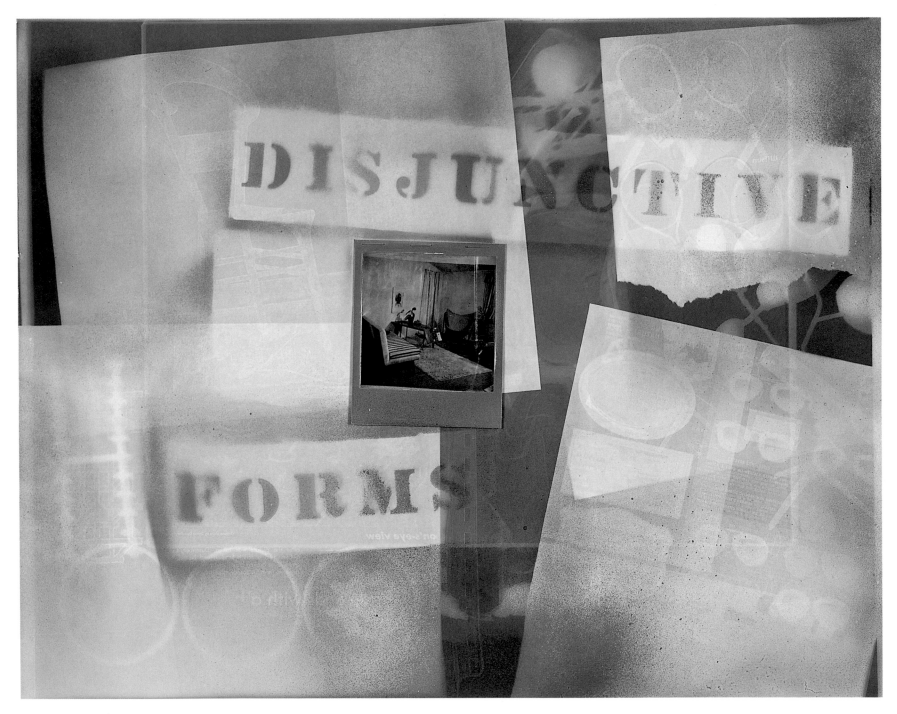

Disjunctive Forms, 1981

The rude shift from the abstract photograms to a detailed photograph is particularly apparent in *Disjunctive Forms*, 1981. The Polaroid, as the sole collaged element, is disjunctive in its form and its manner of representation. Dislocation of visual data appeals to Barrow. In this work the SX-70 print of a reproduction is allied to the two *Interior Thoughts* in the the series Pink Dualities. The Polaroid serves as a device for pulling the eye into the overall composition and into the obdurate wall of print-through material. The high 1950s style, represented by the Butterfly chair and Danish Modern sofa, has gained renewed respectability in the past few years, seeming less of an anachronism. That *Disjunctive Forms* is a comment on design is confirmed by examining the hidden content of the photograms that are suffused by the sheer pink and yellow sprays. The modern Butterfly chair in its abstract biomorphic form stands in contrast to the decorative early modern chair, two similar, yet disjunctive forms. Although the Polaroid has been masked with heavy gray paint, the efforts to camouflage it are insufficient, for it still stands out as a renegade form. This tension between the angular and the curvilinear is not at all accidental, for they are another manifestation of the disjunctive forms.

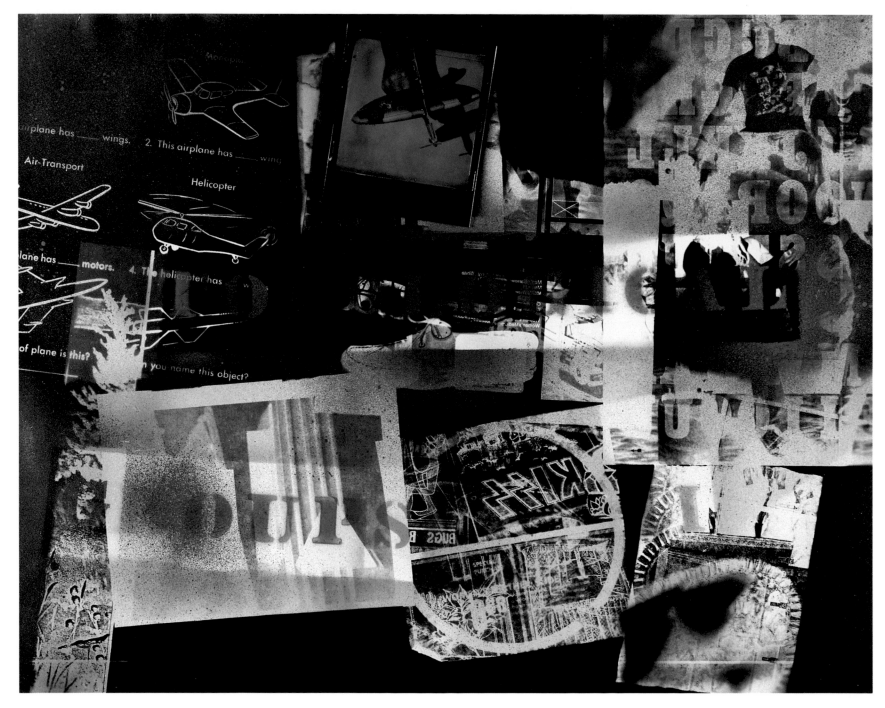

Topological Groups II, 1980

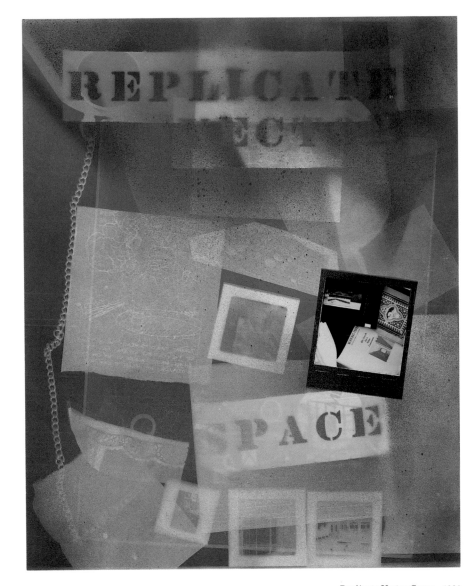

Replicate Vector Space, 1980

The Polaroid of a toy model is the most apparent element in *Topological Groups II*, 1980, due to its surprising realism; it pops out of the black background. Furthermore, the image, a full-color positive, is more legible than the negative photogrammed information that surrounds it. Here the borders have been successfully camouflaged, a theme carried over from the content of the image itself. Placed against a gold ground, the camouflaged pattern toy stands out. Immediately to the left is a series of schematic educational drawings for children of aircraft, neatly paralleling the image in the collaged Polaroid. The title is derived from a mathematical text and seems to be less directly related to the photogrammed content. Press-on letters, shoes, a rock group logo, and comics are part of the multilayered montage.

Contrary to what one might expect, *Self-Reflexive*, 1978, one of the earliest collaged works, is not autobiographical; rather it reflects on the nature of photography as a medium and artifact. A row of found 1930s pictures of children makes a horizontal band across the print. Below it are three Polaroid prints. Barrow cleverly uses the Polaroids to capture the negative version of the pictures that are photogrammed in the upper part. He makes a shrewd transposition of the visual imagery, including positives in the black-and-white print but showing them, surprisingly, as negatives in the Polaroids. They have a ghostlike presence in the negative, and it is odd to see such inversion in a Polaroid. The title indicates the biographical nature of the pictures, and the instant prints add another dimension of time to the work. Photography's ability to transform objects into reproductions and vice versa is addressed.

By 1983 a shift in the sprayed photograms was apparent. As the Polaroid prints were assuming a more active role, the photograms were becoming more opaque versions of the earlier sprays.

163

The Caulked Reconstructions
Started 1979

By 1980 Barrow was thoroughly immersed in his cameraless monoprints and seemed removed from the print derived from use of the camera. In his next group, once again beyond the realm of acceptability, Barrow was to look back to the Cancellations. From the mutilation of the negative in those works it was a logical step, in a sense, to vandalize the print itself. This literal deconstruction carried the visual montage effect to another level, wherein both the surface plane and image are dismantled and then reassembled. The disruption of the picture, seen in the Cancellations, is intensified. The syntactical transformation of the subject is more pronounced in these works, as is Barrow's interest in collage.

Although the negative had been defiled in the Cancellations, Barrow had been fairly scrupulous about the appearance of the finished prints. In contrast, the fine print is demolished in this series, ripped apart and then reconstituted, showing varying similarity to the image in its original state. This ruthless dismemberment of the print into irregular patches transforms the photograph in a number of ways. No longer forming a smooth, continuous two-dimensional surface, the pieces become three-dimensional. Barrow further accentuates this, giving the prints a rude haptic quality by stapling the parts together and crudely cementing them along the joints with industrial silicone caulk. The destruction and reconstruction negates the traditional fine print aesthetic and reflects Barrow's exasperation with straight photography.

The caulked reconstructions are one-of-a-kind, unique pieces. They commenced with a number of tentative experiments during 1979, which were abstract constructions for the most part. The caulked prints seemed to fulfill Barrow's interest in experimenting with process and in direct physical involvement. Increasingly, Barrow had become not only disinterested in the straight print but dissatisfied with the detached process of photography. He was seeking interaction with materials and the opportunity to create a work that would utilize the photographic image as the raw material rather than as the final product.

The caulked reconstruction introduces a primitivism that radicalizes the pictorial representation, permuting the machine-made image. The notion of destruction and abstraction of a subject to create a new dynamic construction is not without precedent, having antecedents in the work of many twentieth-century artists. The "destruction of the old representational image in order to achieve new experiences, a new wealth of optical expression," to use Moholy's words, is precisely what is afforded in the caulked reconstructions.

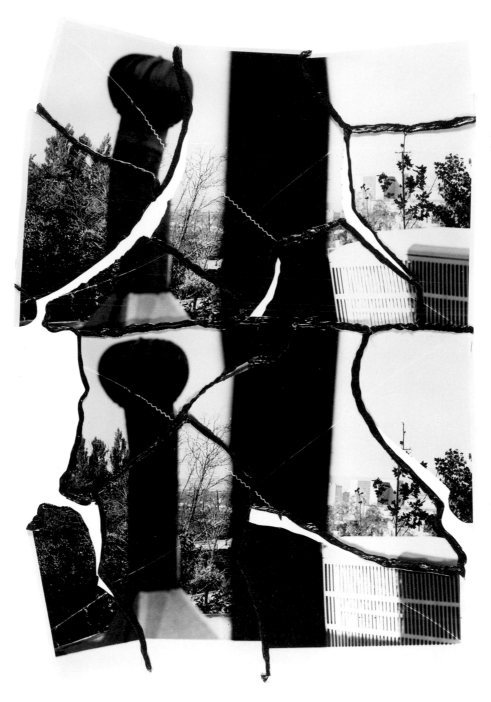

From the series Modest Structures—Downtown Albuquerque, 1981

Working with black-and-white prints, Barrow has festooned some with colorful spray paint but leaves the majority monochromatic. *Springerville Fragment*, 1980, is a caulked, reconstructed photograph with spray paint applied. This print is the basis for the smaller scale lithograph, *Springerville Variant*. *Springerville Fragment* is an energetic, brash composition, loaded with vivid colors—magenta, ochre, and blue. The thick beads of caulking patch together the pieces, adding a surprising impasto to the surface. By dismantling the original print Barrow is free to reconstruct the subject and entire composition as he pleases. The refined print, formerly aloof and reserved, is given a dynamic life as the rectilinear frame of the photographic print is smashed, with the patches erratically protruding. The irregularity of the edges is important to Barrow, for it engages the edge of the picture, never assuming that a straight line will demark the perimeter. Thus predictable shape and scale are obliterated, transformed into a new construction. The flat plane and integrity of the paper are no longer unalterable conditions of the medium. Dismissing the restrictions of the neat rectangular sheet and altering them at will, Barrow considered each print, questioning how it might alternatively be posed. And once again chance is invoked in the ripping, reordering, caulking, and stapling. Thus the final version is never predetermined but takes shape as the transformation progresses. In the negation and disruption there is a playful dadaist approach, with the essential reorganization and reconstruction derived in part from the constructivist concepts. The caulking imbues the print with a palpable visceral quality, giving a three-dimensionality to the surface.

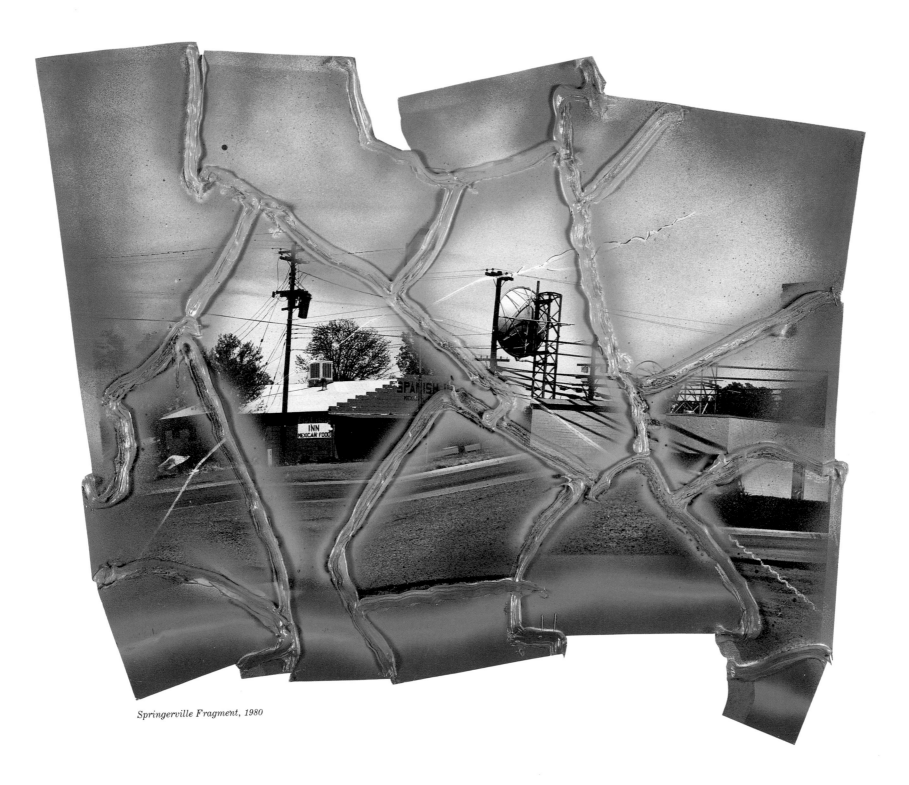

Springerville Fragment, 1980

Teepees, 1979, and *Holbrook, Arizona*, 1981, are two similar works based on the ersatz tepee structures in the Southwest, dated, kitschy motels that are now part of vernacular architecture of the highway. They are not cancelled prints, as some of the landscapes are. The thick fractures that run irregularly across the print set up a curious visual pun, reading, like the X mark of the Cancellations, as a plane in front of the subject. This enhanced sense of depth adds another dimension to the work. Intense sprayed colors of red and gray change the pallid scene. The addition of this war paint and the crooked borders confirm that the original black-and-white print was merely an intermediary step on the way to the final one.

This painting and caulking suggest a patent disregard for the sanctity of the photograph, raising questions about the adequacy of the straight photograph, and about the limitations of the medium. Beyond the formal structural changes, Barrow is experimenting with the way in which photographic imagery functions. He is testing how alteration affects an image's legibility and meaning and toying with veracity of the faithful witness. Once an image is so radically altered, how does this affect our reading of the content? Barrow also is looking toward arbitrary rearrangement of the elements, questioning whether photography can enjoy the same latitude as painting to expand its definition. If the Cancellations questioned the issue of marketability of art photographs, the caulked reconstructions take up that issue more stridently by making each version unique, even though the image can be infinitely reproduced. More important, they challenge the pictorial traditions of the medium, especially with regard to landscape.

It was perhaps inevitable that Barrow would look beyond the single frame and the single sheet of paper in his interests to transform the image. He broke the limitation of size and format by making diptychs, dual images that were caulked and stapled together. In diptychs using the same image, a stereographic effect is created, which changes the visual structure of the work and questions the nature of the multiple image. Although the images were identical at the start, the appearance of each frame is determined by the random order of the tears and reassembly of the parts. The disparity between the two indicates the transformation of visual data that is possible. The whole piece rests with neither frame exclusively, but is a synthesis of the two frames joined together.

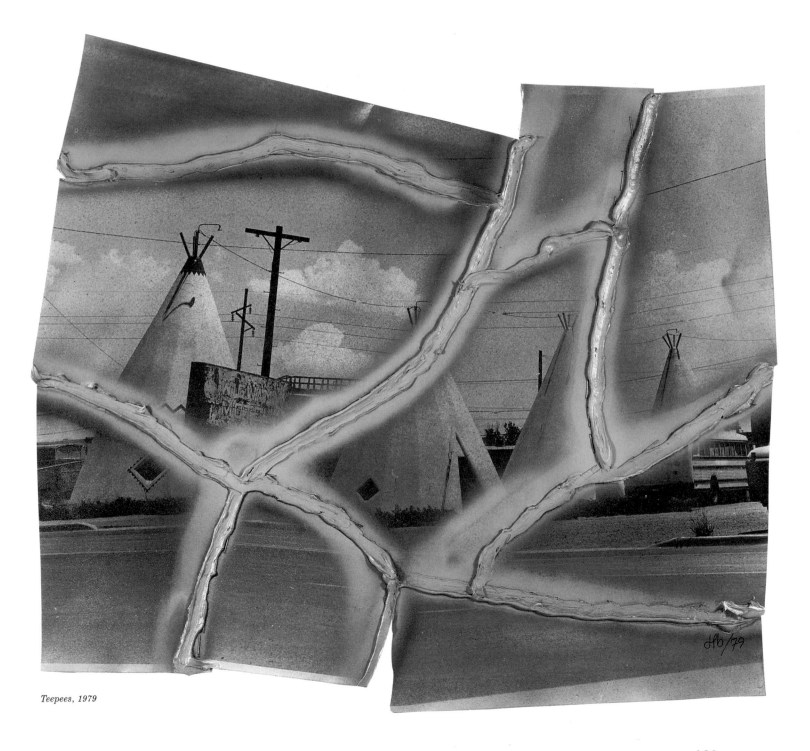

Teepees, 1979

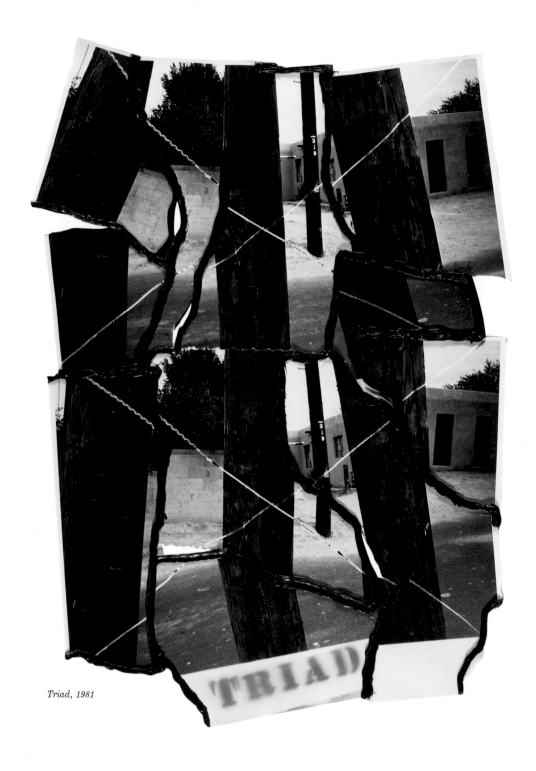

Triad, 1981

Many of the caulked reconstructions are fabricated from cancelled prints, using the same openness, the same mundane views presented in bright light and monochromatic tones. In a vertically oriented diptych, *Untitled (Tank Farm), Near Socorro*, 1980–81, from the series Modest Structures, Barrow focuses, as he often has, on a single industrial structure in the midst of the empty, arid desert terrain. Although both frames are from the same negative, each has been dismantled and reconstructed differently, making the whole slightly more squat than it should be. At the caulked border in the middle, the disparity between the two prints can be readily seen. The similarity between the two formerly identical prints is further diminished by caulk patterns that break up each print into different irregular parts. The work invites comparative assessment, as each fragment is checked against its counterpart on the other sheet. The torn photographic paper has curled and buckled, further contributing to the unevenness and irregularity of the appearance. The gooey caulk is silver, matching the silver spray paint that is applied around the edges and to other parts of the print. The caulking and

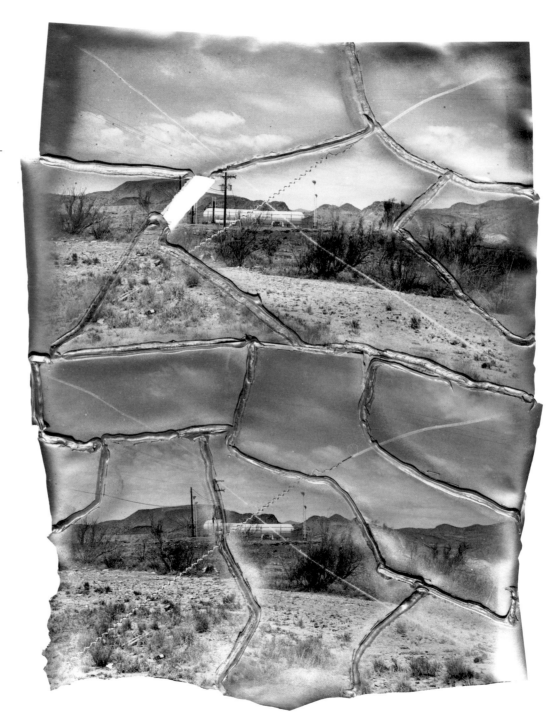

From the series Modest Structures—
Untitled (Tank Farm), 1980–81

automobile paint again demonstrate Barrow's fascination with industrial materials. A clear lacquer has also been applied to the print. The combination of the lacquer and spray paint gives the print a luminescence that complements the pale gray sky and bright silvery tonality of the prints. The pieces are stapled together, reinforcing the caulked joints and giving the print an industrial suturing befitting the subject. In the disruption of space, Barrow toys with illusion and reality.

171

Barrow's destruction of the flat picture plane—a canon in painting far longer than photography—is similar to the experiments that Rauschenberg undertook in moving painting beyond the picture plane. Furthermore the rejection of the certainty, rigidity, and dominant rectangularity of the sheet—the breaking of the form by Barrow—parallels the efforts of established painters Frank Stella and Elizabeth Murray, though theirs is an abstract orientation. The dilemma posed by the caulked works is that the form and methodology are more at ease with abstraction and at odds with the literalness and realism of the image. This collision creates a profound discord, exactly the point of Barrow's investigations.

The precise literalness of photographic imagery contradicts the rough, gestural additions that aggressively subvert the pristine image, creating, to use Barrow's term, a "visual argument." Far more than in the collages there is a tension between the primary photographic detail and the manner and form of presentation. In the caulked works Barrow traverses tentative aesthetic terrain assuredly at odds with the typical pictorial format of photography. The extreme violence, the phlegmatic subjects, and the absence of pictorial normalcy makes these works difficult to accept. Not at all an outgrowth of neo-expressionism, the brutal gestural vigor of these prints offers Barrow another means to engage the structure of the work and question the nature of photographic vision.

Joining two sheets of photographic paper to form a diptych was not limited to images placed beside each other. *Homage: The Bechers*, 1981–82, is a vertical assemblage with an industrial subject confirming that the title refers to German artists Bernd and Hilla Becher. Strangely, the reconstruction of the prints works well with the severe architectonic black structure. This piece clarifies Barrow's interest in comparative views and typology. Much like the Bechers' towers (each nearly the same but with subtle variations), we can deduce however that Barrow's towers were originally the same, before their random alteration. No effort has been made to retain the original shape, and vertical elements are now skewed, giving the structure a more frenetic appearance. The multiple image used before by Barrow is given new form here. Despite the fracturing, the near twins form a harmonious stereo view, reminiscent of the Pink Stuff prints.

The monolithic verticality of the
building is enhanced by the format. In
its bold simplicity one scarcely notices
the X marks crossing each frame. In
keeping with the strict tonal range of
this work Barrow has used a gray
caulking. Silver and black spray paint
has been applied to the prints but
limited to one vertical strip along the
left, echoing the form. The
contrapuntal frames make the work
livelier, richer, and more puzzling
than one frame could.

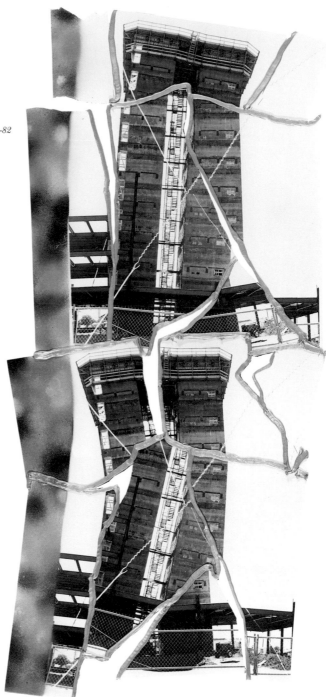

Homage: The Bechers, 1981–82

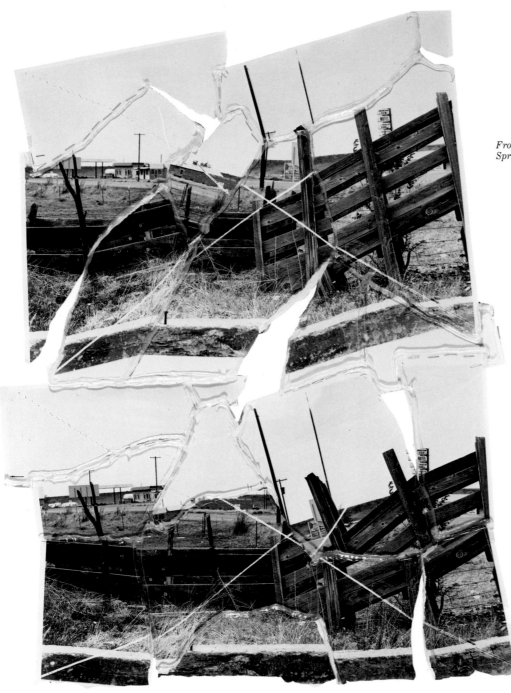

From the series Modest Structures—
Springerville, Az, 1980

The echo between frames can be seen in a number of the caulked landscapes. *Springerville, Az.*, 1980, from the series Modest Structures, uses the pronounced fractured fence pattern to establish a strong gestural sweep across the frames. The alternation of black and white and emphatic horizontality play with the composition optically, flattening and reducing it. Because the thick viscous caulking is clear, it hardly obtrudes into the composition.

The prints are not always pieced together with continuity. In some there are missing fragments or crevasses in the midst of the picture plane. *Camouflaged Pictorialism*, 1982, another tall diptych, is executed in this fashion. The two bland views of a dirt road again are identical photographs before the mutilation. In the center of the lower frame a gaping hole obliterates the integrity of the print, widening the composition, and changing the dimensions of the scene as well as the paper. The left edge is a neat straight line, while the other edges are jagged and irregular. But the clean left edge is itself discontinuous and transformed, for it is a strip of photographic paper that has been painted over in drab greens and ochres in a leafy camouflage pattern, contrasting with the barren vista.

In these works Barrow obliterates the rectangular frames and the neat perimeters of the photographic print, expanding the scale. But beyond the simple change in size, these works illustrate his iconoclastic irreverence, his desire to transform the common photographic print into a unique object released from an obligatory design.

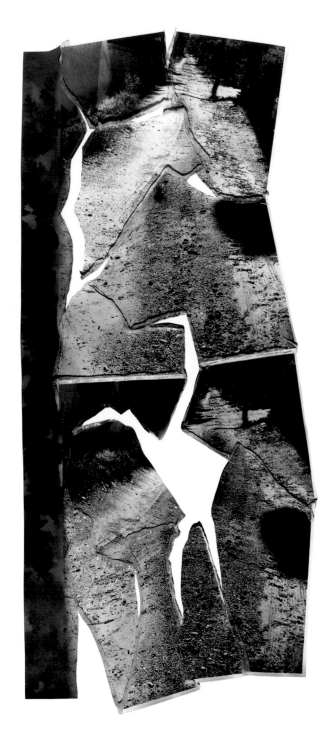

Camouflaged Pictorialism, 1982

175

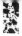

Recent Works
Since 1983

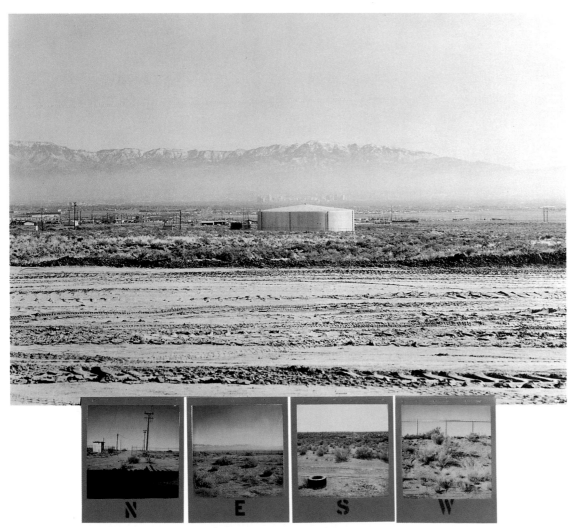

From the series Water as Matrix—
Don Reservoir, 1983

In recent years Barrow's production of work has been looser and less precisely catagorized. The sprayed photograms have continued, but with changes in format and density that mark a shift from those executed between 1978 and 1982. His pieces are generally more discrete now, indicative too of the smaller output in the past several years as the works evolve in a slower fashion. They show an attention to the physicality of objects, much as in the caulked reconstructions.

Somewhat distinct from the others is a group of prints that Barrow produced for a specific project, a photography survey of New Mexico organized by the Museum of Fine Arts in Santa Fe. After considering various approaches, Barrow finally settled on an idea in 1983 that fulfilled a documentary need as well as his current interest in collage. As in the Cancellations, these prints examine aspects of the southwestern landscape. Indeed the two groups are similar in their brown tonality and their attention to ordinary industrial structures and topical aspects of civilization in the West. For this project, Barrow concerned himself with the presence of water for an urban development in the midst of the barren, arid desert terrain, documenting the various facilities designed to contain or pump the vital resource. Because these prints were executed for a specific, episodic commission Barrow felt that they should have a visual solution and appearance different from his other contemporaneous pieces. The works made for the project are a tight group of photographic collages.

Attention to architecture, seen throughout the earlier works, is paramount here. Barrow directly confronts the water tanks, wells, and pumping stations as simple objects, befitting the documentary nature of the project. Presenting the mundane vernacular structures as the focus of eleven-

by-twenty-inch sepia prints formalizes them. Yet the austerity is mitigated by the colorful Polaroid prints that are attached below the central image, providing views of the structure from all four directions as indicated by the N, S, E, and W stenciled onto the borders. Just as with his sprayed photograms and caulked reconstructions, Barrow simply stapled the additional Polaroids to the photograph. Because of the consistency and precision of the format, these works are more methodical, clear, and restrained than his other works.

The Polaroids not only change the scale and rectangular format and interrupt the flat plane of the surface, but they ground the excerpted subject in the real world, providing its milieu quite literally by way of visual footnotes. They disrupt the singularity and rarified presentation of the single image, reminding us that it is but a selected fragment estranged from its environment.

By 1983 the sprayed photograms were taking a turn from the preceding works of this group. The chief distinction is the ascendancy of collage as a dominant element in the work challenging the spray-painted picture. Although applied Polaroids can be seen in works almost since the beginning of the group, they had always been subordinated as components within the overall composition, typically one to three prints affixed to the surface. In the newer spray works the Polaroids take on a more emphatic presence, substantially altering the physical picture plane and the composition.

The photograms were changing in other ways as well. Evolving more slowly, sometimes over as much as eighteen months, the prints have become more abstruse and denser. They are less immediately accessible and more visually discordant. The agreeable warm tones of the early spray prints have given way to dark prints with black

From the series Water as Matrix—
Santa Barbara Well, looking east, 1983

177

"The Polaroids

are like notes

that a

writer jots

down.

I use them to

construct

a piece;

they work in

tandem

with other

elements."

backgrounds and pronounced colors.

The later photograms are not as facile as the early ones, and the viewer is obliged to wade through a profusion of information, slowly decoding and piecing the details together. Barrow uses more opaque items, at times not even placing them directly in contact with the photographic paper, purposefully limiting their clarity. He uses a light pen or other source along with a flashing technique that cuts down on the precision of details. The clarity and the careful balance of the early works are dispensed with to a great degree as Barrow continues to push the limits of legibility and content saturation, making the new prints more loaded and complex.

In *Notations on Modernism,* 1981–83, the clarity is intentionally obscured through the overlay of dark red and black spray paint and the dense montaging of imagery. This work is singular in that it carries no stenciled title as the other sprayed photograms do. The collage of five Polaroids that stream down the page dominates the otherwise severe monochromatic background. The Polaroids are no longer melded into the composition but stand as the principal component. The five images provide the primary clues to the work, each illustrating some aspect of twentieth-century culture.

The alternating red and black borders of the Polaroids suggest a reference to Constructivism, a notion supported by the content of several of the images. The top picture is wholly monochromatic, and, despite the strong abstract pattern formed by the shadow of the venetian blinds, it blends completely with its black frame into the darkness of the background. The role of art and the concept of the avant-garde are directly addressed in the Polaroid taken from Suzi Gablik's article on the sell-out of modern art, in which she notes the transformation from its original position of isolated experimentalism to its current role as a commodity in the bourgeois marketplace. Since the image is purely of text and can be easily read, this print is obviously intended as a pivotal clue for deciphering the collage, working in tandem with the title.

Barrow's consideration of the various guises of Modernism is clearer in the Polaroids than in the background print, where a blurry group or class picture is the most decipherable element. Most of the other aspects are illegible and camouflaged. Architecture, cited in both text and image, is included, as well as the usual miscellany— catalogue items and recipes—that typify the spray prints. The montaging and strident black-and-white imagery reminiscent of experimental cinema and Futurism further contribute to the aura of Modernism. Various details, submerged as they are, form a historical reference to the advances of art from the Greek world, through Byzantine and Romanesque art to the mid-twentieth century.

The zany red-bordered image second from the top represents the pervasive influence of Modernism in our century by showing the metropolis with a cavalcade of vaudevillian girls dressed as New York skyscrapers. This reproduction offers a wry comment on architecture and culture and illustrates Barrow's penchant for the peculiar exponents of progress.

This work does not pretend to explain Modernism, but rather posits manifestations of modernity in art, architecture, and film set against a rich, but indistinct cultural background. Indeed, the piece seems to question the role of the artist today vis-à-vis past contributions and our changing concept of the place of art in culture.

Evolutionary Notes, 1983, similarly uses Polaroid prints as a primary component, breaking up the predictability of the print. Here, though, four prints are uniformly attached on the right and left sides. Their clarity and small glossy surface contrast with the opacity of the central photogrammed print. As the title implies, the Polaroids are used in a casual, notational manner providing oblique references to evolution. The sprayed print addresses the issue of progress using a montage of typographic fonts and reference to the development of the alphabet. Contrasting with dinosaurs and fossils

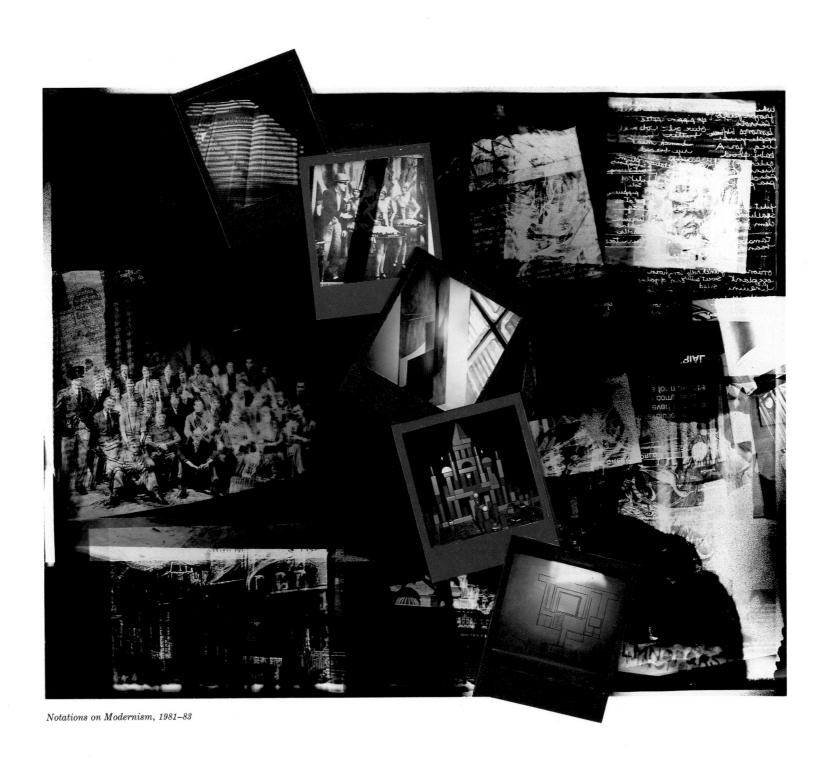

Notations on Modernism, 1981–83

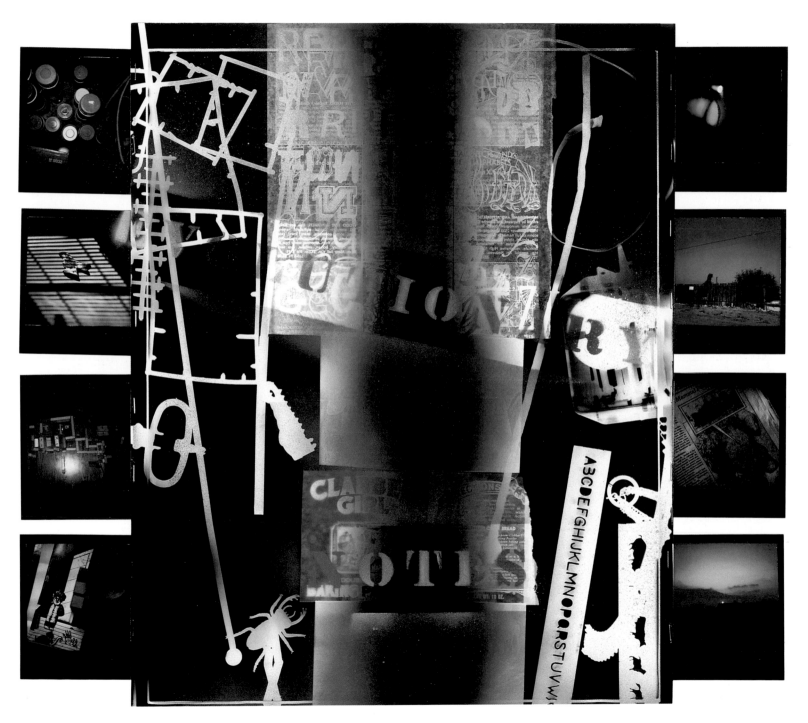

Evolutionary Notes, 1983

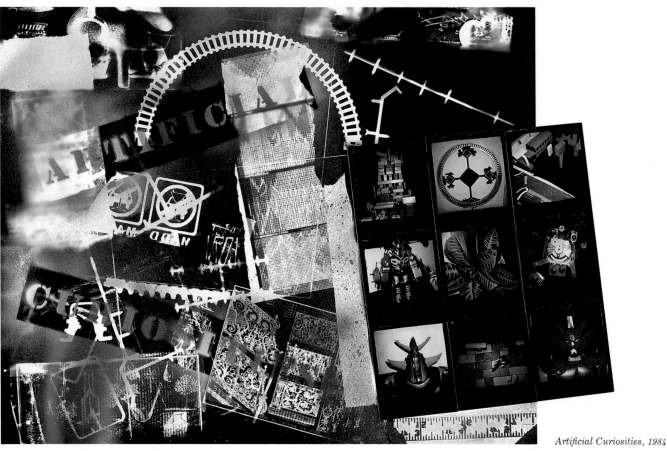

Artificial Curiosities, 1984

are photograms of plastic oddments, more contemporary remnants.

Barrow's exploration of the uses of the small applied Polaroid prints is most pronounced in *Artificial Curiosities*, 1984, in which a grid of nine Polaroids tilt out of the background print border and protrude several inches to the right in front of the surrounding mat. This work shows considerable discordant interaction between the warm-colored Polaroid prints with their exacting details of toys and the softer, indistinct photograms. The low-resolution/high-intensity clutter of the background print indicates Barrow's interest in increasing the content in the print in an oversaturation of details and colors, all moving in different directions. The content of the Polaroids is of an artificial nature; they are all manufactured objects except for the mechanistic, artificial-looking plant. It is not nature that commands attention but that which man has produced.

This cacaphony of detail is apparent in all of the recent spray works after 1983, such as *Syntactic Recognition*, 1984, and *La Moindre Lumière*, 1985. Slightly larger in scale (twenty-four by twenty inches), the arcane detail

La Moindre Lumière (Le Chat Noir), 1985

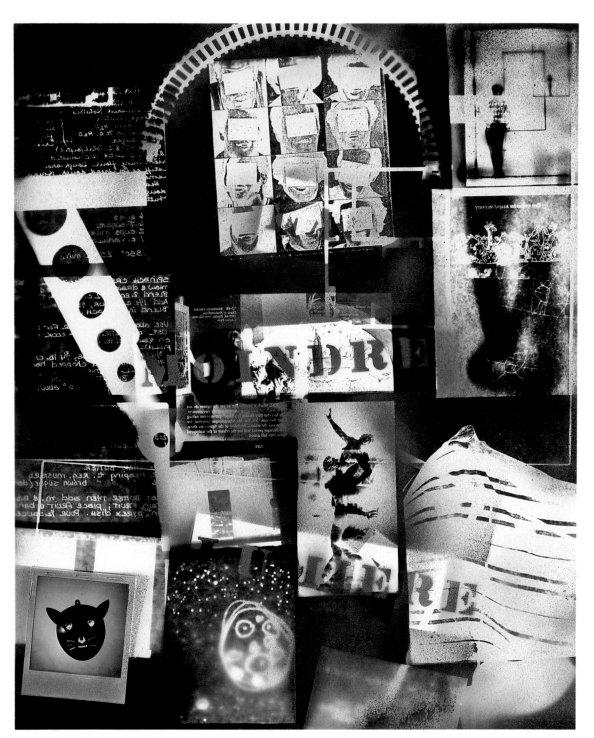

competes for attention with the connections by classifications of categories. Both works are about cognition and illustrate Barrow's interest in the relationships between disparate items, their interpretation and meaning.

Using the Polaroid for what Barrow sees as "notational recording" is clearly evident in *Capitalism Graphed*, 1983–84. This work is unlike any others to date and unrelated to other prints directly, being composed solely of eleven Polaroid prints mounted side by side on a sheet of black plastic laminate. They easily blend into the background, for the borders have been sprayed with black paint, thrusting attention thoroughly onto the imagery. The first five prints are pinkish, while the next six are green (owing entirely to the variations between two different batches of Polaroid film). Like other works, the reproduction again serves as the source for this work. A monochromatic line drawing is the subject of each frame.

Barrow's enthusiasm for Polaroid prints is due in part to their informality and also to their being discrete, somewhat dimensional objects. The ease of production well

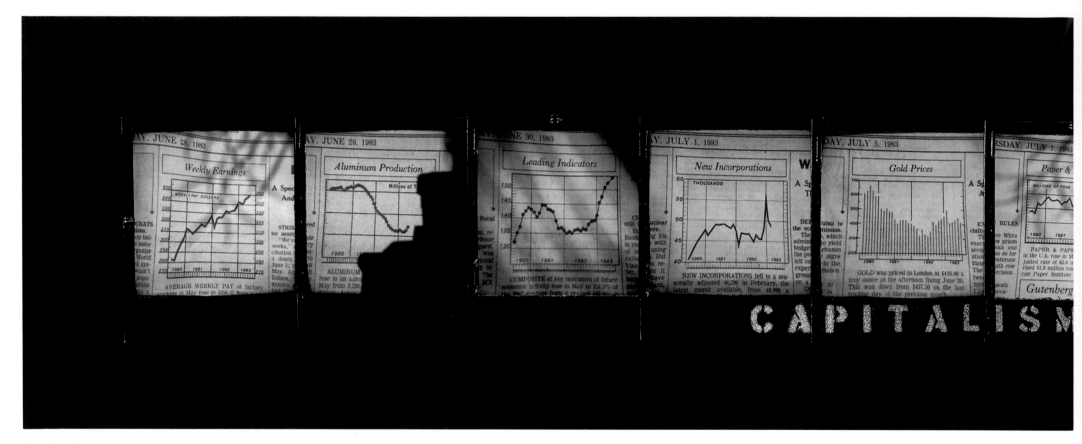

Capitalism Graphed, 1983–84

suits his use of the prints as notations to jot down visual ideas that will be subsumed or related to a work in progress.

In *Capitalism Graphed*, however, the approach toward Polaroids is more methodical and intentional than in the spray prints. The consistent modularity and presentation also testify to this intentionality. Yet, each single image is of only minor significance, a simple daily fragment gleaned from the *Wall Street Journal*. Although each frame functions separately, it is more informative in the comparative serial context of various registers of the American economy. From left to right the graphs chronicle the change in such areas as aluminum production, gold prices, paper and paperboard, unfilled orders, unemployment rate, factory shipments, and proliferating oldsters. Some measure the shift during a week or month period, or in the case of the oldsters, over a five-year period. Barrow shot these eleven images during several weeks in July 1983, thus making his work a literal social document; this statement on the

184

economic structure is consistent with Barrow's focus on the found textual reproduction, more cerebral in impact than visual.

In the past few years Barrow has produced three three-dimensional works incorporating books and Polaroids. They represent his constant interest in the theme of books and literature. The first,

Memories of Stendahl, 1982–84, is a wall piece composed of one volume, an insignificant old textbook that has been wholly transformed by numerous layers of spray paint. The book has a delicate, warm, muted coloration resulting from the subtle paint build up. Tied together with cord, the book has nine Polaroid prints radiating outward from the spine and pages,

parallel to the cover. While the cover is grainy and muted, the Polaroids have crisp red or black borders that are bright in comparison, in harmony with the glossy precise photographic images. The title is suggested in part from the red and black borders of the photographs, recalling Stendahl's novel. Besides the images of books, there is little else though to link the

185

Memories of Stendahl, 1982–84

Strange Attractor, 1984

Principles of Transformational Syntax 2, 1982–83

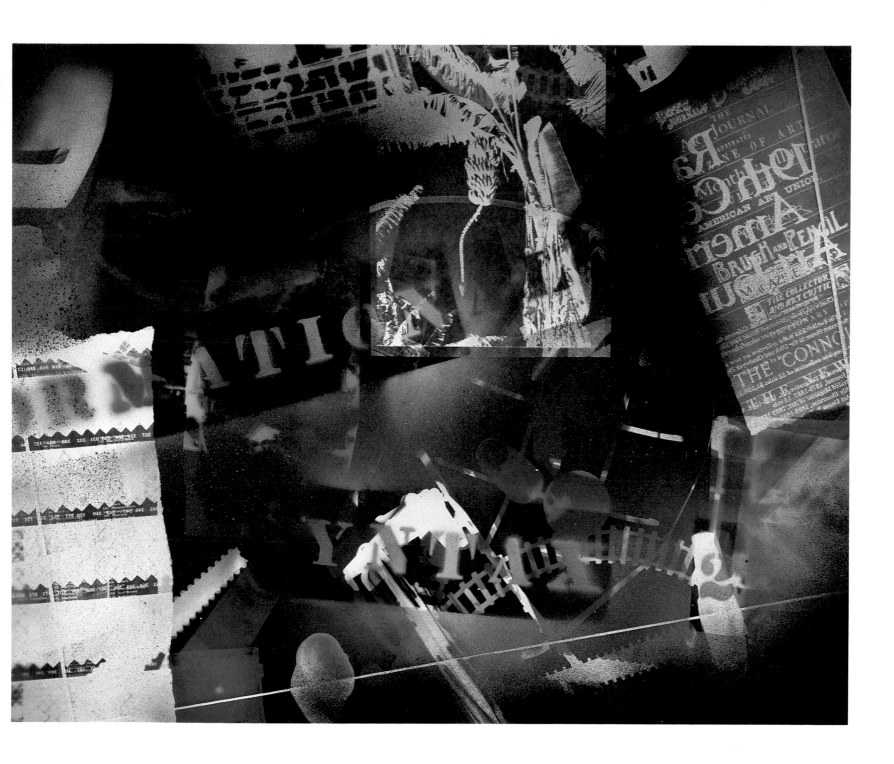

Rigidity Assumption, 1984

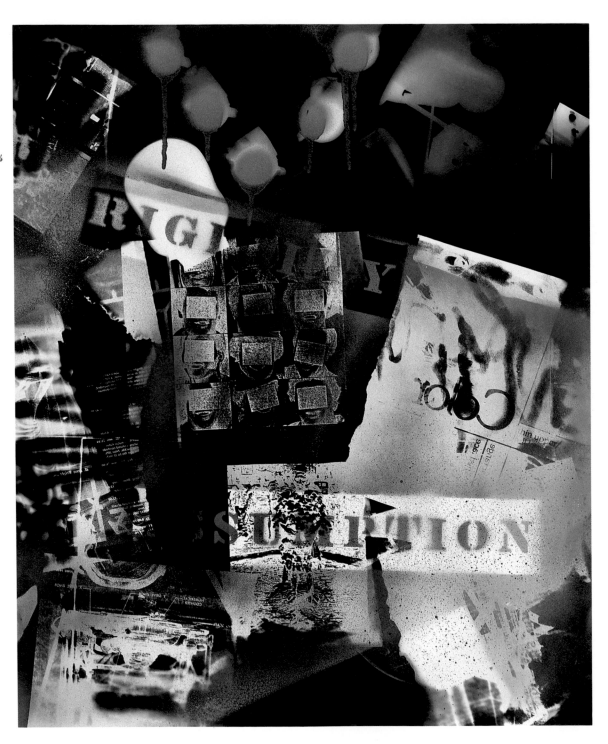

Reading into Photography, 1985–86

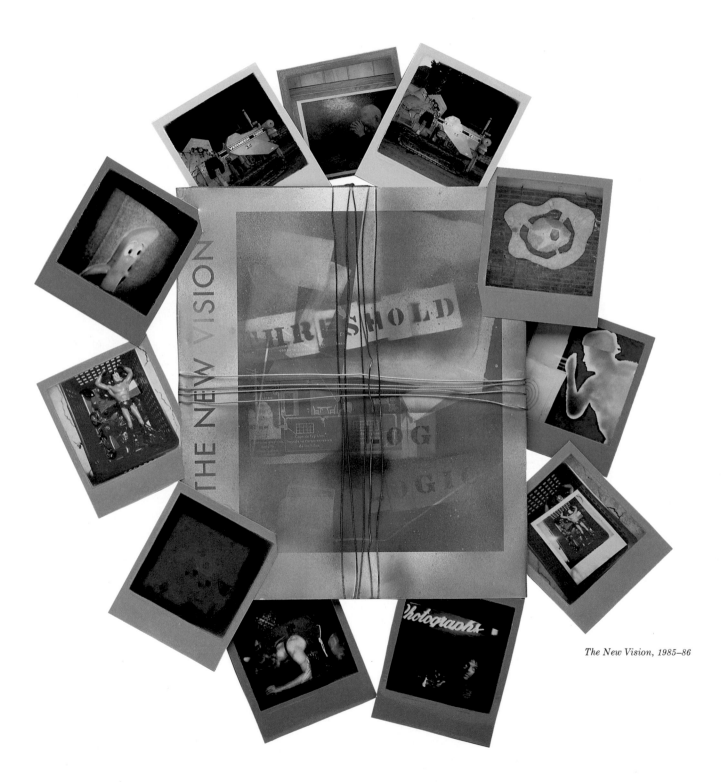

The New Vision, 1985–86

title directly to the visual aspects of this work.

In these book works, the photograph is reduced to a supporting position, rather than being the principal element. The book provides the theme, the foundation, and physical focus. The prints provide the details and the expanded interpretations and function somewhat like epigrams. They are, Barrow observes, notations, and thus are fragmentary, informal, and suggestive, rather than being fully resolved and important images. The photographs are informational, at times anecdotal, intended to work serially rather than standing alone. Many reflect aspects of Barrow's life; many are notations of odd, insignificant items.

Images of incidental items alternate with images showing books, groups or stacks of them, and an article on libraries from the *Times Literary Supplement*. As Barrow moves away from the flat image to collage, and, further, to a three-dimensional form, the photograph becomes more casual and incidental. The form as well as the function of the photograph shifts, subordinated as it is to the larger central component. The Polaroids, each playing a minor part, function together as a single element in many of Barrow's works from this period, thus carrying on the notion of layering information and images, of combining multiple parts into a larger assembly.

The interaction among the printed word, the book as object, and the photographic image is seen in two other similar works, *The New Vision*, 1985–86, and *Reading into Photography*, 1985–86. These pieces again call attention to the book as a multiple. It is the vehicle for intellectual discourse, a source of information, and an indicator of style that codifies its contents. Both works have a strong autobiographical association, for Barrow's images or writing are contained within. More significantly though, the books refer to imagery and thought that are important to him and influential in the evolution of photography. *The New Vision*, a single wall-mounted volume is more particular in its reference to the Institute of Design and its heritage. Additionally, the cover bears an important piece, *Threshold Logic*. *Reading into Photography* is a stacked multiple of nine soft-bound volumes that contain a wide range of essays on photography. In both, the Polaroids are but components of the three-dimensional assemblage. These are homages to books, much like the Libraries of a decade ago, but they are now more physically, sculpturally realized than the straightforward prints of that series. Collage here is intensified, moving off of the flat surface of the paper to a more expansive solution.

Barrow's recent work has become less serialized and more varied as he uses the photograph as a component of a larger whole. He is no longer bound by the immutable perimeter or the stock rectangularity of photographic paper; this work depends less on simple visual elements than on the implications of its content. Montaging continues, as does Barrow's curiosity with cultural detritus, while he pays increasing attention to the physicality of the work in his perpetually iconoclastic approach toward photography.

Footnotes

Prologue

1. Also see Frederick Jameson, "Post Modernism and the Consumer Society," in *The Anti-Aesthetic*, ed. Hal Foster (Port Townsend, Wash.: Bay Prss, 1983), pp. 124–25.

2. The profound change in postwar society and influence of the media shaping art during that period have been discussed in Christopher Finch, *Pop Art: Object and Image* (London: Studio Vista Limited; New York: E. P. Dutton and Co., 1968); Mario Amayo, *Pop Art . . . and After* (New York: Viking Books, 1965); and John Russell and Suzi Gablik, *Pop Art Redefined* (London: Thames and Hudson, 1969).

3. Thomas Barrow in *Photo Facts and Opinions*, ed. Kelly Wise (Andover, Mass.: The Addison Gallery of American Art, Phillips Academy, 1981), p. 13.

4. In the summer of 1937 Moholy-Nagy opened the New Bauhaus in Chicago, but for lack of support it closed in April 1938. In February 1939 the school reopened as the Chicago School of Design, changing its name in 1944 to the Institute of Design. In 1949 the Institute of Design became part of the Illinois Institute of Technology (see "Chronology," *Aperture* 87 [1981]: 73).

5. "A Visionary Founder: László Moholy-Nagy," *Aperture* 87 (1981): 7.

6. Charles Traub, "Photographic Education Comes of Age," *Aperture* 87 (1981): 23.

7. Traub, p. 7.

8. László Moholy-Nagy, *The New Vision*, 3d rev. ed. (1928; New York: Wittenborn and Company, 1946), p. 19.

9. Renato Poggioli, *The Theory of the Avant-Garde* (Cambridge: Harvard University Press, 1968).

10. The use of the magazine pages for photogramming and its place at the Institute of Design course of study was brought to my attention by Aaron Siskind (interview, Providence, R.I., May 1984).

The Series "fashion"

1. Barrow used the lower case *f* both as a typographic decision, reflecting his Bauhaus sensibility, and also to indicate the generic nature of the subject. Also beginning with this series Barrow began including "from the series" in the titles of prints. Typically this is abbreviated as "f/t/s," forcibly placing each print within a larger whole. For clarity and brevity, that designation is eliminated in this essay.

2. Barrow notes that he had the opportunity to see many fashion magazines while growing up for his mother ran a dress shop and subscribed to all the fashion publications.

3. Marshall McLuhan, *Understanding Media* (New York: McGraw Hill Book Company, 1964), p. 176.

4. Barrow provides the deciphering in his title, for only "THE FO" is visible on the print.

The Television Montages

1. John Hanhardt, "Video/Television Space," *Video Art* (New York: Harcourt Brace Jovanovich, 1976), p. 220. He also notes that statistics show that 97 percent of American homes have at least one set.

2. The television is an example too of the experimentalism and interaction between technology and the avant-garde that Poggioli speaks of in *The Theory of the Avant-Garde*, p. 138.

3. See Douglas Davis, *Art and the Future* (New York: Praeger Publishers, Inc., 1973), p. 60; also Herbert Read, *Art and Industry: Principles of Industrial Design* (New York: Harcourt Brace & Co., 1935).

4. See Douglas Davis, "Video in the Mid-70's: Prelude to an End/Future," *Video Art* (New York: Harcourt Brace Jovanovich, 1976), p. 196.

5. See Caroline Fawkes, "Photography and Moholy-Nagy's Do-It-Yourself Aesthetic," in *The Camera Viewed*, ed. Peninah R. Petruck (New York: E. P. Dutton, 1979), 1:175–96.

6. Gregory L. Ulmer, "The Object of Post Criticism" in *The Anti Aesthetic: Essays on Postmodern Culture*, ed. Hal Foster (Port Townsend, Wash.: Bay Press, 1983), p. 86.

7. See James Monaco, *How to Read a Film* (New York: Oxford University Press, 1977), pp. 312–13.

8. Although the man in the iron mask seems to allude to the Alexandre Dumas novel, the helmet belongs to a race-car driver. This visual confusion and multireferenced association had a certain appeal to Barrow.

9. Barrow is interested in camouflage, its military evolution and uses in contemporary civilian life, from the Constructivist "dazzle" pattern used on battleships in World War I, to the painting of ordinary motor vehicles as well as its uses in art. See Roy R. Behrens, *Art and Camouflage: Concealment and Deception in Nature, Art, and War* (Cedar Falls, Iowa: North American Review, University of Northern Iowa, 1981).

The Series Pink Stuff and Pink Dualities

1. See Robert Sobieszek, ed., *Robert Fichter Photography and Other Questions* (Albuquerque: University of New Mexico Press, 1983), p. 88. Compare catalogue number 21 *Driver and Road*, 1967, and catalogue number 37 *Double Rochester Vision*, 1968.

2. László Moholy-Nagy, "From Pigment to Light," in *Photographers on Photography*, ed. Nathan Lyons (New York: Prentice Hall, Inc., 1966), p. 80.

3. Moholy-Nagy, *The New Vision*, p. 37.

4. The zeppelin schematic image also forms the basis of two contemporaneous sprayed photograms, *Optimal Control*, 1980, and *Recent Advances*, 1981.

The Verifax Prints

1. André Bazin, "The Ontology of the Photographic Image," *Modern Culture and the Arts*, ed. James B. Hall and Barry Ulanov (New York: McGraw-Hill, 1972), p. 472.

2. Marilyn McCray, *Electroworks* (Rochester, N.Y: International Museum of Photography at George Eastman House, 1979), p. 5.

3. Herbert Read, *Art and Industry: The Principles of Industrial Design* (New York: Harcourt Brace & Co., 1935).

4. See Lewis Mumford, *Art and Technics* (New York: Columbia University Press, 1952).

5. One might consider a parallel in the innovative work achieved by those who had use of Polaroid's 20 × 24 camera, where there was the same necessity of bringing the subject to the studio, resulting in a different attitude toward image making.

6. This is an oblique reference to the glass of water noted in Moholy-Nagy's *Malerei Fotographie Film*, reprint (1927; Mainz: Florian Kupferberg Verlag, 1967), p. 130.

7. At that time, N.E.A. grants were not awarded for fixed amounts but rather were based on the artist's request and the proposed project.

The Series Libraries

1. Thomas Barrow, "Three Photographers and Their Books," *One Hundred Years of Photographic History: Essays in Honor of Beaumont Newhall*, ed. Van Deren Coke (Albuquerque: University of New Mexico Press, 1975), pp. 8–13.

2. Barrow's most notable design effort was for Lewis Baltz's *The New Industrial Parks near Irvine, California*.

3. From Raymond Roussel's *How I Wrote Certain of My Books* in Barrow, p. 12.

4. Dana Asbury, "Thomas Barrow," *Contemporary Photographers* (New York: St. Martin's Press, 1982), p. 45.

5. See Gregory Battcock, ed., *Idea Art* (New York: E. P. Dutton & Co., Inc., 1973), pp. 1–2.

The Series Cancellations

1. Barrow initially taught one course in the art department; in 1976 he moved from the museum to the art department as an associate professor. Previously he had taught photography at the Rochester Institute of Technology and State University of New York, Buffalo.

2. See David Hanson with Max Kozloff, "Photography: Straight or on the Rocks?," *Aperture* 89 (1982), p. 6. Jonathan Green also describes these views as "intentionally ill-composed, misled by the phlegmatic subject matter" (*American Photography* [New York: Narry N. Abrams, 1984], p. 177).

3. William Jenkins, *New Topographics* (Rochester, N.Y.: International Museum of Photography at George Eastman House, 1975), p. 5.

4. Henri Man Barendse, "Thomas Barrow's Cancellations: The Contradictions Between Doing and Undoing," *Afterimage* (October 1977): 7.

5. Jenkins, *Extended Document*, p. 3.

6. *Pile* is an example showing the circular punches, although in that work they reiterate the circular openings of the concrete pipes and thus seem more premeditated than the diagonal marks. In *H₂O Whole Plate Series*, 1974, Barrow made punctures in the negative, which read much like bullet holes in the wall.

7. In *Field Abrasion*, 1976, for example, the scratches seem to be more contrived because of their similarity to the track-ridden graded earth and windswept furrows.

8. The absence of a title here was purposeful, for Barrow wished to differentiate this print—published in an edition of 120 as part of the *New Mexico* portfolio, 1976—from the other Cancellations, which exist only in extremely small numbers.

The Lithographs

1. The background image of *Films* is a failed Cancellation negative that did not satisfy Barrow.

The Spray-Painted Photograms

1. This technique—the term deriving from the French "to spit"—of splattering ink has been used in printmaking and interested Barrow as a weightier version of the diaphanous spray.

2. See Caroline Fawkes, "Photography and Moholy-Nagy's Do-It-Yourself Aesthetic" *The Camera Viewed*, ed. Peninah R. Petruk (New York: E. P. Dutton, 1979), p 189.

3. László Moholy-Nagy, *Malerei Fotografie Film* (Mainz: Florian Kupfenberg Verlag, 1967 reprint of 1927 ed.), p. 77.

4. László Moholy-Nagy, "Pigment to Light," in *Photographers on Photography* ed. Nathan Lyons (Englewood Cliffs, NJ: Prentice Hall, 1966), p. 77.

5. Andreas Haus, *Moholy-Nagy Photographs and Photograms*, tr. by Frederic Samson (New York: Pantheon Books, 1980), p. 47.

6. Moholy-Nagy, "Photography Is the Manipulation of Light" in Haus, p. 48.,

7. Ulmer, "The Object of Post Criticism," p. 84.

8. See Moholy-Nagy, "From Pigment to Light," p. 74.

9. The titles are taken from books listed in the MIT Press catalogue, other university press catalogues, and listings from other publishers.

10. See Stephan Bann, ed. *The Tradition of Constructivism* (New York: Viking Press, 1974).

11. Moholy-Nagy, *Malerei*, p. 39. Moholy also wrote an essay on "The New Typography" for the Bauhaus exhibition of 1923, indicating his early interest in the importance of typography.

12. Haus, pp. 19–20.

13. Other titles appearing in more than one version include *Species Identification, Strange Attractor, Maximum Damage, Glass Studies, Stellar Formation*, and *Location of Zeros*.

14. Also see Barrow's sprayed photogram *Maximum Damage*.

The Caulked Reconstructions

1. Moholy-Nagy, "From Pigment to Light," p. 74.

Prologue

Untitled [Lingerie], 1963
Gelatin silver print
9⁷/₈ × 7⁷/₈ in. (25.1 × 20.0 cm.)
Collection of the artist

Untitled [Dog], 1963
Gelatin silver print
7¹/₂ × 9¹/₂ in. (19.0 × 24.1cm.)
Collection of the artist

Untitled [Magician Quadriptych], 1966
Gelatin silver prints
8 × 9¹⁵/₁₆ in. (20.3 × 25.3 cm.) each (4 parts)
Collection of the artist

Untitled (#1), 1964–65
Gelatin silver print
4⁵/₈ × 4³/₄ in. (11.7 × 12.1 cm.)
Collection of the artist

Untitled (#15), 1964–65
Gelatin silver print
4¹/₂ × 6³/₈ in. (11.4 × 16.2 cm.)
Collection of the artist

Untitled (#17), 1964–65
Gelatin silver print
6¹/₂ × 4⁷/₁₆ in. (16.5 × 11.3 cm.)
Collection of the artist

Untitled (#18), 1964–65
Gelatin silver print
6¹/₂ × 4⁷/₁₆ in. (16.5 × 11.3cm.)
Collection of the artist

Untitled (unnumbered), 1964–65
Gelatin silver print
4¹/₂ × 6¹/₂ in. (11.4 × 16.5 cm.)
Collection of the artist

Untitled (#76), 1964–65
Gelatin silver print
4³/₈ × 6¹/₂ in. (11.1 × 16.5 cm.)
Collection of the artist

Untitled (#45), 1964–65
Gelatin silver print
4³/₄ × 4¹¹/₁₆ in. (12.1 × 11.9 cm.)
Collection of the artist

Untitled (#77), 1964–65
Gelatin silver print
4³/₄ × 4¹¹/₁₆ in. (12.1 × 11.9 cm.)
Collection of the artist

Untitled (#27), 1964–65
Gelatin silver print
4³/₈ × 6¹/₂ in. (11.1 × 16.5 cm.)
Collection of the artist

Untitled (#29), 1964–65
Gelatin silver print
4³/₈ × 6¹/₂ in. (11.1 × 16.5 cm.)
Collection of the artist

Untitled (unnumbered), 1964–65
Gelatin silver print
4¹/₂ × 6¹/₂ in. (11.4 × 16.5 cm.)
Collection of the artist

Untitled (#58), 1964–65
Gelatin silver print
4⁹/₁₆ × 6¹/₂ in. (11.6 × 16.5 cm.)
Collection of the artist

Untitled (#52), 1964–65
Gelatin silver print
6¹/₂ × 4¹/₂ in. (16.5 × 11.4 cm.)
Collection of the artist

Untitled (#42), 1964–65
Gelatin silver print
4⁷/₁₆ × 6¹/₂ in. (11.3 × 16.5 cm.)
Collection of the artist

Untitled (#38), 1964–65
Gelatin silver print
4⁷/₁₆ × 6¹/₂ in. (11.3 × 16.5 cm.)
Collection of the artist

Untitled (unnumbered), 1964–65
Gelatin silver print
4¹/₂ × 6¹/₂ in. (11.4 × 16.5 cm.)
Collection of the artist

Untitled (#88), 1964–65
Gelatin silver print
4³/₈ × 6¹/₂ in. (11.1 × 16.5 cm.)
Collection of the artist

Untitled (#103), 1964–65
Gelatin silver print
4¹/₂ × 6⁷/₁₆ in. (11.4 × 16.4 cm.)
Collection of the artist

Untitled (#90), 1964–65
Gelatin silver print
4⁷/₁₆ × 6¹/₂ in. (11.3 × 16.5 cm.)
Collection of the artist

Untitled (#94), 1964–65
Gelatin silver print
4⁷/₁₆ × 6¹/₂ in. (11.3 × 16.5 cm.)
Collection of the artist

Untitled (#87), 1964–65
Gelatin silver print
4³/₈ × 6¹/₂ in. (11.1 × 16.5 cm.)
Collection of the artist

Untitled (#93), 1964–65
Gelatin silver print
4¹/₂ × 6¹/₂ in. (11.4 × 16.5 cm.)
Collection of the artist

Untitled (#99), 1964–65
Gelatin silver print
4⁷/₁₆ × 6¹/₂ in. (11.3 × 16.5 cm.)
Collection of the artist

Untitled (#100), 1964–65
Gelatin silver print
6⁹/₁₆ × 4¹/₂ in. (16.7 × 11.4 cm.)
Collection of the artist

The Series "fashion"

Untitled, 1967
Gelatin silver print
9⁷/₈ × 7³/₄ in. (25.1 × 19.7 cm.)
International Museum of Photography at
George Eastman House, Rochester, New York

Untitled, 1967
Gelatin silver print
9¹/₄ × 6³/₄ in. (23.5 × 17.2 cm.)
International Museum of Photography at
George Eastman House, Rochester, New York

Untitled, 1967
Gelatin silver print
9¹/₂ × 6⁷/₈ in. (24.1 × 17.5 cm.)
International Museum of Photography at
George Eastman House, Rochester, New York

Untitled, 1967
Gelatin silver print
9¹/₂ × 6⁷/₈ in. (24.1 × 17.55 cm.)
The National Gallery of Canada

Fashion Diptych, 1967
Gelatin silver print
10 × 7⁷/₈ in. (25.5 × 20.0 cm.)
Collection of Robert A. Sobieszek

Zag, 1967
Gelatin silver print
10³/₈ × 8¹/₂ in. (26.4 × 21.8 cm.)
Collection of Robert A. Sobieszek

Fashion Triptych, 1967
4⁷/₈ × 7⁷/₈ in.
Collection of the artist

Strange Room, 1968
Gelatin silver print
7¹/₂ × 8¹/₂ in. (19.0 × 21.6 cm.)
Collection of the artist

Untitled [The Fog], ca. 1968
Gelatin silver print
12⁷/₈ × 10³/₄ in. (32.7 × 27.3 cm.)
Collection of the artist

Defender, 1968
Gelatin silver print
7¹/₄ × 9 in. (18.4 × 22.8 cm.)
Collection of the artist

Untitled, 1970
Gelatin silver print
9⁷/₈ × 8 in. (25.1 × 20.3 cm.)
Collection of the artist

The Television Montages

Homage to E.P., 1968
Gelatin silver print
8⁷/₁₆ × 13³/₈ in. (22 × 34 cm.)
National Gallery of Canada

"M", the Late News Structure, 1968
Gelatin silver print
9 × 13¹/₂ in. (22.8 × 34.4 cm.)
National Gallery of Canada

Material, Tabooed and Refractory, 1968
Gelatin silver print
9¹/₄ × 12⁷/₈ in. (23.5 × 32.7 cm.)
Los Angeles County Museum of Art

Reciprocal Ovum, 1968
Gelatin silver print
8³/₄ × 13¹/₄ in. (22.2 × 33.6 cm.)
Collection of the artist

Catalogue Deuce, 1968–69
Gelatin silver print
8¹/₄ × 12³/₄ in. (21.0 × 32.4 cm.)
Los Angeles County Museum of Art

Late Beatle, early Blake, even Doris Day, 1968
Gelatin silver print
9³/₈ × 13¹/₂ in. (23.8 × 34.5 cm.)
National Gallery of Canada

Art Mechanism, 1968
Gelatin silver print
5¹/₈ × 6¹⁵/₁₆ in. (13 × 17.7 cm.)
National Gallery of Canada

Art Mechanism II, 1968
Gelatin silver print
5¹/₄ × 10⁷/₈ in. (13.3 × 27.6 cm.)
Collection of the artist

Computer Balloon, 1968
Gelatin silver print
5³/₈ × 13¹/₂ in. (13.6 34.4 cm.)
National Gallery of Canada

Cathode Ritual I, 1968
Gelatin silver print
8³/₄ × 13³/₈ in. (22.2 × 34.0 cm.)
Los Angeles County Museum of Art

Cathode Ritual II, 1968
Gelatin silver print
8⁷/₈ × 13³/₈ in. (22.5 × 34.0 cm.)
Collection of the artist

Cathode Ritual IV, 1968
Gelatin silver print
13³/₈ × 8⁷/₈ in. (34 × 22.5 cm.)
International Museum of Photography at
George Eastman House, Rochester, New York

Cathode Ritual V, 1968
Gelatin silver print
13³/₈ × 8⁷/₁₆ in. (34 × 21.5 cm.)
International Museum of Photography at
George Eastman House, Rochester, New York

Parachute Woman, 1969
Gelatin silver print
8⁵/₈ × 13³/₄ in. (21.9 × 34.9 cm.)
Collection of the artist

10 to Descend 10, 1969
Gelatin silver print
9 × 13⁵/₈ in. (22.8 × 34.6 cm.)
Collection of the artist

Untitled [TV with vertical bars], 1969–70
Gelatin silver print
8³/₄ × 13⁵/₈ in. (22.2 × 34.6 cm.)
Los Angeles County Museum of Art

E.P. & G.B. Revisited, 1969
Gelatin silver print
5¹/₄ × 13¹/₂ in. (13.3 × 34.3 cm.)
Collection of Roger Mertin

from the series War in Our Time—
Head of Pilot, 1968
Gelatin silver print
8⁷/₈ × 13¹/₄ in. (22.6 × 33.7cm.)
National Gallery of Canada

from the series War in Our Time—
Turret, 1968
Gelatin silver print
9¹/₄ × 13¹/₂ in. (23.5 × 34.3 cm.)
Collection of Roger Mertin

from the series War in Our Time—
Tongue, 1968
Gelatin silver print
9¹/₄ × 13⁹/₁₆ in. (23.5 × 34.5 cm.)
Collection of Roger Mertin

from the series War in Our Time—
Phone, 1968
Gelatin silver print
8⁷/₈ × 13¹/₈ in. (22.6 × 33.5 cm)
University Art Museum,
The University of New Mexico, Albuquerque

The Series Pink Stuff

Box, 1970
Toned gelatin silver print
5⁷/₁₆ × 13⁷/₈ in. (13.8 × 35.3 cm.)
Los Angeles County Museum of Art

Ur Camouflage Car, 1971
Toned gelatin silver print
4¹/₄ × 13⁵/₈ in. (10.8 × 34.6 cm.)
Los Angeles County Museum of Art

Camouflage Car, 1971
Toned gelatin silver print
4⁵/₁₆ × 13⁵/₈ in. (11.0 × 34.6 cm.)
Courtesy of Susan Spiritus Gallery,
Newport Beach, California

Channel, 1971
Toned gelatin silver print
4³/₈ × 13⁹/₁₆ in. (11.1 × 34.5 cm.)
Collection of the artist

Interstate Span, 1971
Toned gelatin silver print
4³/₈ × 13¹¹/₁₆ in. (11.1 × 34.8 cm.)
Courtesy of Andrew Smith Gallery,
Santa Fe, New Mexico

K.C. House, 1971
Toned gelatin silver print
4⁷/₁₆ × 13¹¹/₁₆ in. (11.3 × 34.8 cm.)
Courtesy of Andrew Smith Gallery,
Santa Fe, New Mexico

Dying Poplars, 1971
Toned gelatin silver print
4⁷/₁₆ × 13⁷/₁₆ in. (11.3 × 34.1 cm.)
Collection of the artist

Salt Bird, 1972
Toned gelatin silver print
4⁷/₁₆ × 13¹/₂ in. (11.3 × 34.3 cm.)
San Francisco Museum of Modern Art

Pasadena Wedge, 1974
Toned gelatin silver print
4³/₈ × 13¹/₂ in. (11.1 × 34.3 cm.)
Collection of the artist

and Pink Dualities

Scarsdale, 1970
Toned gelatin silver print
4³/₈ × 13¹/₈ in. (11.1 × 33.4 cm.)
Courtesy of Susan Spiritus Gallery,
Newport Beach, California

ROD–X, 1971
Toned gelatin silver print
4³/₈ × 13¹¹/₁₆ in. (11.1 × 34.8 cm.)
Courtesy of Andrew Smith Gallery,
Santa Fe, New Mexico

Ohio, 1971
Toned gelatin silver print
4⁵/₁₆ × 13³/₄ in. (11.0 × 34.9 cm.)
Courtesy of Andrew Smith Gallery,
Santa Fe, New Mexico

J.C. Chaos, 1971
Toned gelatin silver print
4³/₈ × 13¹¹/₁₆ in. (11.1 × 34.8 cm.)
Los Angeles County Museum of Art

Houston Stack, 1971
Toned gelatin silver print
4¹/₂ × 13¹/₂ in. (11.4 × 34.3 cm.)
Courtesy of Andrew Smith Gallery,
Santa Fe, New Mexico

Brunswick Line, 1971
Toned gelatin silver print
4³/₈ × 13⁵/₈ in. (11.1 × 34.6 cm.)
Courtesy of Andrew Smith Gallery,
Santa Fe, New Mexico

Super 100, 1971
Toned gelatin silver print
4³/₈ × 13¹/₂ in. (11.1 × 34.3 cm.)
Collection of the artist

Germanic Etch, 1972
Toned gelatin silver print
4¹/₄ × 13⁵/₈ in. (11.1 × 34.6 cm.)
Courtesy of Susan Spiritus Gallery,
Newport Beach, California

Interior Thoughts, 1972
Toned gelatin silver print
4³/₁₆ × 13¹/₂ in. (10.7 × 34.3 cm.)
Collection of the artist

Interior Thoughts II, 1980
Toned gelatin silver print
4³/₈ × 13⁵/₈ in. (11.1 × 34.6 cm.)
Los Angeles County Museum of Art

The Verifax Prints

Homage to Number Three, 1970
Verifax matrix print
14 × 8¹/₂ in. (35.6 × 21.6 cm.)
Collection of the artist

*from the series Product News—
Lunch Lunokhod*, 1971
Verifax matrix print
14 × 8¹/₂ in. (35.6 × 21.6 cm.)
Collection of the artist

*from the series Product News—
Fan*, 1971
Verifax matrix print
14 × 8¹/₂ in. (35.6 × 21.6 cm.)
Los Angeles County Museum of Art

*from the series Product News—
Reduction*, 1971
Verifax matrix print
8¹/₂ × 14 in. (21.6 × 35.6 cm.)
Collection of the artist

Terminal Boop, 1971
Verifax matrix print
14 × 8¹/₂ in. (35.6 × 21.6 cm.)
Collection of the artist

Making Democracy Work, 1971
Verifax matrix print
13⁷/₈ × 8⁷/₁₆ in. (35.5 × 21.5 cm.)
University Art Museum, The University of
New Mexico, Albuquerque

Chiropodist's Dream, 1971
Verifax matrix print
12¹¹/₁₆ × 8⁷/₁₆ in. (32.2 × 21.5 cm.)
University Art Museum, The University of
New Mexico, Albuquerque

Silicon Homage to Ed. P., 1971
Verifax matrix print
14 × 8¹/₂ in. (35.6 × 21.6 cm.)
Collection of the artist

Visor, 1972
Verifax matrix print
13⁷/₈ × 8¹/₂ in. (35.3 × 21.6 cm.)
Collection of the artist

Firing Fogger, 1972
Verifax matrix print
13⁷/₈ × 8¹/₂ in. (35.3 × 21.6 cm.)
Collection of the artist

Homage to R.H., 1972
Verifax matrix print
13⁷/₈ × 8¹/₂ in. (35.3 × 21.6 cm.)
Collection of the artist

*from the series Trivia 2—
Untitled*, 1973
Verifax matrix print
14 × 8¹/₂ in. (35.6 × 21.6 cm.)
Collection of the artist

*from the series Trivia—
Political Trinkets*, 1973
Verifax matrix print
14 × 8¹/₂ in. (35.6 × 21.6 cm.)
Los Angeles County Museum of Art

*from the series Enigma Cipher Machine—
O/O/S*, 1975
Verifax matrix print
14 × 8¹/₄ in. (35.6 × 21.0 cm.)
Collection of the artist

*from the series Enigma Cipher Machine—
#7*, 1975
Verifax matrix print
14 × 8¹/₂ in. (35.6 × 21.6 cm.)
Los Angeles County Museum of Art

The Series Libraries

N.C. Jr., 1975
Gelatin silver print
9⁵/₁₆ × 13⁷/₁₆ in. (23.7 × 34.1 cm.)
Courtesy of Andrew Smith Gallery,
Santa Fe, New Mexico

E.B., Riverside, Ca., 1976
Gelatin silver print
9³/₈ × 13¹/₂ in.(23.8 × 34.3 cm.)
Courtesy of Andrew Smith Gallery,
Santa Fe, New Mexico

D.D. II (Toronto), 1976
Gelatin silver print
8¹⁵/₁₆ × 13³/₈ in. (22.7 × 34.0 cm.)
Courtesy of Andrew Smith Gallery,
Santa Fe, New Mexico

Dr. J.S., Santa Paula, Ca., 1976
Gelatin silver print
9¹/₄ × 13³/₈ in. (23.5 × 34.0 cm.)
Courtesy of Andrew Smith Gallery,
Santa Fe, New Mexico

Virgil Mirano, 1976
Gelatin silver print
9¹/₈ × 13³/₈ in. (23.2 × 34.0 cm.)
Courtesy of Andrew Smith Gallery,
Santa Fe, New Mexico

UCR Special Collections, 1976
Gelatin silver print
9⁵/₁₆ × 13⁹/₁₆ in. (23.7 × 34.5 cm.)
Los Angeles County Museum of Art

V.S., N.Y.C., 1976
Gelatin silver print
9³/₈ × 13¹/₂ in. (23.8 × 34.3 cm.)
Courtesy of Andrew Smith Gallery,
Santa Fe, New Mexico

N.C. Jr. II, 1976
Gelatin silver print
9¹/₁₆ × 13³/₈ in. (23.0 × 34.0 cm.)
Collection of the artist

Santa Paula II, 1976
Gelatin silver print
9¹/₄ × 13³/₈ in. (23.5 × 34.0 cm.)
Courtesy of Andrew Smith Gallery,
Santa Fe, New Mexico

S.T. & B, 1976
Gelatin silver print
9¹/₄ × 13³/₈ in. (23.5 × 34.0 cm.)
Collection of Susan Harder

R.W.F., Culver City, Ca., 1977
Gelatin silver print
9³/₁₆ × 13¹/₂ in. (23.3 × 34.3 cm.)
Courtesy of Susan Spiritus Gallery,
Newport Beach, California

J. Deal, Riverside, Ca., 1977
Gelatin silver print
9¹¹/₁₆ × 13¹/₂ in. (24.6 × 34.3 cm.)
Collection of the artist

L. Baltz, 1977
Gelatin silver print
9¹/₄ × 13¹/₂ in. (23.5 × 34.3 cm.)
Collection of the artist

D. Andrews, Albuquerque, 1977
Gelatin silver print
9¹/₄ × 13⁹/₁₆ in. (23.5 × 34.5 cm.)
Courtesy of Andrew Smith Gallery,
Santa Fe, New Mexico

TFB, Albuquerque, 1978
Gelatin silver print
9¹/₂ × 13³/₄ in. (24.1 × 34.9 cm.)
Los Angeles County Museum of Art

Gun Club Road/South Wall Variant, 1978
Gelatin silver print
9³/₁₆ × 13⁹/₁₆ in. (23.3 × 34.5 cm.)
Courtesy of Andrew Smith Gallery,
Santa Fe, New Mexico

Gun Club Road/South Wall, 1978
Gelatin silver print
9¹/₄ × 13⁹/₁₆ in. (23.5 × 34.5 cm.)
Los Angeles County Museum of Art

Albuquerque, N.M. (TFB & Friend), 1978
Gelatin silver print
9⁹/₁₆ × 13⁵/₈ in. (24.4 × 34.6 cm.)
Courtesy of Andrew Smith Gallery,
Santa Fe, New Mexico

The Series Cancellations

SLAB (Pasadena), 1974
Toned gelatin silver print
9³/₈ × 13¹/₂ in. (23.8 × 34.3 cm.)
Courtesy of Andrew Smith Gallery,
Santa Fe, New Mexico

Sun Sign, 1974
Toned gelatin silver print
9³/₄ × 13¹/₂ in. (24.8 × 34.3 cm.)
Courtesy of Andrew Smith Gallery,
Santa Fe, New Mexico

Santa Monica House, 1974
Toned gelatin silver print
9³/₈ × 9¹¹/₁₆ in. (23.8 × 24.6 cm.)
Collection of the artist

Pile, 1974
Toned gelatin silver print
9³/₈ × 13¹/₂ in. (23.8 × 34.3 cm.)
Collection of the artist

Albuquerque Platform, 1974
Toned gelatin silver print
9¹/₄ × 13⁹/₁₆ in. (23.5 × 34.5 cm.)
Courtesy of Andrew Smith Gallery,
Santa Fe, New Mexico

Homage to Paula, 1974
Toned gelatin silver print
9¹/₄ × 13⁹/₁₆ in. (23.5 × 34.5 cm.)
Los Angeles County Museum of Art

Dart, 1974
Toned gelatin silver print
9³/₈ × 13¹/₂ in. (23.8 × 34.3 cm.)
University Art Museum, The University of
New Mexico, Albuquerque

Horizon Rib, 1974
Toned gelatin silver print
9¹/₄ × 13¹/₂ in. (23.5 × 34.3 cm.)
Collection of Joe Deal

Nine Hours . . . , 1974
Toned gelatin silver print
9⁵/₁₆ × 13⁹/₁₆ in. (23.7 × 34.5 cm.)
San Francisco Museum of Modern Art

Tank, 1975
Toned gelatin silver print
9¹/₄ × 13¹/₂ in. (23.5 × 34.3 cm.)
Collection of the artist

Plate Variant, 1975
Toned gelatin silver print
9¹/₄ × 13¹/₂ in. (23.5 × 34.3 cm.)
Courtesy of Andrew Smith Gallery,
Santa Fe, New Mexico

San Clemente Bluff, 1975
Toned gelatin silver print
9³/₈ × 13⁹/₁₆ in. (23.8 × 34.5 cm.)
Los Angeles County Museum of Art

Network Pump, 1975
Toned gelatin silver print
9¼ × 13½ in. (23.5 × 34.3 cm.)
Courtesy of Andrew Smith Gallery,
Santa Fe, New Mexico

Reservoir Variant, 1977
Toned gelatin silver print
13½ × 19⅜ in. (34.3 × 49.2 cm.)
Courtesy of Andrew Smith Gallery,
Santa Fe, New Mexico

Homage to M.W., 1977–78
Toned gelatin silver print
13⅞ × 19¼ in. (35.3 × 48.9 cm.)
Collection of the artist

FLW Dusk, 1978
Toned gelatin silver print
13⁷⁄₁₆ × 19¼ in. (34.1 × 48.9 cm.)
Los Angeles County Museum of Art

Terrace, 1978
Toned gelatin silver print
13½ × 19¼ in. (34.3 × 48.9 cm.)
Los Angeles County Museum of Art

Homage to E.W., 1978–79
Toned gelatin silver print
13⁹⁄₁₆ × 19¼ in. (34.5 × 48.9 cm.)
Collection of the artist

Sash, 1978
Toned gelatin silver print
13⅜ × 19⅜ in. (34.0 × 49.2 cm.)
Collection of the artist

Bilingual Communication, 1980
Toned gelatin silver print
13½ × 19⅜ in. (34.3 × 49.2 cm.)
Collection of the artist

The Lithographs

Revisions, 1976
Lithograph
23¼ × 30¾ in. (59.1 × 78.1 cm.)
Collection of Barbara Kasten

Films, 1978
Lithograph
17 × 22⅛ in. (43.2 × 56.2 cm.)
Private Collection

Springerville Variant, 1982
Lithograph and screen print
16¼ × 20¼ in. (40.6 × 50.6 cm.)
Collection of John Upton

The Spray-Painted Photograms

Glass Studies, 1977–78
Gelatin silver print with spray paint
15⁷⁄₁₆ × 19⁵⁄₁₆ in. (39.3 × 49.1 cm.)
Center for Creative Photography,
University of Arizona, Tucson, Arizona

Threshold Logic, 1978
Gelatin silver print with spray paint
19¼ × 15½ in. (48.9 × 39.4 cm.)
Collection of Gilbert Hitchcock

Self Reflexive, 1978
Gelatin silver print with spray paint and
attached Polaroid prints
16 × 19⅞ in. (40.6 × 50.5 cm.)
San Francisco Museum of Modern Art

Homage to Arakawa (Flash Gravity), 1978
Gelatin silver print with spray paint
15½ × 19⁵⁄₁₆ in. (39.4 × 49.1 cm.)
Los Angeles County Museum of Art

Figure of Merit II, 1979
Gelatin silver print with spray paint
19½ × 15½ in. (49.5 × 39.4 cm.)
Los Angeles County Museum of Art

Glass Studies III, 1979
Gelatin silver print with spray paint
19¼ × 15⅝ in. (48.9 × 39.7 cm.)
Courtesy of Susan Spiritus Gallery,
Newport Beach, California

Social Audits, 1979
Gelatin silver print with spray paint
19⅞ × 16 in. (50.5 × 40.6 cm.)
Collection of the artist

Perturbation Theory, 1979
Gelatin silver print with spray paint
15½ × 19⅜ in. (39.4 × 49.2 cm.)
Los Angeles County Museum of Art

Figure of Merit, 1979
Gelatin silver print with spray paint
19¼ × 15½ in. (48.9 × 39.4 cm.)
Collection of Joe Deal

Topological Groups II, 1980
Gelatin silver print with spray paint and
attached Polaroid print
15⅞ × 20 in. (40.3 × 50.8 cm.)
Courtesy of Light Gallery, New York

Replicate Vector Space, 1980
Gelatin silver print with spray paint and
attached Polaroid print
19⅞ × 16 in. (50.5 × 40.6 cm.)
Los Angeles County Museum of Art

Decision Assumptions, 1980
Gelatin silver print with spray paint
15½ × 19½ in. (39.4 × 49.5 cm.)
Courtesy of Laurence Miller Gallery, New York

Optimal Control, 1980
Gelatin silver print with spray paint
15⅞ × 20 in. (40.3 × 50.8 cm.)
Private Collection

Sequential Machines, 1980
Gelatin silver print with spray paint
15¾ × 19⅞ in. (40.0 × 50.5 cm.)
Collection of Victor Schrager

Conceptual Distortion 2, 1981
Gelatin silver print with spray paint
15⅞ × 19⅞ in. (40.3 × 50.5 cm.)
Los Angeles County Museum of Art

Conceptual Distortion 3, 1981
Gelatin silver print with spray paint
15⅞ × 19⅞ in. (40.3 × 50.5 cm.)
Courtesy of Andrew Smith Gallery,
Santa Fe, New Mexico

Disjunctive Forms, 1981
Gelatin silver print with spray paint
and attached Polaroid print
16 × 19⅞ in. (40.6 × 50.5 cm.)
Collection of the artist

Struggle for Identity 3, 1981–82
Gelatin silver print with spray paint
15¹⁵⁄₁₆ × 19⅞ in. (40.5 × 50.5 cm.)
Courtesy of Andrew Smith Gallery,
Santa Fe, New Mexico

Locations of Zeros 2, 1981
Gelatin silver print with spray paint
19¼ × 15⅝ in. (48.9 × 39.7 cm.)
Los Angeles County Museum of Art

Classical Mechanics, 1981–82
Gelatin silver print with spray paint
15⁷/₈ × 19⁷/₈ in. (40.3 × 50.5 cm.)
Collection of the artist

Principles of Transformational Syntax, 1981–82
Two gelatin silver prints with spray paint
15¹⁵/₁₆ × 19⁷/₈ in. (40.5 × 50.5 cm.) (each)
Collection of the artist

Nonlinear Interactions, 1983
Gelatin silver print with spray paint
15⁷/₈ × 19⁷/₈ in. (40.3 × 50.5 cm.)
Los Angeles County Museum of Art

The Caulked Reconstructions

Teepees, 1979
Reconstructed gelatin silver print with caulking,
staples, and spray paint
18 × 19 in. (45.7 × 48.3 cm.) irregular
The Washington Art Consortium

Springerville Fragment, 1980
Reconstructed gelatin silver print with caulking,
staples, and spray paint
19¹/₂ × 20 in. (49.5 × 50.8 cm.) irregular
Los Angeles County Museum of Art

from the series Modest Structures—
Springerville, Az, 1980
Reconstructed gelatin silver prints with
caulking, staples, and spray paint
29¹/₂ × 20 in. (74.9 × 50.8 cm.) irregular
Courtesy of Susan Spiritus Gallery,
Newport Beach, California

from the series Modest Structures—
Untitled (Tank Farm), 1980–81
Reconstructed gelatin silver prints with
caulking, staples, and spray paint
26¹/₂ × 20¹/₂ in. (67.3 × 52.1 cm.) irregular
Collection of Joan Myers

Triad, 1981
Reconstructed gelatin silver prints with
caulking, staples, and spray paint
29¹/₂ × 19 in. (74.9 × 48.3 cm.) irregular
Collection of the artist

from the series Modest Structures—
Downtown Albuquerque, 1981
Reconstructed gelatin silver prints with
caulking, staples, and spray paint
31 × 21 in. (78.7 × 53.3 cm.) irregular
Courtesy of Andrew Smith Gallery,
Santa Fe, New Mexico

Homage: The Bechers, 1981–82
Reconstructed gelatin silver prints with
caulking, staples, and spray paint
39 × 18¹/₂ in. (99.1 × 47.0 cm.) irregular
Collection of the artist

Camouflaged Pictorialism, 1982
Reconstructed gelatin silver prints with
caulking, staples, and spray paint
40 × 17 in. (101.6 × 43.2 cm.) irregular
Collection of Joan Myers

Recent Works

Notations on Modernism, 1981–83
Gelatin silver print with spray paint and
attached Polaroid prints
16 × 19³/₄ in. (40.6 × 50.2 cm.)
Los Angeles County Museum of Art

Principles of Transformational Syntax 2, 1982–83
Two gelatin silver prints with spray paint
16 × 19³/₄ in. (40.6 × 50.2 cm.) each
Collection of the artist

Memories of Stendahl, 1982–84
Construction with published book, spray paint,
rope, and Polaroid prints
17 × 15 in. (43.2 × 38.1 cm.)
Collection of Joan Myers

Interpretation of Structure, 1983
Two gelatin silver prints with spray paint
15⁵/₁₆ × 19⁷/₈ in. (49.1 × 50.5 cm.) each
Courtesy of Andrew Smith Gallery,
Santa Fe, New Mexico

Evolutionary Notes, 1983
Gelatin silver print with spray paint
and eight attached Polaroid prints
20 × 22¹/₂ in. (50.8 × 57.2 cm.)
Courtesy of Andrew Smith Gallery,
Santa Fe, New Mexico

from the series Water as Matrix—
Don Reservoir, 1983
Toned gelatin silver print with
attached Polaroid prints
17¹/₂ × 19⁵/₁₁ in. (45.0 × 49.1 cm.)
The Museum of New Mexico, Santa Fe

from the series Water as Matrix—
College Well and Reservoir, 1983
Toned gelatin silver print with attached
Polaroid prints
17⁵/₁₆ × 19⁵/₁₆ in. (44 × 49.1 cm.)
The Museum of New Mexico, Santa Fe

from the series Water as Matrix—
Santa Barbara Well, looking east, 1983
Toned gelatin silver print with
attached Polaroid prints
17⁷/₁₆ × 19⁵/₁₆ in. (44.3 × 49.1 cm.)
The Museum of New Mexico, Santa Fe

Capitalism Graphed, 1983–84
Polaroid prints mounted on plastic laminate
9 × 44 in. (22.8 × 111.8 cm.) framed
Collection of the artist

Strange Attractor, 1984
Gelatin silver print with spray paint
19³/₄ × 23³/₄ in. (50.2 × 60.3 cm.)
Courtesy of Andrew Smith Gallery,
Santa Fe, New Mexico

Artificial Curiosities, 1984
Gelatin silver print with spray paint
and nine attached Polaroid prints
19¹/₂ × 27 in. (49.5 × 68.6 cm.) irregular
Collection of the artist

Syntactic Recognition, 1984
Gelatin silver print with spray paint
23³/₄ × 20 in. (60.3 × 50.8 cm.)
Collection of the artist

Rigidity Assumption, 1984
Gelatin silver print with spray paint
19³/₄ × 23³/₄ in. (50.2 × 60.3 cm.)
Hallmark Art Collection, Kansas City, Missouri

La Moindre Lumière (Le Chat Noir), 1985
Gelatin silver print with spray paint
and attached Polaroid print
24 × 19³/₄ in. (61.0 × 50.2 cm.)
Collection of the artist

The New Vision, 1985–86
Construction with published book, spray paint,
and Polaroid prints
21¹/₂ × 18¹/₄ in. (53.8 × 45.6 cm.)
Collection of the artist

Reading into Photography, 1985–86
Construction with nine published books, bolts,
and Polaroid prints
13 × 15 × 9 in. (32.5 × 37.5 × 22.5 cm.)
Collection of the artist

Born 1938, Kansas City, Missouri.
Resides in Albuquerque, New Mexico.

Education

M.S., Institute of Design, Illinois Institute of Technology, Chicago, 1967.
Film Courses with Jack Ellis, Northwestern University, 1963.
B.F.A., Kansas City Art Institute, Missouri, 1963.

Grants

National Endowment for the Arts, Photographer's Fellowship, 1978.
National Endowment for the Arts, Photographer's Fellowship, 1973.

Selected Solo Exhibitions

Friends of Photography, Carmel, California, 1982.
Light Gallery, New York City, 1982.
Light Gallery, New York City, 1979.
Light Gallery, New York City, 1976.
Deja Vu Gallery, Toronto, 1975.
Light Gallery, New York City, 1974.
Light Gallery, New York City, 1972.
University of California at Davis (catalogue), 1969.

Selected Recent Group Exhibitions

Thomas Barrow and Victor Schrager, The Light Factory, Charlotte, North Carolina, 1985.
American Images, Barbican Art Gallery, London, England (catalogue), 1985.
A Centennial Celebration: Highlights from Kansas City Art Institute Alumni, Nelson-Atkins Museum of Art, Kansas City, Missouri, 1985.
Photograms, John Kohler Arts Center, Sheboygan, Wisconsin, 1985.
The Essential Landscape, Museum of Fine Arts, Museum of New Mexico, Santa Fe (catalogue), 1985.
Rochester: An American Center of Photography, International Museum of Photography at George Eastman House (catalogue), 1984.
Alternative Directions, San Francisco Museum of Modern Art, 1984.
Cover to Cover: Experimental Bookworks, Museum of Fine Arts, Museum of New Mexico, Santa Fe, 1984.
Eighty Years of Photography, Andrew Smith Gallery, Albuquerque, New Mexico, 1984.

The Television Show: Video Photographs, Robert Freidus Gallery, New York City, 1983.
New Acquisitions, The Hallmark Photographic Collection 1980–83, Nelson-Atkins Museum of Art, Kansas City, Missouri (catalogue), 1983.
Film and Photo Exposition, Armory for the Arts, Santa Fe, New Mexico, 1983.
Ten Photographers in New Mexico, Houston Center for Photography, 1983.
Arboretum, University of Denver, 1983.
The Alternative Image II, J. Michael Kohler Arts Center, Sheboygan, Wisconsin (catalogue), 1983.
Still Lifes from the Collection, Museum of Fine Arts, Houston, 1983.
Recent Acquisitions, Princeton Art Museum, 1983.
Urban America, San Francisco Museum of Modern Art, 1982.
Thomas Barrow, Esther Parada and John Wood, Northlight Gallery, Arizona State University, Tempe, Arizona, 1982.
American Photography Today, University of Colorado at Denver, 1982.
The Alternative Image, John Michael Kohler Arts Center, Sheboygan, Wisconsin (catalogue), 1982.
The Strauss Photography Collection, Denver Art Museum (catalogue), 1982.
Still Modern After All These Years, Chrysler Museum, Norfolk, Virginia (catalogue), 1982.
Form, Freud and Feeling, San Francisco Museum of Modern Art, 1982.
Work by Former Students of Aaron Siskind, Center for Creative Photography, Tucson, Arizona, 1982.
Alterations: Unique Photographs, Sioux City Art Center, Sioux City, Iowa, 1982.
Photo Facts and Opinions, Addison Gallery of American Art, Andover, Massachusetts (catalogue), 1981.
American Photographs 1970–1980, Whatcom Museum of History and Art, Bellingham, Washington (catalogue), 1981.
Altered Images, Center for Creative Photography, Tucson, Arizona (catalogue), 1981.
The Markers, San Francisco Museum of Modern Art (catalogue), 1981.
Acquisitions 1973–1980, International Museum of Photography at George Eastman House, Rochester, New York (catalogue), 1981.
Thomas Barrow and James Henkel, Film in the Cities, St. Paul, Minnesota, 1981.
Color and Colored Photographs 1938–1979, San Francisco Museum of Modern Art, 1981.
Erweiterte Fotografie, 5, Wiener Internationale Biennale, Vienna, Austria (2 vol. catalogue), 1981.

Photography by Kansas City Art Institute Alumni, Kansas City Art Institute, 1981.

Tenth Anniversary, Photographer's Selection, Light Gallery, New York City, 1981.

Urban America, San Francisco Museum of Modern Art, 1981.

Susan Spiritus Gallery (with J. Thurston), Newport Beach, California, 1980.

Crosscurrents: Additions to the Permanent Collection, San Francisco Museum of Modern Art, 1980.

Presences: Contemporary Photography, Albright College, Reading, Pennsylvania (catalogue), 1980.

The New Vision: 40 Years of Photography at the Institute of Design, Light Gallery, New York City, 1980.

Photography: Recent Directions, DeCordova Museum, Lincoln, Massachusetts (catalogue), 1980.

Visitors to Arizona, Phoenix Art Museum (catalogue), 1980.

Alternative Images, Everson Art Museum, Syracuse, New York, 1979.

Fish, Boston College, 1979.

Translations: Photographic Images with New Forms, Herbert F. Johnson Museum of Art, Cornell University, Ithaca, New York (catalogue), 1979.

History of Photography in New Mexico, Art Museum, University of New Mexico, Albuquerque (catalogue), 1979.

Altered Landscapes, Florida School of the Arts, Palatka (catalogue), 1979.

The Altered Photograph Show, P.S. 1, Long Island City, Queens, New York, 1979.

Attitudes: Photography in the 1970s, Santa Barbara Museum of Art, 1979.

The Photographer's Hand, International Museum of Photography at George Eastman House, Rochester, New York, 1979.

Cultural Artifacts, Florida School of the Arts, Palatka (catalogue), 1979.

We Do the Rest: A Photographic Survey, Seigfred Gallery, Athens, Ohio, 1979.

Electroworks, International Museum of Photography at George Eastman House, Rochester, New York (catalogue), 1979.

Contemporary Photography, University of Alabama, 1978.

New York, New York, Light Gallery, New York City, 1978.

Two from Albuquerque (with Betty Hahn), Susan Spiritus Gallery, Newport Beach, California, 1978.

Albuquerque Artists I, Museum of Albuquerque, 1978.

Photography: Four Stylistic Approaches, Katonah Gallery, Katonah, New York, 1978.

The Photograph as Artifice, Art Galleries, California State University, Long Beach, 1978.

Forty American Photographers, E. B. Crocker Art Gallery, Sacramento, California (catalogue), 1978.

Photographie New Mexico, Centre Culturel Americain, Paris, 1978.

Light Group Exhibition, Silver Image Gallery, Ohio State University, Columbus, 1978.

23 Photographers 23 Directions, Walker Art Gallery, Liverpool, England, 1978.

Photo-Language Notes, Florida State University, Tallahassee, 1978.

Image Makers: An Introduction, Silver Image Gallery, Tacoma, Washington, 1977.

Sequential 77, Harkness House, New York City, 1977.

Photographs from the Permanent Collection, Sheldon Memorial Art Gallery, Lincoln, Nebraska, 1977.

The Great West, University of Colorado at Boulder (catalogue), 1977.

Contemporary American Photographic Works, Museum of Fine Arts, Houston, 1977.

Photographic Process as Medium, Rutgers University, New Brunswick, New Jersey, 1976.

Generative Systems, St. Mary's College, Notre Dame, Indiana, 1976.

Aspects of American Photography, 1976, University of Missouri, St. Louis (catalogue), 1976.

American Photography: Past into Present, Seattle Art Museum, Washington (catalogue), 1976.

The Photographers' Choice, Mount St. Mary's College Art Gallery, Los Angeles (traveled to Enjay Gallery, Boston, and Witkin Gallery, New York City), 1976.

Christmas Exhibition, Spectrum Gallery, Tuscon, Arizona, 1976.

Collecting Photography: A Personal Choice, Focus Gallery, San Francisco, California, 1976.

The Extended Document, International Museum of Photography at George Eastman House, Rochester, New York (catalogue), 1975.

Time and Transformation, Lowe Art Museum, University of Miami, Coral Gables, Florida, 1975.

Photo¹. . . Photo². . . Photoⁿ: Sequenced Photographs, University of Maryland Art Gallery, College Park (traveled to San Francisco Museum of Art, California, and University of Texas at Austin, catalogue), 1975.

Repeated Images, Slocumb Gallery, East Tennessee State University, Johnson City, 1975.

Photography II, Jack Glenn Gallery, Newport Beach, California (catalogue), 1975.

Texture: A Photographic Vision, Whitney Museum of American Art, New York, 1975.

Third Invitational Exhibition of Contemporary Photography, Ohio Wesleyan, Delaware, Ohio, 1975.

Visiting Faculty Exhibition, Frederick S. Wight Art Galleries, University of California at Los Angeles, 1975.
Contemporary Photographs, University of Alabama, 1975.
The Photograph and Its Origins, Kresge Art Center, Michigan State University, East Lansing, 1975.
Fifth Annual Photography West (Invitational Section), Utah State University Gallery, Logan, 1974.
Ten American Photographers, Photographers' Gallery, London, 1974.
Third Annual Photography Invitational, Kansas City Art Institute, Missouri, 1974.
Language of Light: A Survey of the Photography Collection of the University of Kansas Museum of Art, Lawrence (catalogue), 1974.
New Images in Photography: Object and Illusion, Lowe Art Museum, University of Miami, Coral Gables, Florida (catalogue), 1974.
Evans, Lacher, Barrow, University Art Museum, University of New Mexico, Albuquerque, 1974.
Five Photographers, Hill's Gallery, Santa Fe, New Mexico, 1973.
Sharp Focus Realism: A New Perspective, Pace Gallery, New York, 1973.
Images and Ideas: Photographic Expression in the Seventies, Everson Museum of Art, Syracuse, New York, 1973.
Light and Lens: Methods of Photography, Hudson River Museum, Yonkers, New York (catalogue), 1973.
Coke Collection, Museum of Santa Fe, New Mexico (catalogue), 1973.
Photo-Phantasists, Florida State University, Tallahassee, 1973.
Fotografit Oggi, Gli Americani, Galleria Documenta, Turin, Italy (catalogue), 1973.
The Book: A New Direction for Photography, Quivira Gallery, Albuquerque, New Mexico, 1973.
Five Photographers, Roswell Museum and Art Center, New Mexico, 1973.
Seen and Unseen, Fogg Art Museum, Harvard University, Cambridge, Massachusetts, 1973.
The Multiple Image, Massachusetts Institute of Technology, Cambridge, and University of Rhode Island, Providence (catalogue), 1972.
Contemporary Photography, Sheldon Memorial Art Gallery, Lincoln, Nebraska, 1972.
Photography into Art, Camden Arts Centre, London (catalogue), 1972.
Women, Zone V Photographers' Workshop, Watertown, Massachusetts, 1972.
Photography Invitational 1971, Arkansas Art Center, Little Rock, and Memphis Academy of Arts, Tennessee (catalogue), 1971.
Variety Show, Focus Gallery, San Francisco, California, 1971.
Inaugural Group Show, Light Gallery, New York City, 1971.
The Photograph as Object, National Gallery of Canada, Ottawa (catalogue), 1970.

Latent Image Gallery, Houston, 1970.
Recent Acquisitions 1969: Modern Painting, Sculpture, Drawing, Prints, and Photographs, Pasadena Art Museum, California (catalogue), 1969.
Rochester Institute of Technology, New York (with Roger Mertin and Harold Jones), 1969.
Nelson-Atkins Gallery of Art, Kansas City, Missouri, 1969.
Riverside Gallery 2, Rochester, New York, 1969.
Four Photographers, Institute of Design, Illinois Institute of Technology, Chicago, 1969.
Vision and Expression, George Eastman House, Rochester, New York (catalogue), 1969.
Friends Purchase Exhibition, Philadelphia Museum of Fine Arts, 1969.
Contemporary Photographers IV, traveling exhibition organized by George Eastman House, Rochester, New York, 1968.
Photography 1968, Lexington Camera Club, Kentucky (catalogue), 1968.
Young Photographers 1968, Purdue University, Lafayette, Indiana (catalogue), 1968.
Light 7, Massachusetts Institute of Technology, Cambridge (catalogue), 1968.
Riverside Gallery, Rochester, New York, 1967.

Collections

Art Museum, Princeton University
California Museum of Photography, University of California, Riverside
Center for Creative Photography, University of Arizona, Tucson
De Cordova and Dana Museum and Park, Lincoln, Massachusetts
Denver Art Museum
Detroit Institute of Art
Fogg Art Museum, Cambridge, Massachusetts
Hallmark Collection, Kansas City, Missouri
International Museum of Photography at George Eastman House, Rochester, New York
Lincoln Rochester Trust Company
Los Angeles County Museum of Art
Massachusetts Institute of Technology, Cambridge
Minneapolis Institute of Arts
Museum of Fine Arts, Houston
Museum of Modern Art, New York
National Gallery of Australia
National Gallery of Canada
New Orleans Museum of Art
Newport Harbor Art Museum, Newport Beach, California

Norton Simon Museum of Art (formerly Pasadena Art Museum),
 Pasadena, California
Ohio Wesleyan University, Delaware, Ohio
Philadelphia Museum of Fine Arts
Ryerson Polytechnic Institute, Toronto, Canada
San Francisco Museum of Modern Art
Sheldon Memorial Art Gallery, University of Nebraska, Lincoln
Spencer Museum of Art, University of Kansas, Lawrence
Sun Valley Center for the Arts and Humanities Collection
University Art Museum, California State University, Long Beach
University Art Museum, University of New Mexico, Albuquerque
Virginia Museum of Fine Arts, Richmond, Virginia
Washington Art Consortium (Whatcom Museum of History and Art)

Academic and Curatorial Positions

Acting Director, University Art Museum, University of New Mexico,
 1985
Professor, University of New Mexico Department of Art, 1981.
Associate Professor, University of New Mexico Department of Art, 1976–
 81.
Director, Summer Photography Institute, University of California,
 Riverside, 1976.
Associate Director, University of New Mexico Art Museum, Albuquerque,
 1973–76.
Editor of *Image*, George Eastman House, Rochester, NY, 1972.
Assistant Director, George Eastman House, Rochester, NY, 1971–72.
Lecturer in photography, summer session, Center of the Eye, Aspen,
 Colorado, 1969–70.
Lecturer in history and asthetics of photography, Rochester Institute of
 Technology and Buffalo State University, 1968–71.
Associate Curator of Research Center (print collection and library),
 George Eastman House, 1965.
Assistant Curator of Exhibitions, George Eastman House, 1965.

Publications

Introduction to *Culture and Record: Nineteenth Century Photography
 from the Collection of the Art Museum of the University of New
 Mexico*, Elvehjem Museum of Art, Madison, Wisconsin, 1984.
Co-editor (with Peter Walch), *New Mexico Studies in the Fine Arts*,
 "Photography and Postmodernism," 1983.
"Roger Mertin," in *Contemporary Photographers*, St. Martin's Press,
 1982.

Reading into Photography: Selected Writings 1959–1981, ed. by Thomas
 Barrow, Shelley Armitage, and William Tydeman, University of New
 Mexico Press, Albuquerque, New Mexico, 1982.
Introduction to *The Photography of Van Deren Coke*, University of New
 Mexico Art Museum, Albuquerque, New Mexico, 1982.
"On Betty Hahn," *Working Papers #1*, November 1980, Minneapolis,
 Minnesota.
"Learning from the Past," *9 Critics 9 Photographers/Untitled 23*, 1980.
"Some Thoughts on the Criticism of Photography," *Northlight 8*, Tempe,
 Arizona, November 1978.
Foreword to *The Valiant Knights of Daguerre*, University of California
 Press, 1978.
"Footnotes" (with Peter Walch), *New Mexico Studies in the Fine Arts* 2,
 1977.
"Three Photographers and Their Books," in *One Hundred Years of
 Photographic History: Essays in Honor of Beaumont Newhall*,
 University of New Mexico Press, 1975.
Britannica Encyclopedia of American Art, Simon and Schuster, 1973 (10
 biographical entries on photographers).
"Notes on the Photoglyphic Process," *Bulletin, University Art Museum,
 University of New Mexico*, No. 7, 1973.
Introduction to *Source and Resource*, Turnip Press, 1973.
"Looking Down," *Image*, Vol. 15, #2, July 1972.
"Notes on the Collection," *Bulletin, University Art Museum, University
 of New Mexico*, No. 5–6, 1971–72.
"Talent," *Image* 14(5–6), December 1971.
Introduction, *Lewis Hine Portfolio*, George Eastman House, 1971.
"The Camera Fiend," *Image* 14(4), September 1971.
"If You'd Like to Do Something About What's Happening To Your Hips
 and Thighs . . . ," *Album 8*, September 1970.
"600 Faces By Beaton," *Aperture* 15(2), Summer 1970.
"A Letter With Some Thoughts on Photography's Future," *Album 6*, July
 1970.

Publication Design

Twelve Contemporary Artists Working in New Mexico, University Art
 Museum, University of New Mexico, 1976.
Peculiar to Photography (with Henri Man Barendse), University Art
 Museum, University of New Mexico, 1976.
Bulletin, University Art Museum, University of New Mexico, nos. 5–9
 (1971–76).
Frederick Hammersley: A Retrospective Exhibition, University Art
 Museum, University of New Mexico, 1975.

The New Industrial Parks Near Irvine, California, Lewis Baltz,
 published by Castelli Graphics, 1975.
Lithography I, University Art Museum, University of New Mexico, 1975.
Light and Substance, University Art Museum, University of New
 Mexico, 1974.
Clinton Adams: A Retrospective Exhibition of Lithographs, University of
 New Mexico, 1973 (with Clinton Adams).
Garo Antreasian: A Retrospective Exhibition of Lithographs, University
 of New Mexico, 1973 (with Clinton Adams).
Image, vols. 14–15, Journal of the International Museum of Photography.
Lewis Hine Portfolio, George Eastman House, 1971.
Beaumont Newhall Bibliography, George Eastman House.

Exhibitions Directed

Self As Subject: Visual Diaries of Fourteen Photographers, University of
 New Mexico, 1983.
*Culture and Record: Nineteenth-Century Photographs from the
 University of New Mexico Art Museum*, Elvehjem Museum of Art,
 1984.
Doris Ulmann and Howard Cook, drawings and photographs, University
 of New Mexico
Light and Substance, University of New Mexico, 1974 (with Van Deren
 Coke).
Figure in Landscape, International Museum of Photography at George
 Eastman House, Rochester, New York, 1969.
Floyd W. Gunnison, International Museum of Photography at George
 Eastman House.
Circular Image, International Museum of Photography at George
 Eastman House.

Inventories and Transformations

Photographs of Thomas Barrow

Edited by Dana Asbury

Designed by Kiran RajBhandary

Composed by the University of New Mexico Press on Linotron 202 typesetting equipment.

Text set in 10-point Century Expanded, originally designed for American Typefounders by Morris Fuller Benton and first made available in 1900. Benton was also responsible for many other typefaces including Stymie, Engravers Old English, and Franklin Gothic.

Headlines and Folios set in 18- and 10-point Helvetica Medium, originally designed for Haas'sche Schriftgießerie by Max Miedinger and first made available in 1957. Miedinger was also responsible for several other styles of Helvetica, including Helvetica Bold, Helvetica Regular, and Helvetica Italic.

Subhead lines set in 10-point Helvetica Light, anonymously designed for D. Stempel A.G. and first made available in 1965.

Text and images printed on 137 gsm. Satincoat stock and bound on 256 gsm. Artpost cover stock by Dai Nippon Printing, Japan.